Th
th

The S
catego
to 182
mode
and it
chang

studie
these
intera
milita
and th

under
differe
remar

ex
30
a
ss
se

se
w
d
al
ie

ir
w
se

Dana Arnold is Professor of Architectural History and Theory at Middlesex University, London. Her other writings on London include *Rural Urbanism: London landscapes in the early nineteenth century* (2006) and *Representing the Metropolis: Architecture, urban experience and social life in London 1800–1840* (2000)

The Spaces of the Hospital

Spatiality and urban change in London 1680–1820

Dana Arnold

Routledge
Taylor & Francis Group

LONDON AND NEW YORK

First published 2013
by Routledge
2 Park Square, Milton Park, Abingdon, Oxon OX14 4RN

Simultaneously published in the USA and Canada
by Routledge
711 Third Avenue, New York, NY 10017

Routledge is an imprint of the Taylor & Francis Group, an informa business

Cover image credit: Wellcome Library, London
General view: condition of the reports – Clinical Records of Guy's Hospital: Surgeon's Reports 198u
Published: [198-]
Collection: Iconographic Collections
Library reference no.: Iconographic Collection 34413i
Full Bibliographic Record: Link to Wellcome Library Catalogue

British Library Cataloguing in Publication Data
A catalogue record for this book is available from the British Library

Library of Congress Cataloging in Publication Data
Arnold, Dana.
The spaces of the hospital : spatiality and urban change in London 1680-1820 / Dana Arnold.
pages cm
Includes bibliographical references and index.
ISBN 978-0-415-32515-8 (hb : alk. paper) -- ISBN 978-0-415-32516-5 (pb : alk. paper) -- ISBN 978-0-203-35813-9 (ebook) (print) 1. Space (Architecture)--England--London--History--18th century. 2. Architecture and society--England--London--History--18th century. 3. Hospital buildings--England--London--History--18th century. 4. London (England)--Social conditions--18th century. 5. London (England)--Buildings, structures, etc. I. Title.
NA9053.S6A76 2013
725'.5109421--dc23
2012041857

ISBN: 978-0-415-32515-8 (hbk)
ISBN: 978-0-415-32516-5 (pbk)
ISBN: 978-0-203-35813-9 (ebk)

MIX
Paper from responsible sources
FSC
www.fsc.org FSC® C013604

Printed and bound by CPI Group (UK) Ltd, Croydon, CR0 4YY

For Nigel

Contents

Figures

Preface

The problematics of space and spatiality are predominant themes in architectural writing. This study aims to bring an historical dimension to these issues. In this book I am interested particularly in thinking about the built environment as space rather than focusing on the architecture that surrounds space. My historical instance is the hospital in London during the long eighteenth century. This period is important as it witnessed the transformation of the city into a modern metropolis. The hospital was very much part of this process and its spaces, both interior and exterior, help us to map these changes in the built environment of London. In this way we can work towards an understanding of how the interior and exterior spaces of this vast metropolis operated.

 The question raised in my mind is how the spaces of these institutions both functioned as internal discrete locations and interacted with the metropolis. This can be explored in terms of how their social structures and governmental systems worked and how these spaces functioned almost as cities within the city, given the large numbers of patients who passed through their doors on an annual basis. We should not forget also that hospitals made a substantial contribution to the urban infrastructure, demography and aesthetic. In exploring these questions my aim is not to attempt to trace a linear sequence of building typology or social purpose; rather it is to explore the continuities alongside the discontinuities and oppositional forces at play.[1] And I wish to do this by looking at the hospital from a range of viewpoints using the concepts of space and spatiality. In this way the spaces of the hospital can be interrogated in a complementary way to social histories of architecture and studies that focus on hospital design.

 I am interested in the interface between theory and archive and particularly here how it is played out in the historical instance of the spaces of the hospital in the long eighteenth century. Each of the chapters operates as a discrete essay which explores a particular theoretical paradigm. Together the essays combine to present a juxtaposition of theory and archive that allow us to interrogate the

interaction of history and space in all its complexities. The aim is to tease out meanings and interpretations from a theoretical analysis of specific hospitals that have implications for our wider understanding of the spaces of the hospital. Institutions that were ingrained in the social fabric take on systems of meanings that relate to the religious, aesthetic and cultural values of the time. But these meanings are not static, as cities and their institutions are constantly in a state of flux.

My overarching frame for this study is a Foucauldian analysis that relies on the premise that power is based on discourse and that in the case of the hospital these discourses are concerned with institutionalising processes and systems of control. I examine how the spaces and processes of the hospitals imposed these sets of (usually) patriarchal values on those who received succour and charity. In this way the spaces of the hospital both inside and out are seen as ways in which certain modes of performance – social, gender or class – are prompted and controlled. Notions of space and spatiality allow us to explore the interplay between the institutionalising rituals and practices of the hospital as a functioning entity and their role as part of the architectural and social urban fabric. We can also articulate how these spaces impacted on the containment and construction of gender, illness and other elements in ways that stand outside established patriarchal discourse. The way architectural structures and institutions can be used and interrogated as agents in the production of a dominant discourse and agents of change in the metropolis is a model that can be applied to other cities and periods. Similarly, the re-interrogation of the spaces of the hospital as an agent of social and cultural control predicated on a patriarchal discourse, and the way in which this notion can be unpicked, provides an important paradigm shift in the narratives of architectural history, which has far-reaching consequences. The volume as a whole not only provides a detailed survey of the social and cultural contexts of an important public building type which is of global significance, but also a re-mapping of how we think and write about monolithic, canonical subjects of architectural history.

Acknowledgements

My thinking about space and spatiality in relation to the hospital has evolved over a number of years. Preliminary work was undertaken during my tenure as a scholar at the Getty Research Institute and as a visiting fellow at CRASSH University of Cambridge. Their twinned research theme of 'biography' allowed me to explore how architecture and life writing can collide in unexpected ways in the spaces of the hospital as all the stages of the human life cycle from birth to death pass through and around its spaces. This enabled me to think about how we can integrate the authentic voice of subjects, including anonymous ones, into the narratives of buildings and indeed the metropolis. Further research supported by a fellowship at the Lewis Walpole Library, Yale University, gave me access to their very rich archival holdings on historical matters relating to hospitals, charity and medicine in the long eighteenth century.

Space and spatiality has been a predominant theme in my writing in recent years. And my two co-edited volumes *Architecture as Experience: Radical Change in Spatial Practice* (with Andrew Ballantyne) and *Biographies and Space* (with Joanna Sofaer) were formative in my thinking on the problematics addressed in this study. I would like to thank my co-editors and the contributors for their collegiality and for giving me the opportunity to work through some of my general ideas. I am grateful to Adrian Rifkin for his generosity in talking through some of the issues raised in the essays in this volume. Any omissions and oversights are my own.

The support of my editors, Francesca Ford, Laura Williamson and Adam Hughes, during the preparation of this book has been much appreciated. I am also greatly indebted to Clare Barry, who has given me invaluable assistance in the collation of the images and for compiling the index.

I would also like to thank Nigel King for his enthusiasm and encouragement. This book is for him.

Chapter 1

The spaces of
the hospital

> One speaks, with good reason, of a sense of space
> (Raumgefuehl) in architecture. But this sense of space is not a
> pure, abstract essence, not a sense of spatiality itself, since
> space is only conceivable as concrete space, within specific
> dimensions. A sense of space is closely connected with
> purposes. ... Architectonic imagination is, according to this
> conception of it, the ability to articulate space purposefully. It
> permits purposes to become space. It constructs forms
> according to purposes. Conversely, space and the sense of
> space can become more than impoverished purpose only
> when imagination impregnates them with purposefulness.
>
> Theodore Adorno

The loaded meaning of space is a common concern in architectural
writing to which this study aims to bring an historical dimension. I am
interested particularly in thinking about the built environment as space
rather than focusing on the architecture that surrounds space. My
archive is the hospital in London during the long eighteenth century.
This period is important as it witnessed the transformation of city into
a modern metropolis. The hospital was very much part of this process
and the purposes of its spaces, both interior and exterior, help us to
map these changes in the built environment of London.

I begin with the Royal Military and Royal Naval hospitals at
Chelsea and Greenwich which serve as a prompt to our period. They
appeared after almost two centuries that had seen little interest in these
institutions. But hospitals soon proliferated across the metropolis and
became a more complex category of social, urban and architectural
space. These were not only for the curing of the sick, but the term
'hospital' was also used for institutions concerned with the poor or
destitute, as in the case of the Foundling Hospital for orphans and
abandoned babies, the Magdalen Hospital founded to rescue penitent

prostitutes, or the Marine Society for Educating Poor Destitute Boys. In a sharp turn around in attitudes in the opening decades of the eighteenth century, five new major hospitals for the care of the sick were founded in London. Within the space of a generation Westminster Hospital led the way (1716), followed by Guy's, St George's, the London and Middlesex. These were not royal hospitals but instead marked the beginning of the cultural phenomenon of the voluntary hospital. This new type of institution redefined the notion of charity within the metropolis and the country as a whole. These hospitals were new in intention and in architectural form.

The history of these institutions has been traced by social historians, historians of medicine,[1] and those interested in the architectural design of the buildings that housed them.[2] The question raised in my mind is how the spaces of these institutions both functioned as internal discrete locations and interacted with the metropolis. This can be explored in terms of how their social structures and governmental systems operated and how these spaces functioned in terms of people management, given the large numbers of patients who passed through their doors on an annual basis. Hospitals also made a substantial contribution to the urban infrastructure, demography and aesthetic. My aim is not to attempt to trace a linear sequence of building typology or social purpose; rather it is to explore the continuities alongside the discontinuities and oppositional forces at play. And I wish to do this by interrogating the hospital in all its complexities using the concepts of space and spatiality. In this way the spaces of the hospital can be interrogated in a complementary way to social histories of architecture and studies that focus on hospital design. Henri Lefebvre is helpful here as he concentrates on the idea of lived experience of architecture in terms of space and spatial practices. In *The Production of Space* Lefebvre argues that the primacy of the image in terms of architectural design and our understanding of it subjugates the role of social space:

> Let us now turn our attention to the space of those who are referred to by means of such clumsy and pejorative labels as 'users' and 'inhabitants'. No well-defined terms with clear connotations have been found to designate these groups. Their marginalisation by spatial practice thus extends even to language. The word 'user' (*usager*), for example has something vague – and vaguely suspect – about it. 'User of what?' one tends to wonder. Clothes and cars are used (and wear out), just as houses are. But what is the use value when set alongside exchange and its corollaries? As for 'inhabitants',

the word designates everyone – and no one. The fact is that the most basic demands of 'users' (suggesting 'underprivileged') and 'inhabitants' (suggesting 'marginal') find *expression* only with great difficulty, whereas the signs of their situation are constantly increasing and often stare us in the face.

The user's space is *lived* – not represented (or conceived). When compared with the abstract space of the experts (architects, urbanists, planners), the space of the everyday activities of users is a concrete one, which is to say, subjective. As a space of subjects rather than of calculations, as a representational space. ... It is in this space that the 'private' realm asserts itself ... against the public one.

It is possible ... to form a mental picture of a primacy of concrete spaces of semi-public, semi-private spaces, of meeting-places, pathways and passageways. This would mean the diversification of space, while the (relative) importance attached to functional distinctions would disappear ...

... the reign of the facade over space is certainly not over. The furniture, which is almost as heavy as the buildings themselves, continues to have facades; mirrored wardrobes, sideboards and chests still face out onto the sphere of private life, and so help dominate it. ... In as much as the resulting space would be inhabited by *subjects*, it might legitimately be deemed 'situational' or 'relational' – but these definitions or determinants would refer to sociological content rather than to any intrinsic properties of space as such.

The hospital is one means of understanding how the interior and exterior spaces of this vast metropolis operated. Institutions that were ingrained in the social fabric take on systems of meanings that relate to the religious, aesthetic and cultural values of the time. But these meanings are not static, as cities and their institutions are constantly in a state of flux. The hospitals that comprise my case studies were founded, changed and developed during the long eighteenth century. But this historical sequence cannot be expressed in spatial terms. This requires a more fluid analysis that shows how these spaces operated at different points in time and from different social and cultural viewpoints. This kaleidoscopic view of the hospital brings the fragments of history into a series of thematic patterns. These are not at variance with each other but rather they begin to map the diversity of the spaces of the hospital.

My aim is to highlight how hospitals helped shape London in terms of metropolitan infrastructures, the built fabric and the city as a site of charity, and to reveal how different kinds of narrative structures can reveal complex and theoretically refined readings of these institutions. The discrete chapters combine to present the interaction of history, community and place that allows us to experience the spaces of the hospital in this period. These different ways of exploring and representing the hospital form a complex set of social, cultural political and economic relationships that cohere around the notion of charity. The chapters trace the importance of these hospitals as set pieces of urban planning and architectural design in the metropolis. Alongside this the architecture of hospitals did much to augment the image or aesthetic of London and enhance the standing of key patrons – for example the Crown in the cases of Greenwich and Chelsea hospitals. Buildings such as Charing Cross Hospital were important elements in the metropolitan improvements. As some of the most impressive buildings in London they became leading examples of architectural design and practice. The professionalisation of the relationships between patron and architect, doctor and patient, charitable institution and the broader social mechanisms of benefaction, helped establish urban bureaucratic processes.

The hospital became a metaphor for the oppositional forces at play in the modern city and how the patriarchal values of the elite were at once challenged and ingrained in its bureaucratic processes. Here the practice of institutional governance became a space where the complex dynamic between the aristocracy and the middle class came to the fore. The hospital gave a spatial expression to contrasting facets of urban culture articulated through the dynamic binaries of innovation/progress and restriction/containment. These oppositional forces are at play in the movement from the scientific advances in medicine to the containment of disease; from the care of orphans to the containment of unmarried women; from the treatment of specific diseases through specialist institutions to the large-scale containment of those with all kinds of mental illness. Alongside this, hospitals became cultural institutions through their role as a nexus of social and cultural activities, not least as spaces for musical performances and the display of fine art. In this way they rivalled the urban spaces of theatres and assembly rooms as places of social exchange and cultural interaction. Funded by subscription, the privately owned voluntary hospital became an instrument in these larger social processes.

Hospitals represented both public and private life and the different kinds of relationships therein. The military hospital was one

of the few state institutions that offered a very public display of royal charity. The private hospitals operated in the public sphere in quite a different way. Some of these institutions were descendants of religious institutions that had become secular after the dissolution of the monasteries as, for instance, in the case of St Bartholomew's; others benefited from the generosity of private donors such as Thomas Guy. The spaces that hospitals occupied in the city also impacted on the private lives of Londoners through their patterns of land ownership and development. Like large country house estates, hospital land was used to generate income. And these similarities in the patterns of land management demonstrate how London's demography and infrastructure were affected by the choices made by hospital governors. For instance, the decision by the Foundling Hospital to develop the land that surrounded it resulted in the disappearance of one of the last remaining grazing areas in the metropolis used by the urban poor. In its place the development of new streets and housing for middle-class urban dwellers generated substantial income for the hospital and the speculative developers who built the houses. The scattered and disparate nature of these institutions in some ways mirrored the city itself as the product of the collective if not unified effort of individuals. We see this in the development of an urban infrastructure around garden squares and private speculative building projects. Hospitals emerged as the product of a collective of philanthropic individuals and had an impact on the urban infrastructure, topography and demography in the same way as the discrete speculative ventures. The scale of the hospital buildings meant that they formed some of the most important monuments in the urban landscape. They were impressive, and not only outshone the urban mansions of the elite that were in any event fast becoming relics of an unfashionable urban culture, but also rivalled the splendour of the new rural palaces built by the landed and newly monied elite.

Discourses

I am interested in the interface between theory and archive, and particularly here how it is played out in my discrete essays that cohere around the theme of the spaces of the hospital in all its complexities. My aim in combining and juxtaposing theory and archive is to explore the meaning and broader consequences of these spaces and the agency that we can attribute to these buildings and the institutions they housed. My overarching frame for this study is a Foucauldian analysis that relies on the premise that power is based on discourse and that in the case of the hospital these discourses are concerned with

institutionalising processes and systems of control. I examine how the spaces and processes of the hospitals imposed these sets of (usually) patriarchal values on those who received succour and charity. In this way the spaces of the hospital both inside and out are seen as ways in which certain modes of performance – social, gender or class – are prompted and controlled.

I begin with the Foucauldian concept of the heterotopia, as hospitals in this period do reflect, invert and subvert the workings of the metropolis and contemporary culture and society. The chapters comprise theoretically informed discussions of specific instances as a means of teasing out the subtle nuances and meaning from a set of historical circumstances. This enables me to locate these new kinds of institutions in their social, cultural and political frame. But my concern goes beyond the phenomenological, and intersects to some extent with Foucault's argument that there is a pleasure in negotiating bodily boundaries that relates not only to the (re)construction of the self, but also to the way in which society operates. Foucault is interested in the ways in which the physical spaces of our bodily boundaries are policed. And this maps directly on to the spaces of the hospital in our period. These institutions enable us to explore how these modes of discipline (and punishment) are both external to and inscribed within the body. In this way the body becomes both a disciplining and self-disciplining entity. In other words the nexus at which power is produced through action and resistance. We can trace this in the binary social, cultural and architectural relationships outlined above.

The chapters also engage with other theoretical models that extend our understanding of these binaries. This helps elucidate how the spaces and processes of the hospitals imposed these sets of religious, moral and behavioural values on their patients. The physical body – whether young or old, healthy or unhealthy, virtuous or sinful, sane or mad – is a microcosm of the social body. Symbols grounded in the human body are used to express social experience, and, vice versa, the human body is 'taught' to individuals by society. The spaces of the hospital allowed both physicians and philanthropists to try to understand how the body works, and so understand how society works. The hospital is an ideal vehicle through which to explore a number of ritualistic expressions of this bodily/social relationship and their impact on politics and the urban cultural fabric. But space for Foucault is also a textual entity. In, for instance, his *Archaeology of Knowledge* the concept of spacing is essential in order to distinguish between traditional history and its opposite, variously termed effective history, genealogy or archaeology. For Foucault this textual space 'defines the blank space from which I speak, and which is

slowly taking shape in a discourse that I still feel to be so precarious and so unsure'.³ In this way the chapters combine to present a new way of thinking about monolithic canonical subjects in architectural history.

Architectures

It is the military hospital, conceived of as a small city, which marks the opening years of this study, and its impact on subsequent ideas and debates about hospital design continues throughout the period. But throughout most of the long eighteenth century, the architectural form of many of the newly established hospitals comprised one or more ordinary Georgian townhouses. It was only a few of these small-scale institutions, with no distinguishing architectural characteristics, that expanded, and their premises were transformed into a large-scale semi-public building, whose contribution to the cityscape was as a piece of monumental architecture. Later in the period the improvements in medical knowledge impacted on the design and layout of hospitals, with distinctive designs to create healthier environments for patients and staff. This addresses important issues of the period regarding the development of metropolitan space, infrastructures and the urban aesthetic. The hospital in all its complexities was a new building type, and certainly became the largest and most impressive structure to be built in the eighteenth century in London. There was limited royal patronage at this time and hardly any royal building projects in the capital. Moreover, the aristocratic mansions that had been the hallmark of post-Restoration London were being given over to speculative developers to demolish and build townhouses – as were the greenfield sites owned by the elite in the west end of the metropolis. The architectural aesthetic of London was becoming more domestic and the hospital stands out as distinct from this trend. And it can be argued that this monumental building type led the way in the transition of London from a city to a metropolis in the long eighteenth century. In some ways hospitals ran contrary to the trend, as they began as monastic, domestically inspired structures and became monumental structures with a heterotopic function – and this was manifest early on in our period.

There were other ways in which the architectural design/ presence or image of the hospital was aligned to the metropolis and the formation of urban identity and social structures. Architectural design was certainly important to the image of the institution. The building operated as a visual symbol or sign that often enjoyed greater prominence than any kind of coat of arms or shield. For instance, the appearance of an image of the building on the training certificate for

Figure 1.1 Training certificate for entry into the medical school at St George's Hospital, 1793.

surgeons or the entrance ticket for medical schools, as seen in St George's, 1793 (Figure 1.1) or Middlesex, 1826 (Figure 1.2), cements the relationship between the monumental architecture and the status and importance of these institutions. This contrasts with the relationship between buildings and any kind of social and cultural identity forged today.

Volumes

There is no doubt that London was in a state of flux during the long eighteenth century, as evident in its changing geography and infrastructure. The demographic shifts were equally considerable, with the population of London increasing two and a half fold in our period. There are various estimates of the population figures for London in the pre-census era. It appears that between 1500 and 1700 the population of London grew from 120,000 to 500,000. What is clear is that the increase during our period was far more rapid. By 1750 the population was around 750,000 and the accurate figures we have from the 1801–1821 censuses chart an exponential surge from 864,845 to 1,225,965. This demonstrates how London became increasingly important, and how it acted as a magnet for both the upper and lower levels of society, all of whom required housing and feeding, although not all were able to provide this for themselves. The new West End of London grew most rapidly in the eighteenth and early nineteenth

Figure 1.2 Training certificate for surgery from Middlesex Hospital, 1826.

centuries and housed a large number of the new residents. During this period the City – the traditional trading centre of London – saw a decline in its inhabitants from about 140,000 in 1702 to 56,000 in 1821.[4] It remained a vital economic area, but employment could be found elsewhere in the metropolis as the Industrial Revolution cranked slowly into action. We have already seen how London's population grew in our period. But what of the volumes of people who were cared for by hospitals in their broadest constituency? The *Gentleman's Magazine* provides a snapshot of the numbers of people (and these were the needy who could not afford care at home) who

were cared for by some of the major London institutions in 1747, which totalled 32,532:

> The Number of Objects under Care in the last year in several hospitals and infirmaries of the Metropolis:
>
> | St Bartholomew's Hospital | 7193 |
> | St Thomas's Hospital | 7243 |
> | Bethlem Hospital | 403 |
> | Bridewell Hospital | 401 |
> | St George's Hospital | 5436 |
> | Westminster Infirmary | 2336 |
> | Mr Guy's Hospital | 2242 |
> | London Hospital, or infirmary | 7298[5] |

The magazine reports that this is a great pleasure

> to observe by the late increase of hospitals, within, or near this metropolis, that no less than 32,552 poor diseased objects have been relieved within the compass of the last year, and it is, therefore, hoped that a deserved encouragement, and support, will be continued to these best calculated and most diffusive charities.[6]

Charity

Since their medieval foundations very few new hospitals had been founded. Indeed, the Reformation in England saw the end of the monastic institutions that had been the basis of much of this kind of charity. Some of the principal hospitals in London with medieval origins were originally founded as part of a religious order, for example St Thomas's, St Bartholomew's, Christ's and Bethlem. They changed from monastic to royal hospitals after they were seized by the Crown on the dissolution of the monasteries. With this came a shift in motive from religious to charitable institution. And this is not just a secularisation of care and succour for the needy; it is a change in attitude to the status and role of the needy in society and how they should be dealt with. In medieval society a beggar or someone in need was cared for, fed and housed by monastic institutions as part of their religious duty. It was God's will if the sick became well, and if an individual had been punished by God to become a beggar it was still the duty of the faithful to care for this object of God's wrath. In this way the medieval hospital was 'an ecclesiastical not a medical institution. It was for care rather than cure: for the relief of the body ... staff sought to elevate and discipline character',[7] but this was for preparation for the

next life rather than re-entry into contemporary society. The emphasis was on spiritual care rather than medical care, so the architectural form of these buildings did not need to accommodate spaces for the practice of medical science. Monastic succour catered for strangers – the traveller and the pilgrim were frequent recipients of hospitality.

Since the Reformation for nearly 200 years Protestantism in its various manifestations in England had not driven the church, state or the elite to found a new hospital in order to express their charitable intentions. The Elizabethan poor laws were an attempt to deal with demographic shifts on a country-wide basis and to make charity local. The beginnings of change in our period are evident in the way the state tried to deal with the plight of retired, wounded and infirm soldiers and sailors. The hospitals founded in London to offer succour to these servicemen were only part of a state-wide apparatus. By contrast both the royal hospitals and the new voluntary hospitals founded in the eighteenth century became far more locally focussed, often serving the immediate parish. The monastic origins of St Bartholomew's, where hospitality had been offered to travellers and pilgrims, were abandoned in favour of an institution that cared only for the residents of the City of London. Dr John Colbatch noted the absence of any kind of hospital or charitable institution in the City and Liberties of Westminster, where national government, the monarchy and the urban elite were to be found. Colbatch was one of the first doctors to offer his services to the newly established Westminster Hospital. The new institution was housed in premises owned by Mrs Frowde, to whom Colbatch wrote on Easter Day 1716:

> The City of London has several noble foundations to the relieve the needy sick, who are the greatest objects of human compassion; but Westminster the abode of the royal family, the premier nobility, and gentry, of the nation, has no such thing, which is a great reproach to it.[8]

The purview of this new institution was indeed localised, as in the beginning it was to serve only the parish of St Margaret's.

Parishes at this time still had obligations to their poor and needy residents, which may explain some of the localism. There was another important difference in that the founders, benefactors and governors of the new eighteenth-century charitable institutions donated their own money and in turn earned the right to nominate local residents for treatment by the institution: this gave them a sort of seigneurial power. There is a distinct social shift here: as the population of towns and cities increased so did the number of poor.

These people had been displaced from their rural residences as they sought employment in the newly formed industries, which were based in urban areas. The corollary of this is that there was also a growing number of wealthy city dwellers. These were the new rich, and their wealth was based on trade and industry, albeit before the Industrial Revolution. Benefaction was key to the identity of this new urban elite. They had time and means to observe society and enable work that could improve the lot of those less fortunate than themselves. Perhaps also as they had risen from the ranks, as we shall see for instance in the cases of Thomas Guy and Thomas Coram, they perhaps realised that privilege was just that and fortunes could be lost as well as made.

Arithmetic

The purpose of these new hospitals – take the Westminster for instance – was to 'relieve the sick and needy and other distressed persons'. In other words their purpose went beyond attending to the medical needs of the population. Indeed, in the case of the Westminster the relief of the poor was a driving force in its foundation, as the first pages of the first minute book notes:

> Notwithstanding the provision settled by our laws, and collections made by the charity of well disposed Christians, for the relief of the poor, 'tis obvious to anyone that walks the streets that the same is not sufficient to preserve great numbers of them from beggary to the great grief of all good men and no small reproach of our religion and country.[9]

Their solution to this problem is: 'Nothing but the revival of the true Christian spirit of justice and charity in the persons employed to take care of the poor and the voluntary assistance of others acted by the same spirit can produce a remedy.'[10]

There is an important dynamic at play here between the public and the private, in terms of social conscience and action, that had a direct impact on the built environment. The voluntary hospital movement as manifest in these five major London institutions both implicitly and explicitly criticised bad public administration that allowed such regular instances of beggary and the general needs of the population to go untended. In some ways this stood distinct from the institutional arrangements overseas, as we shall see in the example of the Foundling Hospital. But at the same time there was a resistance to the expansion of public administration when it attempted to deal with these issues. Perhaps this was to do with the

social class that predominated in the founding of these new institutions. This new monied 'middle' class resented or at least questioned the privilege and restriction that underpinned much of the social and cultural structure of the country. Instead they remained in passionate pursuit of profit, private enterprise and a kind of social and spiritual independence. This inflected the relationship between what can be termed public and private conscience. For this new class charity was a matter for private conscience, and this should be answered by addressing the needs of those less fortunate in society. The state was not able to answer these needs and nor should it be permitted or required to do so – public conscience was not a proper substitute for the necessary actions of right-minded individuals. This sets up an interesting dynamic between the individual and the state that plays out in a number of ways in our period. The spaces in and around the hospital, in all their complexities, allow us to explore these from a range of viewpoints.

The rise of a substantial urban middle class in our period provided the mechanism through which these systems of control came into being. This form of social control required a bureaucracy to implement it, and the middle-class philanthropist provided this through their individual efforts. This authority was expressed through the spaces of the hospital. The architectural form, together with the social and cultural practices, operated as a kind of Foucauldian arithmetic comprising of concepts that date from the sixteenth century: the reason of state and the theory of police. These refer to two separate articulations of power that are wielded over the populace: legal and pastoral, respectively. State power required precise knowledge and monitoring of subjects, and this was achieved in part through the institution of the hospital. The army and naval hospitals at Chelsea and Greenwich were intended to care for vast volumes of the military population in London. The apparatus of state was complemented by the royal and voluntary hospitals in London. For the first time the human lifecycle could be mapped and quantified in terms of birth and mortality rates, illnesses and so forth. The populace – or at least the urban needy – became a discrete entity that could be quantified in legal terms and be in receipt of pastoral care through these charitable institutions. In this way the hospital shaped the lives of Londoners through the complex sets of social relationships and the assertion of moral and political (in the broadest sense) authority by civic bodies and institutions. These forms of arithmetic helped formulate a coherent idea of the state, which in turn forged a national identity based on these virtual and actual metropolitan infrastructures. There is no doubt that there is a connection between shifts in urban culture and new forms of

social and political life.[11] But these relationships changed, depending on the kind of cultural arena in which they were formed and developed. I am interested here in the middle-class participation in the specific instance of the voluntary hospital as a means of exploring how this new class engaged with the politics of urban culture. This charitable movement for the care of the needy poor was the result of a complex set of motives that compelled the new urban bourgeoisie and the elite to action. The establishing of these institutions both affirmed and reordered authority and power in the metropolis through the physical, mental and bureaucratic spaces they created. The systems of governance challenged those of the patrician political system. Great emphasis was placed on honest, incorrupt management, and no greater power or influence was given to members of the landed elite who were involved with an individual institution. A system of ballots, annual reports and the rigorous collection of subscriptions was common practice, and aimed to ensure democracy within the board of governors. Indeed, in contrast to other kinds of new urban institutions or existing macro political systems, both the structure and management of these voluntary hospitals were socially inclusive as they encouraged the involvement of the middle classes.[12] The institutions were funded by subscription – in itself a standard method of raising capital in the eighteenth century. But the levels of subscription were quite low – as little as £5 per annum. In return the subscribers gained the status of governor and enjoyed voting rights and an involvement with the running of the institution. The specifics of the governance of individual institutions is not the focus here; rather it is the general point of the social inclusivity of these hospitals and the way this operated as a subversive force in relation to the national political status quo. The hospitals were a new initiative by a new social group that soon found a powerful voice in the metropolitan social structure, which in turn found potent architectural expression. Doubtless for some the cachet of aristocratic governors and patrons encouraged some socially ambitious middle-class benefactors, as they could use this connection to their advantage. But the real ideological cement behind the coming together of these different social groups was the recognition that patriotism should be translated to helping the poor. Charity was a social duty borne out of an ideological consensus between the middle classes and the landed elite in the absence of a national strategy for helping the needy. There is no doubt that the spaces of the hospital in their broadest manifestation are indexical of these social and cultural shifts. The buildings worked to improve the urban infrastructure and its aesthetic, as they became some of the most splendid sights of the metropolis. This moral purpose in architecture was continued in the ways hospitals

regulated their patients through religious and behavioural requirements that rewarded industry. The poor and needy were converted wherever possible into a new labouring class ready to support the commercial society that had shown them such benefaction.

But these monumental institutional buildings form other narratives that contain the complexities of social and ideological reform at this time. In addition to curing illness, hospitals were seen as the solution to many social problems that appeared to be more prevalent in the ever-expanding metropolis, including unemployment, poverty, madness and vice. Perhaps most importantly, their spaces contained these social ills and worked towards curing the bodies or reforming the characters of their charges so they could become once more fully engaged in the production of national prosperity. Medical science could be advanced through the containment of patients, as doctors could observe the progression and/or cure of a disease. Indeed, medical education became an increasingly important part of hospitals during the long eighteenth century.[13]

The growth of the hospital in our period had important effects on the idea of the city as a site of charity in contrast to being a place of sin and vice. It also impacted on demography and ideas of locality within the spaces of the metropolis. Notions of space and spatiality allow us to explore the interplay between the institutionalising rituals and practices of the hospital as a functioning entity and their role as part of the architectural and social urban fabric. We can also articulate how these spaces impacted on the containment and construction of gender, illness and other elements in ways that stand outside established patriarchal discourse. The way architectural structures and institutions can be used and interrogated as agents in the production of a dominant discourse and agents of change in the metropolis, is a model that can be applied to other cities and periods. Similarly, the re-interrogation of the spaces of the hospital as an agent of social and cultural control predicated on a patriarchal discourse, and the way in which this notion can be unpicked, provides an important paradigm shift in the narratives of architectural history which has far-reaching consequences. This volume as a whole not only provides a detailed survey of the social and cultural contexts of an important public building type which is of global significance, but also a re-mapping of how we think and write about monolithic, canonical subjects of architectural history.

Chapter 2

Heterotopias

This chapter sets out the social, cultural and urban topography of the notion of a hospital in London c.1680–1820. My intention is to highlight how hospitals helped shape London in terms of metropolitan infrastructures, the built fabric and the city as a site of charity. In this way I aim to establish a firm physical location for the complex archive that offers us many readings of the hospital. The different interpretations and meanings surrounding these various topographies act as a prompt to the way in which this book works to dissemble the archive of the history of hospitals in London and use the fragments as a means of retelling these narratives using different predicates. It is, then, the military hospital, conceived of as a small city, which marks the opening years of this study and provides us with a starting point for a consideration of the idea of a hospital. A discussion of two well-known examples, the Royal Hospital Chelsea and the Royal Naval Hospital at Greenwich, enables me to highlight the ways in which hospital design relates to that of the metropolis as a whole (Figures 2.1 and 2.2). These hospitals are indexical of the interaction between each institution and their environment in terms of urban development and planning, and the influence of these institutions on the shape, size and perimeters of the city.

Of particular interest in the case studies of the Royal Hospital Chelsea and the Royal Naval Hospital at Greenwich are the changing attitudes towards the metropolis in the latter part of the seventeenth century as the country became more unified in the aftermath of the Civil War and the Glorious Revolution. The apparatus of government established post 1688 was London-focussed as Parliament began to play an increasingly important role. But the physical spaces of the city that gave place to the social, political and cultural practices of this new modern nation remained unremarkable and domestic in character. Exceptions such as Inigo Jones' set piece of urban planning in Covent Garden served only to highlight the unexceptional character of the rest of the metropolis, and the desirability and aesthetic superiority of continental design (Figure 2.3).

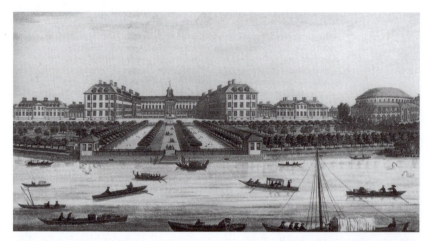

Figure 2.1 *View of the Royal Hospital Chelsea* by T. Bowles the younger, 1744.

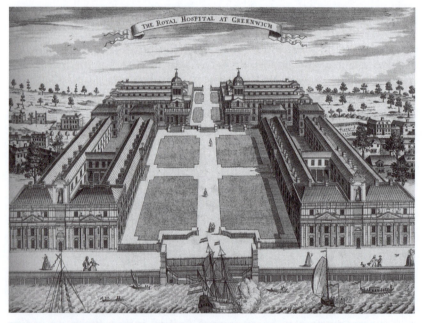

Figure 2.2 *Royal Naval Hospital, Greenwich* by Sutton Nicholls, 1728.

The dissonance between the political system and urban form becomes more apparent when the modernity of the new state is contrasted with the political systems of Britain's European counterparts. One of the ways in which this new, coherent national identity found expression is in the rise of institutions established and run by the state. The military hospital was an important element in the founding of this new identity. It responded to the need to unify and reward the population, not least

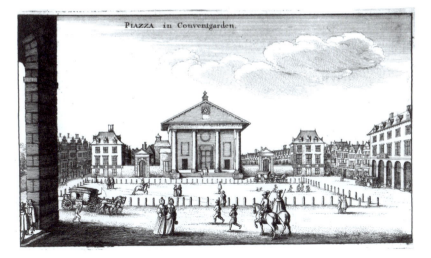

Figure 2.3 *Covent Garden Piazza* by Wenceslaus Hollar, 1650.

those who had fought in battle. Furthermore, this type of institution can be seen in the context of the rise of similar establishments in Europe. The design of the military hospital and the substantial intervention it made on the urban planning of London can be considered in the context of the emerging identity of the new state. In this way the Royal Hospital Chelsea and the Royal Naval Hospital at Greenwich can be seen as visions of how a modern state can be represented in a modern metropolis.

It is here that Michel Foucault's discussion of the idea of a heterotopia is useful.[1] Foucault's analysis of the spaces that act as heterotopias relies on their sustained ambiguity in relationship to other sites. A site, according to Foucault, is defined by a cluster of relations it has – in other words it is characterised by the things to which it relates rather than by its own intrinsic qualities. But certain sites have the property of being related to other sites 'in such a way as to suspect, neutralize or invert the set of relationships they happen to designate, mirror, or reflect'. In this way places exist in society that are something like counter-sites, a kind of effectively enacted utopia in which real sites that can be found within a culture are simultaneously represented, contested and inverted. It is at this point that the analogy of the mirror used by Foucault helps to demonstrate the ambiguous relationship between utopia and heterotopia:

> I believe that between utopias and heterotopias there might be a sort of mixed, joint experience, which would be the

> mirror. ... I see myself in the mirror where I am not, in an
> unreal, virtual space that opens up behind the surface; I am
> over there, where I am not. ... but in so far as the mirror does
> exist in reality ... it exerts a sort of counteraction on the
> position that I occupy. ... It makes the place that I occupy at
> the moment when I look at myself in the glass at once
> absolutely real ... and absolutely unreal.[2]

The mirror analogy suggests an absence of temporal linearity – a
moment frozen in time rather like a snapshot, whilst also
acknowledging the potential for flux and change. As a result Foucault's
concept of a heterotopia can allow for the passage of time, as society
can make a heterotopia function in a different fashion as its history
unfolds.[3] But it is the static, momentary quality that is of particular use
in relation to my reading of the hospital in London.

In this way the royal hospitals operate as heterotopic visions
of London. They mirror the city and enact the utopian ideal that it was
intended to be. It is important to remember that much of the
architectural vision for London that was to express this new national
identity remained unrealised. The grand schemes for Whitehall
produced by Sir Christopher Wren are a case in point.[4] His
monumental designs were intended to augment the status of the
Stuart dynasty and enhance the urban fabric of London, which
appeared shabby when compared to other European capitals. A lack
of will and financial constraints meant these plans went unrealised,
so London in the latter half of the seventeenth century remained
domestic in character. Unlike other continental European cities there
were no impressive royal or governmental buildings. Moreover, the
new West End, albeit that it was expanding rapidly, added more
low-rise brick-built domestic architecture to the urban topography.[5]
The opportunity for revising the cityscape offered by the Great Fire of
1666 found expression only partly in the new St Paul's Cathedral and
the city churches.[6] In the context of this study, and against a
background of the grand visions expressed in paper architecture as
opposed to the domestic reality of the city, perhaps the most pertinent
shift in ways of thinking about London is the evolving view in this
period of the city as a site of charity. In this way we can explore how
London responded to the modernity of other European capitals in
terms of its own identity, social systems and architectural
manifestations thereof. In the period leading up to the start of this
survey, London and indeed Britain as a whole lagged behind Europe
not only in terms of care for the poor and needy but also in the

absence of monumental architecture and urban planning. By focussing on the notion of charity we see the impact this way of thinking had on urban planning and architectural patronage, both of which cohere around the idea of the hospital in all its complexities.

There is no doubt that the hospital took on a new significance in the closing years of the seventeenth century as London grew in size and political importance. And it can be argued that the royal hospitals at Chelsea and Greenwich were attempts by the state to shape experience of this form of charitable social interaction by creating a new kind of metropolitan environment. Conceptualising the royal hospital as a heterotopia foregrounds its character as an oppositional space – both in terms of its own internal dynamics between public and private and the symbolic and the functional, as well as its ability to refract these aspects of the city itself.

The historical context behind the emergence of the Royal Hospital Chelsea and the Royal Naval Hospital at Greenwich as national institutions needs some discussion as it helps to unpack some of the complexities of the notion of a hospital that are germane to this study. From the Middle Ages the 'hospital' or 'guest house' for the care of the poor, the infirm and wounded or maimed soldiers was a residence supported by the charity of the wealthy and administered by monastic institutions. Although this type of institution continued to operate in Europe in the early modern period, the dissolution of the monasteries in the mid-sixteenth century followed by Elizabethan poor law reform resulted in a haphazard system of relief for disabled soldiers.[7]

In 1592 an Act for the Relief of Soldiers, which levied weekly rates in each parish, did little to augment the situation of former servicemen who wandered the country receiving assistance from whomever and wherever they could. This system was followed by the more general Act for the Relief of the Poor in 1601. Now responsibility for the care of those in need rested with individual parishes with the financial obligations being met by the wealthier members of the community. But the itinerant nature of some of those requiring aid resulted in unequal demands being placed on certain parishes. Partly in response to this problem, the Settlement Act of 1662[8] established the parish to which a person belonged, this being the only one obliged to supply succour. The care of wounded and maimed soldiers did not fit easily into this network of localised assistance. In recognition of this a scheme was introduced comprising council warrants issued by the council of the individual soldier commending him to the justices of the peace in the parish where he was born, which enjoyed some success.[9]

Yet it fell mostly to private individuals following the medieval practice of charitable hospitals to make arrangements for the care of soldiers. As a consequence a number of small-scale institutions housing no more than a couple of dozen men and scattered randomly across various counties, including Buckinghamshire (1598) and Herefordshire (1617), were established. During the Civil War for the first time the idea of a national public scheme emerged as Parliament began to allocate monies from sequestered funds for this purpose. However, it was only at the Restoration with the beginnings of a regular army established by Charles II that the issue began to be resolved. For the first time this national problem was addressed with a large-scale national solution. The result was first the Royal Hospital Chelsea, followed by the Royal Naval Hospital at Greenwich, both of which established London as the centre of this kind of charitable support. And each institution was intended initially to accommodate a large number of residents, over 400 in the case of Chelsea and more than 2,000 at Greenwich. This high level of occupancy required a complex administrative structure, which meant both hospitals effectively operated as if they were small cities.

These hospitals worked to invert the sets of social relationships they mirrored in London as a whole as their bureaucratic systems operated as symbols in the performance of the rituals of a patrician authority. At the same time these institutions were counterbalanced by the increasing political importance of the landed elite whose urban presence precipitated a need for some kind of aesthetic expression of identity. Here, the heterotopic function of the spaces of the hospital is evident as the reordered spaces of Chelsea and Greenwich both re-present the city while offering a tighter, more orderly version of the same, 'juxtaposing in a single real place several spaces, several sites ... to create a space that is other, another real space, as perfect, as meticulous, as well arranged as [its referent] is messy, ill constructed and jumbled'.[10] The orderly reflection proposed by Foucault endorses the dominance of royal patronage, but at the same time the mirror effect reveals uncertainties whereby these spaces can reveal ambiguities in the formation of a national identity – or memory.

The Royal Hospital Chelsea and Royal Naval Hospital at Greenwich are indexical of the larger hospitals that comprise the focus of this study. The design of these kinds of hospitals largely followed the plan of the monastic infirmary. The combination of religion and charity was manifest in the architectural conjunction of a hall with beds ranged

in the aisles and a chapel situated at the east end. Certainly the memory trace of the beginnings of this kind of institution in terms of its physical form and charitable ethos endured. But the ambitions of these royal hospitals were far greater than their predecessors. In order to realise them the traditional, simple design layout of infirmary hall and chapel required modification. The plan of each hospital followed more closely that of an entire convent or monastery that included a great hall and chapel together with dormitories, cubicles or cells ranged around a central court. This format was echoed in the design of the first colleges to be established at the universities of Oxford and Cambridge, and there is little doubt that this source was influential for the principal architect for both hospitals, Sir Christopher Wren. This was noted, for instance, by the diarist John Evelyn on a visit to the site of the new Royal Hospital at Chelsea (Figure 2.4):

> 1682, 25th May. I was desired by Sir Stephen Fox and Sir Christopher Wren to accompany them to Lambeth, with the plot and design of the College to be built at Chelsea, to have the Archbishop's approbation. It was a quadrangle of 200 feet

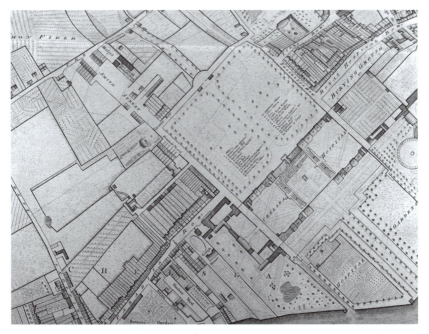

Figure 2.4 The Royal Hospital Chelsea and its environs, Horwood's Map of London, Westminster and the Borough of Southwark, 1799.

square, after the dimensions of the larger quadrangle at Christ Church, Oxford, for the accommodation of 440 persons, with Governors and officers. This was agreed on.[11]

The plan and design established by Wren became the blueprint for subsequent hospitals that appeared in the metropolis. The layout and internal organisation of the large London hospitals built in the eighteenth century drew their inspiration from Wren's designs, which in turn evoked the memory trace of their medieval architectural predecessors and systems of charity. The most important requirement was an adequate tract of land to accommodate the substantial footprint of the building. Moreover, as the architecture was intended to be impressive there needed to be enough space around the hospital itself to allow for grand vistas. This allowed the whole ensemble to work as a set piece of urban planning within the cityscape. Once again we see here how the heterotopic function of the hospital as a utopian vision of how the city *could* be comes to the fore. This is evident in the choice and acreage of site, the opportunity to create grand vistas from a range of vantage points and the materials used in the construction of the buildings (Figure 2.5). The grand institutions at Chelsea and Greenwich hospitals made a substantial intervention in the relationship between the hospital and the metropolis. Their imposing designs upgraded the urban aesthetic and impacted on the infrastructure of the city.

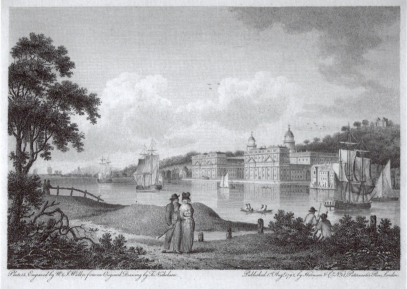

GREENWICH HOSPITAL.

Figure 2.5 *Greenwich Hospital* by W. and J. Walker, 1792.

Moreover, each institution also renegotiated the interface between London and the river Thames, which remained one of the principal routes through the capital. Importantly, the efforts of the crown were channelled into the construction of these noble edifices with a charitable purpose, rather than royal palaces with a stately mien.

It must not be forgotten that both hospitals were constructed on the sites of pre-existing buildings on royal land. In the case of Chelsea, part of the site comprised land granted by James I for a religious institution for training priests: King James' College. After the Commonwealth, the college, which had had several uses including as a prison and as home for the newly formed Royal Society, was sold to the crown in 1681–82. The 18 acres of land that comprised the college grounds were increased through the purchase of small parcels of land from neighbouring estates. The site of the new hospital originally bordered the river Thames on the old road from Westminster to Chelsea.

John Evelyn gives us a helpful account:

> 1682. 27th January. This evening Sir Stephen Fox acquainted me again with his Majesty's resolution of proceeding in the erection of a Royal Hospital for emerited soldiers on that spot of ground which the Royal Society has sold to his Majesty for £1300, and that he would settle £5000 per annum on it, and build to the value of £20,000 for the relief and reception of four companies, namely 400 men, to be as in a college or monastery. ... So, in his study, we arranged the governor, chaplain, steward housekeeper, chirurgeon, cook, butler, gardener, porter, and other officers, with their several salaries and entertainments. ... Thus we made the first calculations, and set down our thoughts to be considered and digested better, to show his Majesty and the Archbishop. He also engaged me to consider of what laws and orders were fit for the government, which was to be in every respect as strict as any religious convent.[12]

The original scheme for the Royal Hospital at Chelsea comprised blocks arranged on three sides of an open quadrangle, with the grounds and the river to the south. The northern range, which housed the common hall and chapel, ran parallel with the river and with the old road from Westminster to Chelsea. These were separated by a modest vestibule, above which the central cupola was located. Two wings comprising four floors and an attic storey ran south from the

outer edges of this block, providing space for the dormitories and other accommodation.

There is no doubt that in conception, if not execution, the scheme drew on the Hôpital des Invalides in Paris. The domestic character of the materials – brick with stone dressing – tempered the grand scale of the buildings, the like of which had not really been seen in the capital, especially as a result of royal patronage. The coherence and rapid execution of the plan was rivalled only by the mansions of the landed elite which had begun to appear in the western portion of the metropolis.[13] In this way, the Royal Hospital at Chelsea offered at once a mirror image of the metropolis in terms of its materials and domestic character, and a utopian vision of social order expressed through the planned monumental architecture that evaded London.

The Royal Naval Hospital at Greenwich tells a similar story to its counterpart in Chelsea. Indeed, the focus of London as the site of royal charity remained despite the change in the relationship between the sovereign and state that took place on the accession of the joint monarchs William III and Mary II in 1689. The previous year had seen the ousting of James II and the Glorious Revolution, which was followed by the Bill of Rights. The resulting increased power for Parliament and the people and a constitutional monarchy raised the status of the capital city and formed a locus both for political activity and for the aesthetic expression of these new sets of relationships. Perhaps appropriately, the new hospital was built on the site of the royal palace of Placentia, more commonly known as Greenwich Palace, which had fallen into disrepair during the Civil War. The ramshackle collection of half-ruined buildings, which incorporated the King Charles II Building (1664–72) designed by John Webb held no cachet for William III who preferred to live at Kensington Palace. By 1691, in response to the earlier, successful Chelsea Hospital, Mary II signalled her desire to grant John Webb's building and the land of the rest of the former palace for conversion 'as a hospital for seamen'. This received greater impetus from the casualties sustained at the naval battle at La Hogue in May 1692, and in October that year she and King William III made a formal grant of the building 'to be a hospital for wounded seamen'.[14] It took some time for the design to be agreed, as discussed below, but as John Evelyn noted in his diary entry of 4 June 1695,

> A Committee met at Whitehall about Greenwich Hospital, at Sir Christopher Wren's, his Majesty's Surveyor-General. We made the first agreement with divers workmen, and for materials; and gave the first order for proceeding on the foundation.[15]

The building history of the Royal Naval Hospital Greenwich spanned in the first instance from 1694 to 1735. The site, which was granted in 1694, was on the south bank and bounded by the river Thames to the north.[16] The Queen's House, designed by Inigo Jones in 1616 although only structurally completed in 1635, was the only part of the palace that survived intact after the Civil War. It was situated directly to the south and its garden formed the southern boundary of the initial parcel of land.[17]

From the outset the project was more complex and grandiose than its predecessor in Chelsea (Figure 2.6). The designs involved some of the leading architects of the day. And the hospital earned a place in the first edition of the lexicon of British buildings, Colen Campbell's *Vitruvius Britannicus* (1715).[18] Its grandeur clearly rivalled the classically inspired country houses built by the landed elite, which were beginning to pepper the nation's architectural map (Figure 2.7). Sir

Figure 2.6 *Elevation of One Wing of the Great Court of Greenwich Hospital* by Colen Campbell from *Vitruvius Britannicus*, 1715.

Figure 2.7 *The West Front of Wanstead House, Essex* by Colen Campbell, from *Vitruvius Britannicus*, 1715.

Christopher Wren, who gave his services free of charge, produced the earliest of the designs for Greenwich. These were approved in January 1695 and work began in June that year with the laying of the foundation stone, which was noted by John Evelyn:

> 1695 30th June, I went with a select Committee of the Commissioners for Greenwich Hospital, and with Sir Christopher Wren, where with him I laid the first stone of the intended foundation, precisely at five o'clock in the evening, after we had dined together. Mr Flamstead, the King's Astronomical Professor, observing the punctual time by instruments.[19]

Some years later revisions were made to these plans to expand the hospital by constructing extensions to the west and south of the original building. Indeed, by 1711 Nicholas Hawksmoor, originally Wren's assistant on the scheme, proposed additional amendments to the design. Hawksmoor produced plans for the further expansion of the hospital involving the doubling in size of the north pavilions of the King Charles II and Queen Anne buildings. After the appointment of a new Commission in 1727, Hawksmoor's final scheme for enlarging the hospital was approved, including his proposals for an infirmary on a site to the west of the hospital which was acquired in 1714. The melange of architects, styles and changes of plan continue with Thomas Ripley's scheme for the completion of the hospital, which was approved by Parliament in March 1735.

The minutiae of the evolution of the design have been ably noted elsewhere.[20] For our purposes the 'side step' scheme and the three subsequent schemes that followed are the principal points in the design process. These developments in the plan show the fluidity of the architectural footprint of the Royal Naval Hospital. But at the same time the vastness of the ambition of the whole initiative remains constant. Of particular note is the large number of men each of the various schemes was intended to house. This underscores the scale of the enterprise behind the Royal Naval Hospital and the significance this institution had for the metropolis. From the outset the planned high level of occupancy together with the necessary bureaucratic systems of administration meant Greenwich would indeed function as if it were a small city. And this underscores how the hospital operated as a heterotopia.

Designs for the first 'side-step' scheme refer to 'The fabrick being 3 story high will Contain 2376 people'.[21] Even by today's

standards this is a huge project. In terms of late seventeenth-century British architectural practice the scale was unheard of. There had been neither anything comparable in the monastic or collegiate architecture from which Wren drew his inspiration. Nor had there been any such large-scale building of housing in the metropolis despite the increase in the urban population. The density of the volume of residents and the contingent complexities of the building, infrastructure and bureaucracy cannot be overestimated. But right from the beginning there was thorough consideration given to how the hospital was to function both as a residential space and as a multifaceted organisation. This is evident for instance in the attention paid to how residents were to be accommodated. Appropriately, the retired seamen were each allocated an individual cabin. These were clearly marked on the detailed ground plan.

The first 'side-step' scheme was followed by a proposal for an even more ambitious design. Had this been built, it would have accommodated 3,888 men in twelve wards. These were to be located to the south of the hall and chapel range. The formation of two further ranges of six wards, each running south from the eastern and western ends of the hall and chapel, created an open-sided court that recalled the monastic beginnings of this kind of institutional design.

This enormous scheme retained the three-storey design of the 'side-step' scheme. Each of the wards comprised units that housed 108 men per floor, making a total of 324 for each unit or block. Perhaps unsurprisingly this plan was reduced in scale. In its stead Wren proposed a scheme that would have involved a loss of half the number of ward blocks, from six on each side of the axis to three. These wards were to retain the three-storey arrangement and each accommodated the same number of men as the previous design. As such, the new scheme would have offered a total of 1,944 beds. The planned density of habitation in each of these designs was intense and far exceeded the population ratios found in much of the metropolis itself.[22]

The scale of the Royal Naval Hospital offered an unprecedented level of royal beneficence. The ambition of the scheme heralded a new era in the social and political life of Britain. And there is no doubt that Wren's various designs made an appropriate architectural response to this modern state-driven charity. Perhaps unsurprisingly, from the outset Wren pushed for more land to be granted for the site of the hospital.[23] It is true that the constraints of the original site, together with the Queen's wish to retain both the King Charles II building and the vista from Queen's House to the

river, did present Wren with some design problems. But his wish for a larger site was not necessarily simply a desire to produce a monumental and more symmetrical design. The wording of a request for additional land in 1695 underscores the desirability of axiality and vista, as well as adequate space for a grand design. But, importantly, it also tells us something of the envisaged use of the hospital for the public good and how it was to operate.

> And considering the ground already granted with be very scanty & narrow for a design so generall as the entertainment of aged & disabled seamen their widows & children, in case his Ma.ty will be graciously pleased to bestow the rest of the Tilt-yard the Queens house and the Park (at the intersession of your Hon.ls) for this good and publick use; We humbly conceive it will be a great incouragement to persons (see a situation necessary to such an Hospital) to contribute towards the building and endowing of the same.[24]

We must also remember that here Wren perhaps saw an opportunity to realise some of the vision he had for London itself. Here the relationship of the site to the river Thames and the potential to realise a design based on axiality and vista were opportunities Wren was denied elsewhere in London. His designs for the remodelling of the City and St Paul's after the Great Fire of 1666 had largely been thwarted, and we have already seen how his Whitehall schemes remained paper architecture.[25] The combination of a function and plan that recalled medieval monastic architecture together with contemporary European classically-inspired design resulted in a distinctive aesthetic. The four main buildings are arranged in a number of quadrants or courts that are bisected east–west by an internal road and north–south by a grand square and processional route. The latter provided access to the river and ensured the vista remained open between it, the Queen's House and Greenwich Park beyond. Here Wren took the opportunity to adapt some of the grand architecture of European cities such as Paris and Rome, which had impressed him so considerably.

L'Hôpital des Invalides in Paris is perhaps the most obvious inspiration, not only as Wren had spent time in the city, but also through the common function of the two institutions (Figure 2.8). Louis XIV had commissioned the architect Libéral Bruant to design L'Hôpital des Invalides in 1670 as a home and hospital for aged and unwell soldiers. Commonly known as Les Invalides, the institution had a substantial footprint on the urban plan of Paris and enjoyed

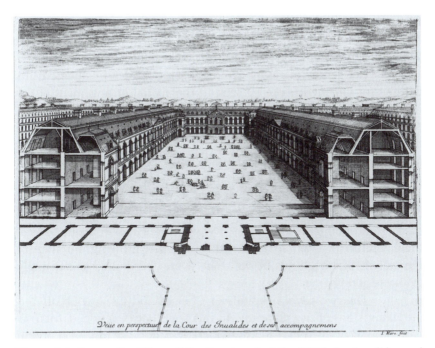

Veue en perspectiue de la Cour des Inualides et de ses accompagnemens

Figure 2.8 *Perspective View of the Courtyard of the Hôtel des Invalides and Sections*, by Jean Marot from *Description générale de l'hôtel des Invalides, c.1727.* Reproduced courtesy of the Courtauld Institute of Art, London.

Europe-wide renown. Like the royal hospitals at Chelsea and Greenwich, its site was suburban and it enjoyed a riverside location bordering the river Seine. As in the cases of its London cousins, the river frontage of Les Invalides was a key element in the design. Bruant's initial plan was gradually expanded and by its completion in 1676, the structure comprised an impressive river frontage of 196 metres. The hospital complex itself comprised no less than fifteen courtyards, the largest of which was the Cour d'Honneur, which was also used for military parades. The evolution of the design of Les Invalides did not end in 1676, as only 3 years later Jules Hardouin Mansart added a chapel for the residents known as L'Eglise Saint-Louis des Invalides. Mansart went on to design a separate private royal chapel that dominated the Cour d'Honneur. It took its inspiration from the form of St Peter's Basilica in Rome and was consequently known as the Eglise du Dôme. To the north the Cour d'Honneur was extended by the Esplanade des Invalides – a grand open space that forms an axis with the Le Pont Alexandre III. (The Pont des Invalides is located further downstream.) This impressive set piece of urban planning was well known across Europe and without doubt made a lasting impression on

Wren. And there is little doubt that, in an early manifestation of the competition between London and Paris, Les Invalides spurred on William III to commission the Royal Naval Hospital at Greenwich.

References made by Wren to L'Hôpital des Invalides in his designs for Greenwich can be seen in the spatial arrangement of the courts, the dominant central dome, and the stepped and domed mansard roof forms of the wings. Wren did, however, develop on the design of Les Invalides by opening up the closed quadrangle plan to make the main hospital building visible.[26] St Peters in Rome was also influential on Wren's architectural thinking, as seen in the arrangement of the cupola of the dome, with its tiers of lunettes, and the quadrant's colonnades, open on both sides, and with small, projecting pedimented bays at mid-points in the curves. Detailed information about both of these buildings was accessible through the growing number of illustrated architectural books that were becoming increasingly available at this time.[27]

The two royal hospitals of Chelsea and Greenwich offered utopian visions of city planning. In this way they functioned, then, as heterotopias of the social and bureaucratic systems of modern London and indeed of a new Britain. Charitable institutions were a key part of this modernity. But the heterotopic meaning of these institutions was more complex as they also reflected Europe. The push towards charity was also a response to attitudes elsewhere on the continent, where succour for the needy was more deeply ingrained in the social and urban fabric. Additionally, these hospitals operated as counter-sites where the architecture of mainland Europe could be re-enacted. Here the shift in aesthetic between Chelsea and Greenwich was not without significance. As we have already noted, Chelsea spoke to the domestic character of London in terms of its materials. It remained an indigenous architectural response to the increased need for charity. Greenwich expands this response as it embraces the European in terms of its design. The shift in style and use of stone rather than brick was in part an expression of Wren's increasing ambitions as an architect. But European classicism had been seen as the architectural manifestation of Catholicism. In the period following the Civil War the new Protestant state resisted any expression of sympathy with Catholicism, as it was perceived as a political threat. It was only with the stability brought by the accession of William and Mary that this fear began to subside.

The heterotopic meaning of the royal hospitals of Chelsea and Greenwich is extended further, as they also mirrored the emergence of the urban palace as a metropolitan phenomenon in the late seventeenth

and early eighteenth centuries. Each building type represented aspects of the social and political complexion of a new national identity. As we have seen, the royal hospitals emphasised the charitable nature of the constitutional monarchy through a new kind of public architecture. This stood in contrast to the expression of absolutism evident, for instance, in the large-scale building projects of the French kings, as outlined in the discussion of Les Invalides above. Moreover, the royal hospitals were distinct from the architecture of the royal palaces. During the post-Restoration period little was done to the royal residences in the city itself. Wren's grand designs for William and Mary's Hampton Court Palace suffered from too much haste in construction and a surfeit of ambition.[28] And we have already seen how Wren's plans for the rebuilding of the Palace of Whitehall after the fire in 1698 remained on paper.

By contrast, British aristocratic patrons had fewer inhibitions about the display of wealth and status through their metropolitan residences. The urban palaces of the landowning elite made important first steps in the upgrading of London's architecture from the distinctly domestic to a more appropriate aesthetic for a modern capital city. Berkeley Square provides us with a typical example of a post-Restoration landowner, his estate and his metropolitan mansion. This square does not take its name from one of the great aristocratic families whose lineage stretched back deep into time. Instead the first Lord Berkeley of Stratton was commander of the royalist forces in the Civil War. He acquired extensive lands north of Piccadilly after the restoration and erected a great mansion there, surrounded by substantial grounds laid out in the latest fashion. John Evelyn remarked of Berkeley House after a visit in 1672:

> [the] new house, or rather the Palace, for I am assured it stood him near 30,000 pounds, and truly is very well built, and has many noble rooms in it...!

The mansion was destroyed by fire in 1733 but rebuilt by the architect William Kent as Devonshire House. This upgrading of the architectural fabric reflected the incoming aristocratic occupant, the Duke of Devonshire, who had purchased the property in 1696. Here old money and lineage replaced new.

As the land in the West End of London became more valuable and residential property more sought after, townhouses became less grand, often being part of a terrace. In order to meet this growing demand, and to turn a tidy profit, the land surrounding these great

mansions was leased to speculative developers for profit.[29] An example of this can be found in Burlington House on Piccadilly which, like Berkeley House, was originally a Restoration mansion which stood in substantial grounds – this time nearly ten acres (Figure 2.9). The house underwent substantial redevelopment and redesign in the early eighteenth century, transforming it from a plain Charles II house into a classically styled 'neo-Palladian' mansion. This in itself helped to improve the urban aesthetic and was part of the move to upgrade the cityscape by private landowners – rather than the crown. But alongside his unusually keen interest in grand architectural projects, the resident of Burlington House, Lord Burlington, was closely involved with speculative development, primarily as a way of raising money. The 'ten acres' at the back of Burlington House were developed by Burlington from the late 1710s.

The instance of Burlington House typifies the way in which the landowning elite, who sought income from the speculative development of their estates, expanded the West End of London. The resulting garden squares that were surrounded by rows of terraced houses emphasise the domestic nature of town planning and urban growth in our period. Of interest here is the elision between domestic and medical space. In terms of interior space, these new institutions

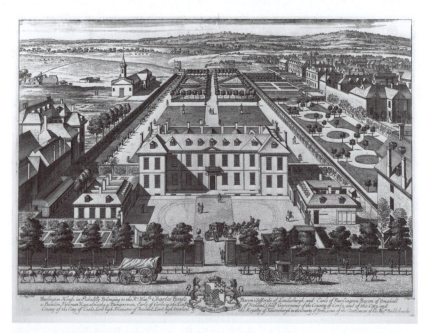

Figure 2.9 *Burlington House* by Johannes Kip after Leonard Knyff, from *Britannia Illustrata*, 1707.

were often housed in ordinary speculatively built townhouses that formed an essential part of the great estates. In addition, the grandeur of the design of the more substantial hospitals mirrored that of the London mansions of the elite in terms of internal plan as well as external aesthetic.

The exterior spaces of the hospital offered a different kind of engagement with the urban topography. The basic plan of the urban palace in the late seventeenth and early eighteenth centuries comprised a main block with protruding wings that flanked three sides of a courtyard. This design format made the house and its immediate surroundings into an area sheltered from the rest of the city. In this way it is reminiscent of the enclosed spaces of the garden squares that became a hallmark of the metropolitan plan of London in the eighteenth century (Figures 2.10 and 2.11). Together these protected places appear as repetitive forms in the urban topography. And there is no doubt that this brings us full circle to the hospital and its monastic beginnings, referencing this charitable institution where dormitories, chapel and hall were ranged around a courtyard. This memory trace is remarked upon by S. E. Rasmussen:

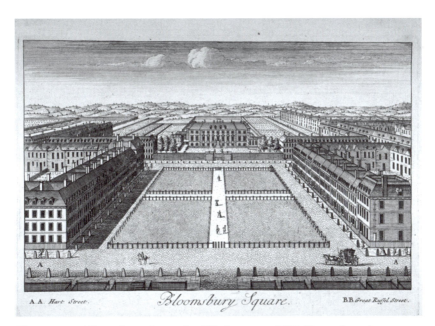

Figure 2.10 *Bloomsbury Square* by W. Angus, *c.*1750. Reproduced courtesy of the Guildhall Library, City of London.

Figure 2.11 Map of the West End of London. John Rocque's Map of London, Westminster and Southwark, 1746.

The English square or crescent ... is a restricted whole as complete as the courtyard of a convent. They form fine geometrical figures in the town plan, they are regular and completely uniform on all sides, and a series of such squares may be linked together in any order. ... It is as if the traditions of the Middle Ages had been handed down to the present day in the squares in these domestic quarters. But the narrow courts of the old town have been transformed into the open squares of the newer quarters.[30]

The enclosed spaces of the hospital together with the garden square symbolised the modern metropolis and acted as an emblem of the city itself. In this way the spaces of the hospital operated as a kind of *lieu de mémoire* that collapsed the space–time dimension of the urban topography.[31] It provided a memory trace of the medieval, monastic traditions of care for the sick and needy. At the same time it was a space that attempted to create a new kind of national memory in response to the changing social and political conditions in Britain, and to the symbolic needs of the newly reinstated constitutional monarchy.

There is no place like home

Alberti claimed that a house is a small city. Perhaps, then, he would agree with my assertion that hospitals are heterotopias. We have seen how the spaces of the hospital operated as a kind of countersite or dystopian image of the metropolis. Here I want to think about the aesthetics of the hospital – its phenomenological presence. In other words, how it was encountered as a physical object in the urban topography and how its interior spaces were experienced by its occupants and by the range of publics who passed through it. My frame for this investigation is the discourse around the notion of home. The conflation of domestic and (in the broadest sense) medical space has been considered in terms of magnificence and luxury and intentionality.[1] Interrogating this material through the lens of the concept of home presents a different set of interpretations and meanings that complements and enriches these other points of view.

The notion of home is helpful here as it references the domestic beginnings of the hospital. Moreover, it allows us to explore the spaces of the hospital through the resonance between the architectonic and the architectural – that is to say the theorisation of architecture and what might be termed the habitual or the usual sense of how we conceive architecture. This is found in the conventional understanding of buildings as a series of spaces or rooms that respond to and help form our habits of existence. And this is especially the case in domestic architecture. In addition, the house as a building type does respond to the inside/outside binary by establishing its own economy or 'law' that operates within. In this way we find a house is a secure, physical piece of architecture, which enables it to operate as a vessel of containment. A house is also a series of spaces that shape and respond to human activity. There are problematics when thinking about how domestic space, in all its varying forms, in

the long eighteenth century was considered or became appropriate for hospitals. In addition we have to consider the symbiotic relationship between the form and function – how did domestic space influence the operation of the hospital? We also need to think about the relationship between the institution of the hospital and the aesthetics and architectonics of its spaces. This is perhaps most relevant in the grand edifices that appeared in London in the long eighteenth century.

There were a number of ways in which the architectural exterior design/presence or image of the hospital promoted the identity of the institution. In turn this interacted with the metropolis and the formation of the urban aesthetic. The building operated as a visual symbol or sign that often enjoyed greater prominence than any kind of coat of arms or shield. We have noted this for instance in the appearance of an image of the building on the training certificate for surgeons as seen in St George's Hospital, 1793 (see Figure 1.1) or on the entrance ticket for the medical school at Middlesex Hospital in 1826 (see Figure 1.2). There are numerous engravings of views of the new monumental hospitals in London which underscore the message these imposing, classically inspired buildings conveyed. Indeed these views, which correspond to the glamorous visions of country houses and substantial public buildings, cement the relationship between the monumental architecture and the status and importance of these institutions.[2]

The great houses of Restoration London had begun to work to upgrade the urban aesthetic. We have seen how they offered a kind of architectural dialogue with the royal hospitals at Chelsea and Greenwich in terms of their repertoire of continental design motifs mixed with indigenous forms. We have also seen how the large purpose-built hospital owed its architectural form and vocational conception to the monastic institutions of the Middle Ages. Here I am interested in how the institutional aims and ambitions of the many new kinds of hospital that emerged in London in the opening decades of our period interacted with domestic space in all its complexities. My foci are the tensions and interactions on the one hand between the spatial relationship of the facade to the urban topography and on the other hand between the interior arrangement of space and the social patterns that are introduced and reinforced.

Point de folie – maintenant l'architecture

My interest in the aesthetic focuses here on the notion of home, and through this I want to explore why the grand architecture of Europe that had influenced the design of the great house seemed

appropriate for these social institutions. In addition, housing can be conceived of as the opposition between interior and exterior. It is concerned with shelter and containment. But there are more binaries at play here. Jacques Derrida explores the distinction between the architectonic and architecture, important for our understanding of the facades, spaces and the general aesthetic of these large hospitals in London:

> On the one hand, this general architectonics effaces or exceeds the sharp specificity of architecture; it is valid for other arts and regions of experience as well. On the other hand, architecture forms its most powerful metonymy; it gives it its most solid consistency, objective substance, which implicates all dimensions of human experience in the same network: there is no work of architecture without interpretation, or even economic, religious, political, aesthetic or philosophical decree. But by consistency I also mean duration, hardness, the monumental, mineral or ligneous substance, the hyletics of tradition. Hence the resistance: the resistance of materials.[3]

In this way architecture, in all its complexities, is contingent both with the materiality of history and human experience. And the aesthetic of the hospital is an ideal way of exploring this.

One of the most provocative connections between medical and domestic space is the design of the new Bethlehem or Bethlem Hospital (also known as Bedlam), 1674–76, by Robert Hooke (Figure 3.1).[4] In some ways the story is a familiar one to other great London institutions like St Thomas', Christ's and St Bartholomew's that were founded in the Middle Ages and enjoyed architectural improvement and increased metropolitan significance in the long eighteenth century. Bethlem was founded in 1247 with a gift of land from the Bishop of Bethlehem to found a priory of the order of St Mary of Bethlehem. But early on in its history Bethlem (or Bedlam as it is also referred to) began to specialise in the treatment of the insane. It remained unique in this role up until the seventeenth century. That said, it continued as a small-scale institution, housing only twenty-seven patients in 1632. The hospital, which was originally sited on Bishopsgate, was enlarged in 1667 allowing a doubling of capacity to fifty-nine, but the state of the medieval fabric of the building demanded complete renewal. A new location on the open site of Moorfields in the City of London and impressive new premises propelled Bethlem into the public sphere.

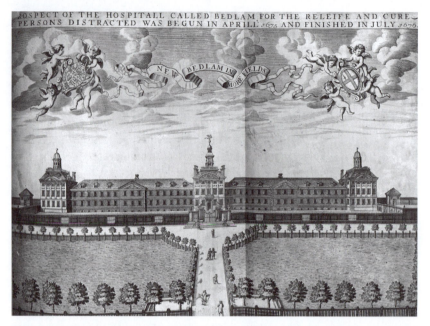

Figure 3.1 *Bethlehem Hospital, Moorfields* by Robert White, 1677. Reproduced
courtesy of the Courtauld Institute of Art, London.

The design of the new building stands in contradistinction to the
other two grand hospitals that immediately followed it. As we have
seen, both Chelsea and Greenwich enjoyed a quadrangular
arrangement with buildings ranged around a central court. The
design of Bethlem, as far as we know it, hovered somewhere between
a two-dimensional stage set and the more traditional great house
design found in urban and rural environments. The popular myth
that the design was modelled on the Tuileries in Paris may or may not
have substance, but it is indicative of the importance attached to the
aesthetic of the building and its visual impact on its immediate
environment. Moreover, it is part of the architectural dialogue with
Paris that continues throughout our period. The important thing here
is that a hospital for lunatic paupers made a more significant
contribution to the grandeur of the urban topography of London than
any royal or indeed aristocratic palace.[5]

Bethlem was situated in the City of London, which alongside
Westminster and the Borough of Southwark formed the nucleus of the
metropolis. In the mid-sixteenth century its administration passed to
Bridewell Hospital, and both institutions remained part of the social
apparatus of the City.[6] There was a curious dynamic between London
and the City. At the heart of it was a complex set of relationships
centring on civic pride and the financial autonomy of the City's

institutions, which covered all manner of trades as well as banking. The City of London was a discrete entity within the metropolis. It represented the financial and commercial interests of the capital and the country. The Corporation of London administered the business activities and acted as a kind of local government with the lord mayor as its principal official. Up until the middle years of the seventeenth century the City comprised the largest part of London as a whole and often stood in opposition to both the court and government. During our period its status was gradually challenged as London grew in size, so diminishing the City's physical dominance of the geography of the metropolis. Moreover, its autonomous local government was overshadowed by the increasing significance and clout of the systems of national government as expressed through Parliament at Westminster. But the City's sense of civic pride and will to preserve its privileges and rituals did not diminish. The Great Fire of London in 1666 provided the potential to rebuild the City along the lines of a modern urban space. But the proposed rational street plans and grand edifices were largely rejected in favour of retaining the idiosyncrasies of the historic layout of the City. The architecture remained domestic in character, peppered with the occasional City church designed by Sir Christopher Wren.[7] Indeed, it was the grand architecture of Wren's newly rebuilt St Paul's Cathedral that expressed the City's resurgence after the devastation of the Great Fire.[8] The phoenix carved by C. G. Cibber appears over the south entrance, echoing the City's rise from the ashes of the Great Fire. Here Wren's exuberant dome and classical detailing resonated with his work a little way east across the Thames at the Royal Naval Hospital at Greenwich. Looking in the other direction, the urban palaces of the West End were only beginning to appear as an early herald of the increasing primacy of this part of London. Against this background it is possible to interpret the rebuilding of Bethlem as to be symbolic of the City's status within the growing metropolis. And it is important to question why, especially given its location, the governors chose to upgrade massively the architectural presence and medical capacity of this unique institution. The resulting urban phenomenon rivalled the architectural aesthetic of other major European capitals as well as the supremacist language of the classically inspired great house.

The emergence of the great hospitals in London in the late seventeenth and early eighteenth centuries coincided with the beginnings of the boom in country house building. Just as there is the memory trace of the monastic roots of these institutions in their plan, we also find reference to the architectural style and spatial planning of contemporary great houses. Bethlem is a good case in point, not only

because of its perceived relationship to royal French architecture, but also in the way indigenous aspects of high-end domestic design were adopted. In this regard Bethlem's closest architectural cousins are Sir Roger Pratt's Clarendon House on Piccadilly (1664–67) and Hooke's own Montague House in Bloomsbury, which he worked on at the same time as he did Bethlem. Notably, both of these urban palaces differed in ground plan from Bethlem as they comprised a central double pile block with protruding wings ranged around a courtyard. But their classically inspired aesthetic was a common bond.

Although no plan of the layout of the hospital has yet come to light there are a number of descriptions that articulate the space in ways that are helpful for our interests. In addition we have engravings of views of the entrance facade and a detailed map of the area showing the location of the hospital on Moorfields (Figure 3.2). Perhaps most unusually we also have the memory trace of the seventeenth-century premises in its replacement that was built on a new site in the early nineteenth century (Figures 3.3 and 3.4).[9] We know that there was a single public entrance that gave access to the central lobby from where Bethlem a vast facade.[10] The pattern of fenestration and the classically

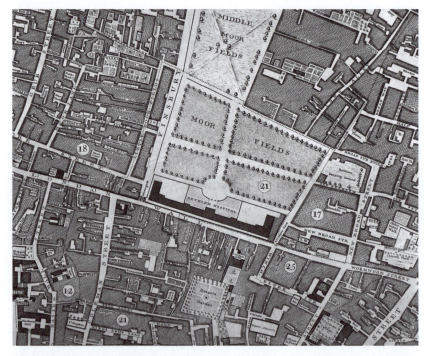

Figure 3.2 Map of Moorfields. Horwood's Map of London, Westminster and the Borough of Southwark, 1799.

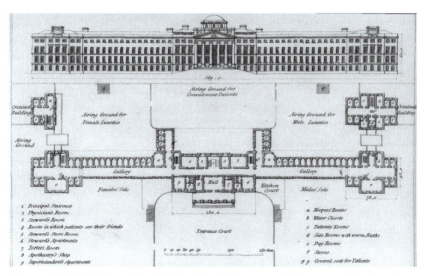

Figure 3.3 *Bethlehem Hospital* by John Britton and Augustus Pugin, from *Illustrations of the Public Buildings of London*, 1838.

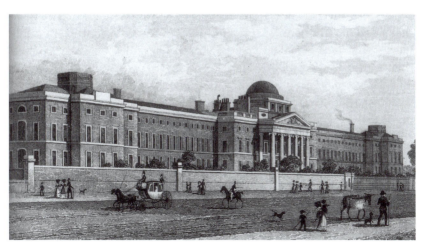

Figure 3.4 *New Bethlehem Hospital, St George's Fields* by Thomas H. Shepherd, 1830.

inspired detailing of the entrance facade ensured the hospital's usual circuit of steward's room and administrative and medical offices could be accessed. But of particular note here is the adoption of the long gallery as the mainstay of the spatial planning. There were two of these, one on each storey and punctuated only by the central lobby. Debates about the precise measurements of these galleries remain unresolved, but there is no doubt that they were long – approximately 600 ft in combined length and around 40 ft deep – creating monumental

aesthetic. No wonder the architecture of the Paris of Louis XIV was seen as an inspiration, or indeed competition for such an imposing edifice. Each of Bethlem's galleries gave access to the cells for individual patients, which were about 12 ft wide, each with a window at the rear of the hospital. Bethlem was, then, an extremely long, narrow, single-pile building with two completely contrasting facades. This gave the interior and exterior structure a rather uncanny appearance – a point to which I shall return.

Moorfields was one of the few remaining open sites in the City of London that offered the health and air considered so important for the wellbeing of patients.[11] The hospital design also benefited from this open site that ensured clear uninterrupted views of the main facade. The long, thin structure occupied the southernmost edge of Moorfields, which formed a grand space or 'place' in front of the hospital. This augmented the majesty of its appearance, especially as it contrasted with the cramped surrounding streets. The ancient Roman structure of London Wall, which ran parallel to the rear facade of the hospital, was only 9 ft away from it. It functioned both as barrier and screen forming part of the perimeter of the exercise yards for patients that stood at either end of the building and were shielded from public view. The choice of such a palatial entrance facade by the governors of this location in the City of London has been the cause of much comment and debate. Perceived as extravagant and its magnificence ridiculed, the new design was criticised as a palace for paupers whose exterior masked the grim reality of its interior form and function.[12] This caused contemporaries to question who were the madder – the occupants or the governors who had commissioned such an 'ostentatious piece of vanity'. A different reading of the design of both facades can be explored through the notion of home. It allows us to think about the relationship between public and private space and how the architectural grandeur of the great house was mapped onto institutional design.

If we think about architecture as an aesthetic mask to a building, we can begin to interpret both the north and south facades of Bethlem. The imposing entrance facade on its north side presents the building to the eye as if it were a picture. The viewer is confronted first of all by the phenomenon of Bethlem, which is a completely different spatial experience from walking through its narrow plan. The viewer responds initially to the visual affect of Bethlem, rather than to the effect on his or her intellectual or cognate processes. An imposing facade is essential for the representation of a building; according to Colin Rowe it is 'the existential interface between eye and idea',[13] and this was necessary for any interaction between building and viewer –

and monumental institutions such as Bethlem were designed to impress and impose on a number of levels. Why then the adherence to variants of the classical style in architecture? Perhaps it was to narrate the humanist message of these institutions. With proportions based on the human body the hospital building could speak the language of the viewer and indeed of its function and purpose. This would help viewers, patrons and visitors to transcribe architecture into an expression of themselves and the buildings to become images of their humanist functions.

The symmetry of the building adds a level of control over the parts that can be traced back to Albertian architectural theory. This again is the aesthetic expression of Bethlem's function as a vehicle of bodily containment. Indeed, this adds to its uncanny qualities as here we are looking specifically at an institution that hovers between attraction and repulsion. Attraction as it does civic good and repulsion as it contains a part of humanity we do not want to recognise. Is this not the language of the facades of Bethlem? I want to concentrate on the notion of attraction for the time being. Attention has been paid to this in terms of the notions of luxury and magnificence. We must also think here of the scale of the building and how it dominated the immediate area and indeed the whole of the urban topography. It was a statement of civic prowess and charitable good deeds.

Look behind you

The rear of the building also presents a facade. The south facade of Bethlem also interacted with the urban topography and indeed historic infrastructure of the metropolis. Two views of the rear of Bethlem as seen from the south side of London Wall afford us a glimpse of this facade (Figures 3.5 and 3.6). It offers a striking contrast to the openness of the entrance facade on the north side of the edifice, and it speaks a very different kind of architectural language. Instead of a facade articulated with the vocabulary of classical antiquity we have virtually architectural silence. An isolated Serlian window on the west flank of the hospital makes a strange reference to the grandeur of the entrance facade (Figure 3.6). But the rear of Bethlem is plain unarticulated architectural space and to highlight its separateness it is hidden from view. The mask is London Wall, the historic fabric of the City that encases and articulates or muffles the double height run of individual cells contained within. The window apertures of these are just visible (Figure 3.5). We could see the juxtaposition of wall and facade as a mask for the repulsion that the building houses – the unacceptable or off-putting aspect of humanity. Architecturally and aesthetically this is ingrained in the urban fabric of the City. The binaries at play here

between inside/outside, attraction/repulsion open/closed are high-lighted by the two facades of Bethlem.

The readings of these two facades address the relationship between social structure and social consciousness. In this way the experience of the architecture and architectonics of Bethlem can be conjectured as the interaction between subjective feeling and external influences. The social historian E. P. Thompson was one of the first to consider this relationship between the structural and the psychological.

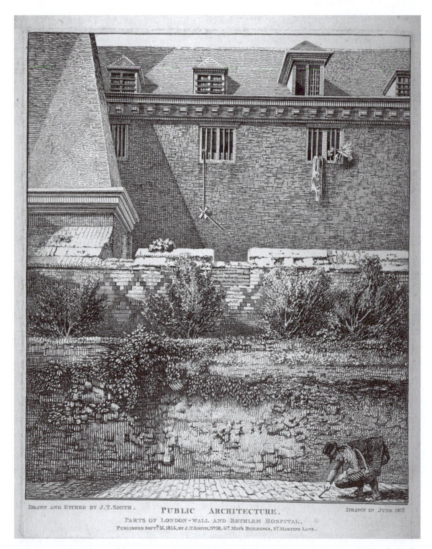

Figure 3.5 *Parts of London Wall and Bethlem Hospital* from J. T. Smith, *Antiquities of London*, 1791. Reproduced courtesy of the Guildhall Library, City of London.

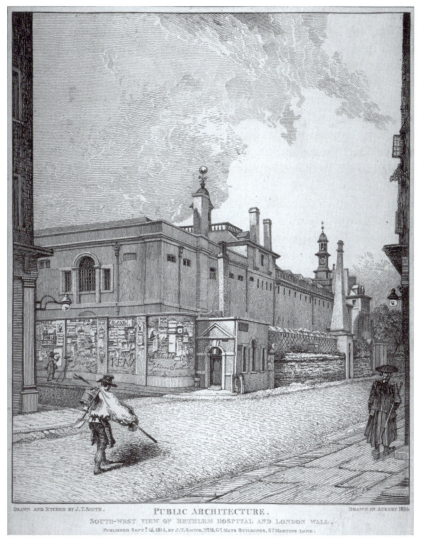

Figure 3.6 *Southwest view of Bethlem Hospital and London Wall* from J. T. Smith, *Antiquities of London*, 1791. Reproduced courtesy of the Guildhall Library, City of London.

'People do not only experience their own experience as ideas, within thought and its procedures ... they also experience their own experience as feeling'.[14] This maps onto our concern with the experience of the hospital as being shaped by structural and psychological factors that work to endorse cultural hegemonies. The role of architecture, specifically here the hospital, as a symbol of patrician authority is paramount in this context. This is seen in the relationship between the style of architecture and the style of politics and in the rhetoric of the

ruling elite. Architecture is then a microcosm of the social, political and cultural trends in Britain and had a crucial role in maintaining the status quo in the face of increasing adversity. Here these questions become more complex as the patrician authority comprises the merchants of the City of London rather than the landed elite. As we shall see, the involvement of the newly monied, and the aspiring middle and merchant classes was not unique to the institution of Bethlem. Indeed, it was common to just about all the new and redeveloped hospitals in London in our period.[15] To this end architecture functioned as a space for the performance of highly visible paternalistic displays which in the case, for instance, of the hospital, included medical succour, charity and prudent governance. All these elements were used to exact deference from the lower orders and reinforce the social system. In this way the performative elements of the display of power were important and architecture functioned as the spatial focus for these. The difference here is that the recipients of charity were not in a position to recognise the beneficence bestowed upon them. In this way the usual obligation conferred as part of the gift exchange was not in operation.[16] Parallel to this is the formidable presence of the hospital in the metropolis.

Architecture (and its spaces) is therefore an ordered physical structure that acts as a metonym for other inherited structures – this encompasses the makeup of society as a whole, a code of morality, a body of manners, a system of language and the way in which an individual relates to their spatial surroundings. Architectural style was a means of enabling these kinds of performances. The changing relationship between the aristocratic and bourgeois classes is part of the performance of these rituals, and architecture provides both the space and the aesthetic for this ongoing process. The notion that domestic architecture, here I mean lived-in spaces, is the physical embodiment of governmental and social systems is evident not only in private mansions in rural and urban settings, but also in the ways in which these translate into hospital design. The added ingredient here, in the specific instance of Bethlem, is the aesthetic expression and reception of the housing of the insane in such a splendid architectural setting. This could only work to rupture the architectural embodiment of the social status quo, as mad paupers appeared to be housed as if they were kings.

Display

The proliferation of published material and the development of a print culture made the hospital available to an ever-expanding range of publics. But this more general interest in architecture, where its

appreciation based on the buildings of antiquity was seen as a marker of social rank, ran parallel to the practices of country house visiting or home tourism. This impacts on our consideration of the phenomenological presence of the hospital as it was distanced from its physical context, making it part of an intellectual debate. In this way the hospital was transformed into an object that could be consumed by a range of publics. As architecture became the concern of the patrician elite, their aesthetic and moral values were codified into a visual language which formed a distinct, recognisable and readable system that ultimately placed architectural discourse in the wider public domain. These are not just my anachronistic concerns with systems of viewing. The practice of the display and consumption of the domestic architecture (both interior and exterior) of the elite is well documented.[17] In the case of Bethlem it is clear that the main facade of the building was meant to be seen. The wall enclosing the courtyard on the north side was kept low and it was pierced by six sets of railings each 10 feet wide. The eye was guided towards this facade and the architectural language it spoke to the viewer was familiar. As we have seen, a curtain in the form of the 1,400-year-old London Wall was drawn on the south facade (Figures 3.5 and 3.6).

The interiors of country houses were also of interest to visitors, and those of appropriate social rank gained entry. This cultural practice can also help us to understand how the interiors of Bethlem were experienced by the viewing public. There is no doubt that the role of visitors in the formation of the social image of Bethlem has been crucial. The negative connotations of peering at the unfortunate inhabitants have been rightly condemned as prurient voyeurism.[18] My interest here is not in rehearsing these arguments or indeed to attempt to condone (albeit perversely) such activities. Rather, I would like to explore this through the notions of display within the broader context of home.

The starting point for this consideration must then be the terms on which hospitals were available and to whom. This can be compared to the concept of hospitality that underpinned the well-documented practice of country house visiting. Visitors of a certain social rank were welcomed by the owners or else paid the housekeeper a small fee to be shown around the building. We have seen that the concept of hospitality was germane to the early monastic beginnings of the hospital. To this end admission to Bethlem was free, but it was hoped that a donation would be made to help with the upkeep of the institution. I want now to enter Bethlem to experience its interior spaces. I begin with an image by Hogarth engraved some five decades after the opening of the new premises. It shows the interior of Bethlem as the spatial location of the

final scene from the morally edifying tale of Tom Rakewell as illustrated in *The Rake's Progress. The Rake's Progress* is a series of eight paintings by William Hogarth that also enjoyed a wide circulation as prints.[19] They reflect Hogarth's concern with modern moral subjects. This is also seen as the pendant piece for this series – *The Harlot's Progress*, which is discussed in Chapter 4.[20] The moralising tale is that of Tom Rakewell, the spendthrift heir of a miserly father.[21] We meet Tom as he inherits his father's wealth whilst at the same time rejecting his pregnant fiancée whom he now refuses to marry.

Tom goes on to lose his fortune and to marry a rich elderly widow in an attempt to solve his financial problems. Eventually the law and Tom's rakish lifestyle catch up with him and he moves from debtor's prison to madhouse. The story is a commentary on avarice, moral turpitude and the perils of the modern consumer society. But my concern is with the representation of home and its dystopian counter-site. The madhouse where Tom ends his days is a mirror image of his home in the second scene of the picture cycle (Figure 3.7). Here, Tom is fashionably dressed and at his morning levée in his

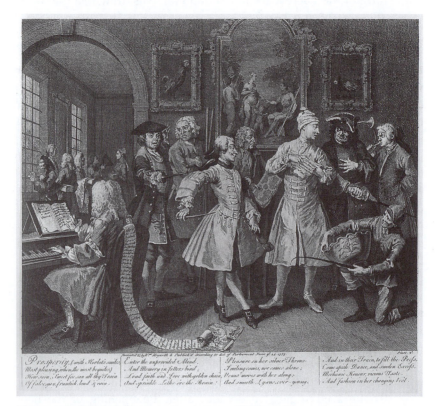

Figure 3.7 *A Rake's Progress: Levée Scene.* William Hogarth, 1733.

smart, new London house attended by musicians, other hangers-on and acolytes. This is in part a commentary on the cultural pursuits of contemporary society, many of which took place in a domestic setting. The fact that certain well-known cultural figures can be identified gives this scene added piquancy.[22] Of particular note is the music master at a harpsichord, who is supposed to be George Frideric Handel. The landscape gardener Charles Bridgeman is also represented. There are also a number of generic cultural types including a fencing master and a dancing master with a violin. It is a microcosm of the social and cultural world of the long eighteenth century as played out in the country house and town residence.

Tom's inevitable moral, physical and financial decline culminates in the final scene where he is confined in Bethlem (Bedlam) (Figure 3.8). In a parody of the levée scene we see Tom manacled and practically naked, lying on the ground unable to get up. This dystopian image is emphasised as Tom is surrounded by his fellow inmates, all of whom present a strange echo of the outside world and in some ways of the earlier levée scene. The characters represented, who appear in the

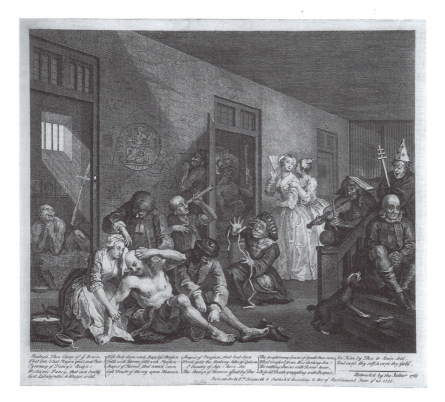

Figure 3.8 *A Rake's Progress: Bedlam Scene.* William Hogarth, 1733.

large space of the long gallery, include a tailor, a musician, an astronomer and an archbishop. In the door to one of the cells is a man who thinks he is a king – he is naked and wears a straw crown and holds a sceptre. Tom himself has become part of the display or spectacle of Bethlem. And we are reminded of this by the presence of two fashionably dressed women who have come to the asylum as a social occasion, to be entertained by the bizarre antics of the poor suffering lunatics. The lighting which streams in from a small window placed high up in one of the cells that opens onto the long gallery emphasises the strangeness of the scene. The inmates are unable to see out and, as we know, London Wall masked this facade of the building.

Hogarth's Bethlem is a microcosm of society for all to see. And the notion of display brings us back to the interior arrangement of the hospital. The plan of Bethlem also has strong resonance with the notion of home. The formality of the entrance arrangements and separation of public and private space can be traced back to the social function of space in the English country house.[23] This is normally interpreted in terms of tracks through the house where the social rank of the visitor is calibrated by how far into the space they are allowed to penetrate. But of particular note is the use of the long gallery as a mainstay of the spatial planning.

The inclusion of galleries in hospital building was not new, but again had its roots in domestic architecture. Bridewell Palace, built

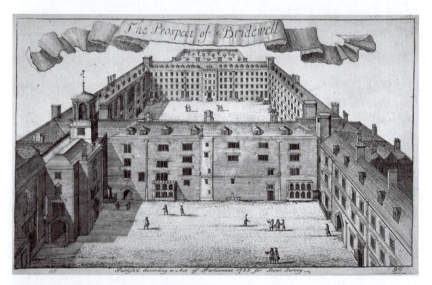

Figure 3.9 *The Prospect of Bridewell* by John Strype, 1720. Reproduced courtesy of the Guildhall Library, City of London.

in the first half of the sixteenth century, was turned over to the City of London for use as a workhouse. Indeed, the governance of Bethlem came under the aegis of those who ran Bridewell. The palace had a long gallery that ran to a length of around 200 ft, which was incorporated into the functioning spaces of this correctional facility. Furthermore, many infirmary halls, which formed part of monastic institutions, were not dissimilar to the long gallery format. The common factor is that whether servants' garret, purpose-built hospital gallery or monastic hall, these spaces were subdivided into individual cells.

The galleries and the central stair echoed the planning of contemporary great houses. The stair followed the domestic tradition of separating the occupants of the house by gender and/or social class and providing different tracks through the space. Moreover, the central stair also divided the men's and women's wings.[24] This kind of layout had been seen a few years earlier at Roger Pratt's Coleshill House, Berkshire, where a gallery ran across the attic providing garret rooms for servants, men being separated from women. Galleries were not just for the provision of servants' quarters. They had also been a hallmark of English domestic architecture since the sixteenth century, providing social spaces for the elite, as seen at Hardwick Hall, for instance. Sometimes they operated as covered walkways that were open on one side, or else they were completely enclosed spaces that also housed pictures. Both kinds of space were places of recreation and health where it was possible to walk and take exercise in all weathers. The display of pictures and other artworks in these spaces added cultural gloss to this practice. The combination of physical and mental health as being the concern of domestic architectural space finds a reprise in the hospital. In addition, the idea that these spaces, whether domestic or medical, could also be of cultural interest adds a layer of complexity. The important thing here is the interchangeability of function and the volatility of meaning of domestic and institutional space.

Why then was there so much upset and controversy about the living conditions of the patients in Bedlam? The expectations of the visitors and viewing public were directed in ways that emphasised the dissonance between the splendour of the entrance facade and the modesty of the accommodation. As Henri Lefebvre noted:

> A church is an architectonic space, but without a specific purpose. It is merely a space to be in, to move and speak, a room for living in the most general sense of the word: the space that we naturally need to situate ourselves in the space of nature and to feel at home.[25]

Perhaps the close relationship between the notions of home and comfort can be helpful here. And this extends into the debates concerning the differences between luxury and necessity. What we find in Bethlem is the beginnings of the shift in emphasis from the early modern notion of comfort as being a moral and spiritual state, with its antonym discomfort implying feelings of melancholy and gloom, to a more spatially defined concept. Throughout our period there was a growing emphasis on physical comfort – the satisfaction with one's immediate physical circumstances. And this led to a wish for the improvement of the comfort afforded by domestic environments.[26] This also led to the blurring of lines of definition between comfort and necessity. The shock of Bethlem was the mixed metaphors of its interior and exterior aesthetic, but we must remember that the two facades spoke different languages ...

Domesticated medicine

The notion of home remains ingrained in the spaces of the hospital throughout our period. This is not only through the classically inspired grand edifices that appeared, but also in the use of ordinary domestic townhouses as premises by some institutions. These modest beginnings of some hospitals were often outgrown, as seen for instance in the case of the Middlesex Infirmary, which opened in 1745. It was a private venture with funding coming from subscriptions. Once again it was a charitable institution designed to provide medical help for the poor. And its beginnings were domestic, as the initial premises were a series of ordinary townhouses in Windmill Street in the West End (Figure 3.10).

The houses provided beds for eighteen patients, and two years after its foundation the hospital became the first in England to add 'lying-in' beds for expectant mothers. The Middlesex soon outgrew its modest domestic accommodation and moved to the new, purpose-built Middlesex Hospital, in Mortimer Street, which was opened in 1757 (Figure 3.11). The foundation stone was laid in 1755 by the hospital's president, the Earl of Northumberland (see Chapter 5). The new premises underwent subsequent improvement and expansion, giving the hospital an increasingly grand presence in the urban topography (Figures 3.12 and 3.13).

We find a similar story of domestic beginnings in the Westminster Public Infirmary in Petty France, which was founded in 1720. Like the Middlesex, Westminster responded to the medical needs of the growing poor population of the West End. It was located in an ordinary townhouse that was soon outgrown, and moved to larger

Figure 3.10 *Original Premises of the Middlesex Infirmary.* Anon., c.1840.

Figure 3.11 *The New Premises of Middlesex Hospital.* Anon., 1757.

premises in Chapel Street in 1724.[27] But in contrast to other hospitals that were founded or moved to improved premises at this time, the governors of the Westminster had no interest in constructing a new building. Instead, they sought an existing structure that would provide an instant solution to the problem of lack of space. The increased need for space was met by simply multiplying the number of units of ordinary townhouses that had comprised the original hospital. This solution to the accommodation problem replicated the domestic scale and spaces of the existing premises. The governors leased a series of townhouses in and about Castle Lane in the lower part of Westminster.

Figure 3.12 *Middlesex Hospital.* Anon., 1829.

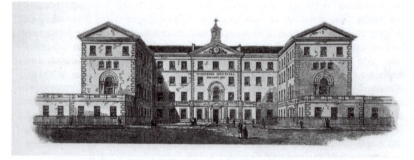

Figure 3.13 *Middlesex Hospital.* Anon., 1848.

But once again increased civic need did work to produce another monumental institution in London as a forceful minority, including the physicians and surgeons attached to the institution, rejected these premises in favour of Lanesborough House at Hyde Park Corner.[28] Instead of building a hospital that looked like a great house, the governors simply moved into one and founded St George's. The interior spaces of Lanesborough House amply accommodated the various medical and bureaucratic needs of the institution. The internal arrangement of the floors lent itself to the various functions of the hospital. Numerous offices and the surgery were located on the entrance level. A monumental wooden staircase led to the first floor. This was a galleried space that provided access only to the two wards: one for men and one for women, each accommodating fifteen patients.[29] The interchangeability of domestic and medical institutional space gives the architectonics of the hospital a volatility of meaning which the concept of home helps us navigate. Indeed, this slippage between the two can be surprising. In 1746 William Bromfield, surgeon to St George's Hospital and to the Prince of Wales, took up a lease on a

house in Grosvenor Place which then backed onto the open fields beyond Knightsbridge. Here Bromfield founded the Lock Hospital – the first modern hospital to concentrate solely on the treatment of the socially stigmatised venereal disease.[30] The spatial needs of the institution were catered for in an ordinary townhouse where the medical needs of the population were also met. For instance, in 1758, 442 patients were admitted, 100 of whom were married women.[31] In the Lock Hospital we find charity and need, and the attraction and repulsion of a social taboo. And this brings us back to the notion of the uncanny.

The uncanny

In 1750 a second hospital was founded in London for the care of pauper lunatics. In contradistinction to many other new institutions, St Luke's was originally housed in a foundry located on Windmill Hill, Upper Moorfields (Figure 3.14). As the address suggests, this was not far from Bethlem. The building was converted by George Dance the Elder, who was one of the principal architects working at that time. He was succeeded on his death by his son George Dance the Younger as surveyor to the hospital. Like many new institutions, St Luke's was initially modest in scale, accommodating only twenty-five patients. Piecemeal enlargements did not relieve the overcrowding, and by 1771 a decision was made to build a new, much larger hospital on a new site; and in 1776 ground was leased a little further north on Old Street. A year later after a failed architectural competition for the new premises, Dance was asked to produce the design.[32]

Construction was carried out in three phases between 1782 and 1789, and in 1786 St Luke's moved to the new purpose-built premises. The magnificent design rivalled that of Bethlem. The main facade, which ran to some 500 ft in length, was of clamp brick but displayed much classical detailing, including a giant central portico. The internal arrangements again mirrored that of Bethlem, with men and women housed to the left and the right, respectively. More tellingly, St Luke's comprised 300 single cells, each with small windows set high in the wall, no heating, and loose straw on wooden bedsteads. Unlike the inmates of Bethlem, the pauper lunatics of St Luke's were not on public display. But they were housed in single cells so their living accommodation was similar to Bethlem. Does this lead us to a different reading of the aesthetic, both interior and exterior, of St Luke's? A scene from Ackermann's *Microcosm of London* (c.1800) presents a very different image of the interior space from that shown by Hogarth (Figure 3.15). The parody of homeliness and domesticity represented by Hogarth is replaced by a vast dramatically lit space that is anything but homely. In

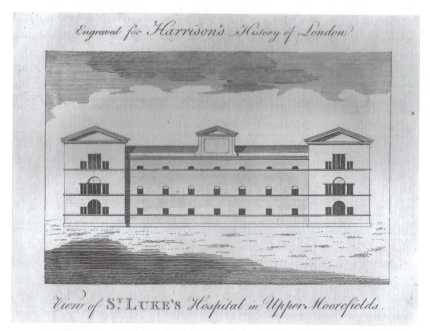

Figure 3.14 *View of St Luke's Hospital, Upper Moorfield* from Harrison's *New and Universal History*, 1766.

Figure 3.15 *St Luke's Hospital for Lunatics* by A. Pugin and T. Rowlandson from Ackermann's *Microcosm of London, c.*1800.

a chapter concerned with the institutionalisation of the human mind before the discovery of the subconscious, I suggest that Freud's notion of the uncanny is still appropriate. This is based on the idea of something being uncomfortably strange or familiar and evoking feelings of attraction and repulsion. Freud suggests that social taboo can provoke both reverence and horror. Moreover, if such taboo items (including here lunatics) are hidden from public view, they must be a threat or uncanny monsters. The words Freud uses to explain his focus on the notion are homely, *heimlich*, and unhomely, *unheimlich*. The uncanny is then centred on the notions of home, familiarity and their opposites. In this way the spaces of the hospital can be both as attractive, and repulsive, as they are paradoxical.

> The subject of the uncanny ... is undoubtedly related to what is frightening – to what arouses dread and horror; equally certainly, too; the word is not always used in a clearly definable sense, so that it tends to coincide with what excites fear in general. Yet we may expect that a special core of feeling is present which justifies the use of a special conceptual term. One is curious to know what this common core is which allows us to distinguish as 'uncanny' certain things which lie within the field of what is frightening.[33]

Chapter 4

Matter out of place

Any discussion of the hospital in our period might well be expected to address the notion of hygiene as it refers both to the preservation of health and to the idea of cleanliness. Advances in medicine and the growing understanding of the pathology of disease led to developments in hospital design. Better ventilation and sanitation of wards and the ability to isolate contagious diseases gave patients an improved chance of survival. The literature on this topic is thorough and needs no rehearsal here.[1] Instead, I would like to think about the antonym of hygiene: dirt. The symbolic concept of dirt enables us to understand the ways in which the hospital worked to cleanse society. Specifically, here I am interested in the hospital as a space of containment and purification, and particularly, but not exclusively, how this operated in regards to women. Mary Douglas asserted that dirt, when understood as matter out of place, simultaneously implies both the existence and the contravention of an established order or system and that this in turn establishes dirt as symbolic.[2] Dirt is not then indexical of an objective category of pathogens; rather it is indexical of a contravention of a social order, and by extension, its boundaries. Dirt transgresses boundaries of a given order and as a consequence it works to reaffirm the validity, naturalness, and purity of that which remains within. In this way dirt through its dangerousness can become a means to arrange both culture and society.

Douglas considers the importance of boundary markers and analyses the ideas of pollution and taboo across a range of world cultures. What is clear is that such beliefs and rituals played a key role in the way political and economic resources were deployed and that they can be used metaphorically as well as in the physical acts and rituals to do with cleansing. Douglas shows us the moral and religious elements in rituals and beliefs that play a key role in legitimising claims of superior status. These symbolic systems were centred upon notions of masculinity and femininity and layered upon the human body. The city was conceived of as a dangerous place where moral

and/or physical contamination was imminent. These ideas were expressed readily on issues ranging from the nature of the water supply to the continual attempts to clear the streets of prostitutes (Figures 4.1 and 4.6).

The notions of pollution and taboo can help us to understand how the hospitals that appeared in London during the long eighteenth century operated as spaces of exclusion and cleansing. I am interested here in how the spaces of the hospital worked to move anomalous people to new statuses through the practice of ritual. Matter out of place or polluting elements are not members of any clear category. Rituals to purify people who have been exposed to pollution work to correct any misplacement or confusion and so dispel danger. What, then, was considered matter out of place? This fell into two broad categories: bodily and behavioural 'impurities'. Certain kinds of contagious disease that were spread through impure social practices acted as a bridge between these. In this way institutions purified moral and biological threats and served to isolate potentially 'contagious' behaviour from the rest of society.

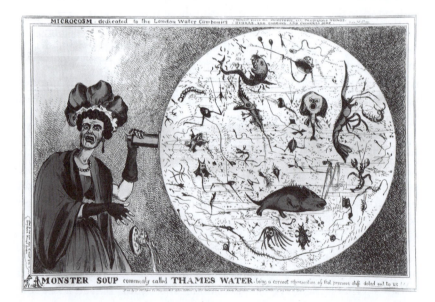

Figure 4.1 *Monster Soup Commonly Called Thames Water, Being a Correct Representation of That Precious Stuff Doled Out to Us!* by William Heath, 1828.

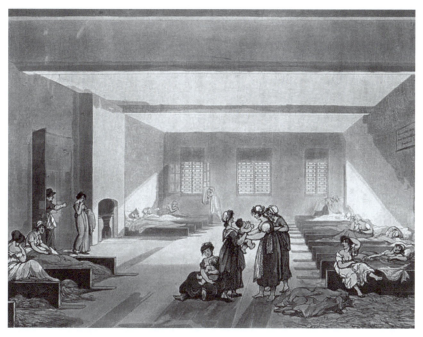

Figure 4.2 *The Pass Room, Bridewell Lying-in Hospital* by A. Pugin and T. Rowlandson from Ackermann's *Microcosm of London, c.1800*.

Bureaucratic vigilance

The negative associations and stigma attached to disease and the places where it was treated certainly date back to the Middle Ages. As a result, restrictions on the movement and behaviour of the (poor) populace were imposed in order to protect society as a whole from widespread illness. This relates to the 'strict spatial partitioning' identified by Michel Foucault when he discusses the social and spatial consequences of leprosy and the plague in early modern Europe.[3] He sees the treatment of both as analogous to other unwelcome societal pollutions. This is evident in the containment of unwanted people in the society such as the insane or criminals, and their subsequent subjection to regimes of behavioural and bodily comportment that form Foucault's idea of bureaucratic vigilance. He uses the two diseases to identify two different but parallel ways in which society operates: lepers represent 'rituals of exclusion' whilst the plague gave rise to disciplinary projects.[4] In order to contain and treat the plague and the evil this might bring out in the populace, Foucault contests that sufferers must be 'caged':

> This enclosed, segmented space, observed at every point, in which the individuals are inserted in a fixed place, in which the slightest movements are supervised ... all this constitutes a compact model of the disciplinary mechanism.[5]

Foucault is referring to the panopticon and the scopic regime it enables. But this concept of space also becomes a metaphor for the hospital in its broadest constituency in our period:

> The constant division between the normal and the abnormal, to which every individual is subjected, brings us back to our own time, by applying the binary branding and exile of the leper to quite different objects; the existence of a whole set of techniques and institutions for measuring, supervising and correcting the abnormal brings into play the disciplinary mechanisms to which the fear of the plague gave rise.[6]

Here specifically it helps us to understand how the spaces of the hospital dealt with 'matter out of place'. And this enables us to think about the hospital in different ways. We can look beyond the hospital as being part of the history of philanthropy where techniques of rehabilitation and reform were only 'benign' methods of social control.[7]

A plague on both your houses

The system of separating 'unclean' elements of society from the rest can be traced back to the leper hospitals or lazar houses.[8] Around ten such institutions were established in London in the Middle Ages.[9] They were originally situated outside the city as a means of quarantining the patients. But as the city grew these spaces were absorbed into the urban fabric – sometimes in surprising ways. At the Reformation these institutions, which were religious in origin, became Crown property. The slippage between medical and domestic space is a thread that runs through this volume. The story of the lazar house dedicated to St James, founded c.1100, continues this theme. In a curious reversal of fortune, in the mid-sixteenth century this hospital was retained by Henry VIII, and converted into St James's Palace. Its location on the then western edge of London made it attractive and the new royal residence gave easy access to the royal parks that bordered this side of the metropolis The majority of the other lazar houses in the London area were put under the aegis of St Bartholomew's Hospital as part of its post-Reformation re-foundation by Henry VIII. Of these the hospital at Knightsbridge survived until the early eighteenth century. The Lock Hospital across the river

Thames in Southwark, and the Kingsland Hospital just to the north of London in Islington, were retained by St Bartholomew's for the reception of convalescents and incurables.[10] Although this category originally included lepers, from the mid-sixteenth century onwards 'incurables' were more likely to be sufferers from venereal disease. The hospital at Southwark was reserved for men, and that at Kingsland for women; each had thirty beds. By the mid-eighteenth century both institutions were flourishing in terms of patients but considered a burden on the resources of St Bartholomew's.[11] In 1760, despite the continuing need, both were closed and their premises converted to dwelling spaces. Indeed, most hospitals were not at all sympathetic to those suffering from venereal disease. St Thomas' had four 'foul wards' that had been opened in the mid-sixteenth century for 'the victims of disease so degrading to humanity'.[12] The London Hospital had a separate establishment for those with syphilis. Of the newly established large voluntary hospitals that were founded in our period, the Middlesex Hospital only opened its first lock ward in 1806 and the Westminster Hospital refused to admit patients at all.[13]

Nevertheless, the need for such institutions grew throughout the long eighteenth century. In 1747 the first newly established hospital to treat nothing but the socially stigmatised venereal disease opened in Knightsbridge.[14] William Bromfield, Surgeon to St George's Hospital and to the Prince of Wales, took up a lease on a townhouse in Grosvenor Place and founded the Lock Hospital.[15] The volume of patients treated was substantial. In 1758, 442 patients were admitted, 100 of whom were married women, and by 1783 the numbers had increased to 530.[16] There was a widespread belief that venereal disease was solely the result of sexually promiscuous behaviour and as such it was an appropriate punishment for such impropriety. As long as it remained a danger it could act as a constraint on immoral behaviour. The threat of incurable disease could keep matter in its place, so why was there an interest in offering charity and succour to the afflicted? The drive to discourage this kind of sexual activity was at once moral and economic. The exponential rise in venereal disease was seen as a threat to the necessary population expansion as it caused disability, premature death and mass infertility. In turn this led to economic decline and reduced recruitment for the army and navy that were crucial for Britain's bellicose and colonising activities overseas. But there was a perceived dilemma in supporting such a charity as the Lock Hospital, as no-one wanted to be seen to appear to be condoning vice. Perhaps, then, unsurprisingly, subscribers were fewer than for other hospitals: there were only 165 in the first 3 years of the hospital's existence and the financial situation was precarious.[17] The supporters of the Lock

Hospital came from distinctive social groups, but there were fewer women than might have been expected, and those who did donate protected their identity. There were the usual philanthropic landed elite and monied merchant classes who habitually gave to charity. In addition a number of medics also supported the hospital, either from professional curiosity and/or the fact that treating disease of this kind was big business! There were also a large number of military and naval officers, which we can interpret either as enlightened self-interest or a recruitment and retention campaign.[18]

The lazar houses and lock hospitals narrate how 'matter out of place' became an urban rather than a suburban phenomenon during the early modern period. The city did continue to be a site of exclusion for certain social groups, but this exclusion took place within the confines of the metropolis itself. There were still those who were expelled from the city. Throughout our period paupers who came from outside London and who were apprehended by the authorities could be imprisoned for seven days before being sent back to their own parish. This process was not just to rid London of those who would make demands on its charity; it also cleansed the urban environment. The Pass Room at Bridewell Prison and Hospital (Figure 4.2) is an example of the kind of institutional

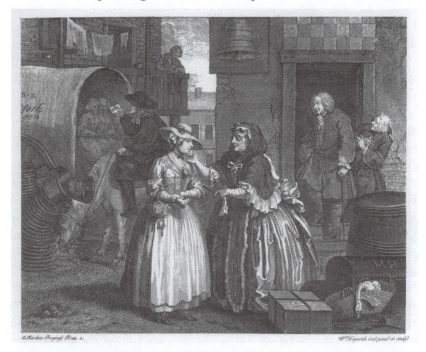

Figure 4.3 *A Harlot's Progress: Moll Hackabout arrives in London* by William Hogarth, 1732.

space where the dislocated poor were held before being expelled from the city. This segregated social group was subdivided before being confined. One particular form of matter out of place is identified in one of the plates from Ackermann's *Microcosm of London* (*c*.1800). He refers to the Pass Room illustrated as being for 'one class of miserable females' by which he means single mothers. Narratives of the taboos of female licentiousness run through this volume. Illegitimacy, the frequent consequence of such behaviour, is discussed in detail in the next chapter. Here I want to focus on women as 'matter out of place'.

Sex and the city

I want now to think about the metropolis and how it provided a location for the kinds of feminine social impurities that were perceived as dangerous. The idea of London as a potential locus for vice is alluded to by Prince Puckler Muskau, who visited London in the mid-1820s. His thoughts on the view from the outskirts of the city:

> In an hour's riding I reached a hill. ... The sun darted its rays ... like a huge torch ... the centre of which rested directly on the metropolis of this world, – the immeasurable Babel which lay outstretched with its thousand towers, and its hundred thousand sins, its fog and smoke, its treasures and misery, further than the eye could reach.[19]

The bustle and diversity and social misdemeanors identified by Puckler Muskau had been evident throughout the preceding century. Just as London had become a site of increasing charity and philanthropy in the eighteenth century, so it had also become a centre for vice. William Hogarth is the nearest thing we have to a camera-like vision of London in the opening decades of the eighteenth century. We have seen already in Chapter 3 the ways in which his narratives addressed contemporary issues and debates about morality and propriety. In the *Rake's Progress*, Hogarth shows us how the protagonist Tom Rakewell's lack of purity of action and deed leads to his eventual downfall and incarceration in Bethlem. We see vignettes of London life as part of the story, but the city remains a backdrop.

In Hogarth's picture series *A Harlot's Progress* (1731 and 1732 in a printed version) we see how London is represented as a corrupting influence and site of moral depravity.[20] The six scenes chart the downfall and death of Moll Hackabout, an innocent girl who arrives from the country and is tricked into prostitution by a devious brothel

keeper. We see episodes from Moll's life in London where Hogarth employs a range of narrative techniques that evoke feelings of pity and bathos. Hogarth's cautionary tale is given added piquancy as the characters are drawn from contemporary events. Moll herself is a conflation of two well-known London prostitutes: Daniel Defoe's fictional Moll Flanders and the real-life Kate Hackabout. The brothel keeper, who greets Moll in scene 1, is based on the notorious Elizabeth 'Mother' Needham, who had died in 1730 after being brutally assaulted by the London crowd as she stood in a pillory (Figure 4.3). Sir John Gonson, a judge whose enthusiasm for raiding brothels and handing out harsh sentences to those involved in prostitution was well known in London, appears in scene 3 to make one of his famous (or infamous) arrests.[21] My purpose here is not to give a close reading of Hogarth's symbolism and social commentary – this has been done by others.[22] It is the locus the city gives to this polluting moral corruption that is important. Moll's story is vivified not only through the use of real-life characters but also by the authenticity of the location of each event. Moll's corruption by Needham begins at the Bell Inn in Cheapside in the City of London. She becomes a kept mistress of a wealthy Jew and lives in a luxurious townhouse – the location is unspecified but no doubt a reference to the fashionable West End of London favoured by the elite (Figure 4.4). We find her next in Covent Garden, where having fallen from favour she works as a prostitute in one of the many brothels for which the area was renowned. Her arrest by Gonson moves Moll back eastwards to the City of London to Bridewell Prison (or Hospital as it was formerly known).[23] This was used to house those convicted of a range of petty offences of which prostitution was considered one. Moll is shown beating hemp to make hangman's rope – hard labour was a common punishment in Bridewell, as were the weekly whippings of felons, including prostitutes (Figure 4.5). The final scenes show Moll once again in Covent Garden where, after the humiliation and punishment of prison, she succumbs to venereal disease and dies in a dingy garret.

Moll's sorry tale is indexical of the proliferation of prostitutes and the very public and omnipresent nature and practice of their trade in eighteenth-century London. By the third decade of the eighteenth century a concerted effort began to curtail the growth of prostitution, especially in Covent Garden, which was a particularly problematic area. This movement did not succeed – the oldest profession continued to flourish in London. Indeed, it became part of the urban scene, reinforcing the notion that the city was a place of sin and corruption. James Boswell remarked how he 'strolled in the Park and took the first whore I met'.[24]

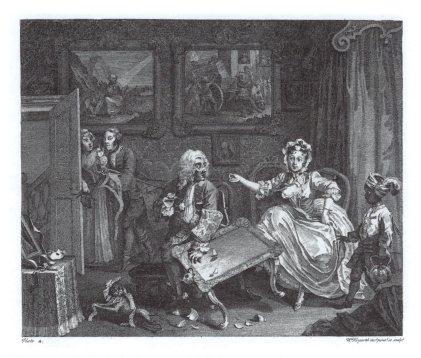

Figure 4.4 *A Harlot's Progress: Moll becomes a kept woman* by William Hogarth, 1732.

This matter out of place pervaded the metropolis and posed a danger to the social order. How, then, did the spaces of the hospital respond to this and offer the potential for containment and cleansing?

One of the narrative threads in this volume is the ways in which charitable acts and philanthropic gestures were inscribed in the urban fabric. Throughout our period succour continued to be offered to the needy, including soldiers and sailors, the ill and the insane. And this category was eventually broadened to encompass orphans and abandoned infants.[25] By contrast, fallen women and prostitutes did not attract much public or private sympathy. Instead they were blamed for their circumstances and seen as an element of society that needed to be expunged. Indeed, areas of the metropolis such as Covent Garden, Whitechapel and Cheapside were renowned for their bawdy houses, brothels and molly houses as well as coffee houses and the streets themselves where casual solicitations took place. It was only in the middle years of the century that attitudes began to change. A letter published in *The Rambler* in March 1751 signalled this shift as it addressed itself to 'the public on behalf of those forlorn creatures, the women of the town; whose misery might here satisfy the most rigorous censor'.[26] Seven years later Robert Dingley noted in his 'Plan for a

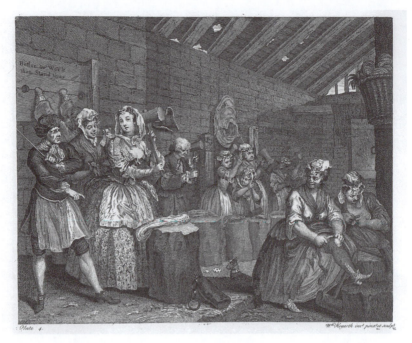

Figure 4.5 *A Harlot's Progress: Moll in Bridewell Prison* by William Hogarth, 1732.

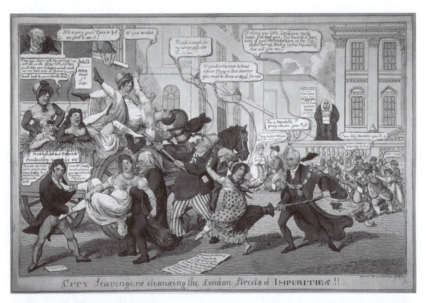

Figure 4.6 *City Scavengers Cleansing the London Streets of Impurities* by C. Williams, 1816.

Magdalen House' that although charitable institutions were proliferating across London, 'unfortunate females seem the only objects who have not yet catched the attention of public benevolence'.[27] Dingley's plan was the winning entry in a competition held by the recently founded Society for the Encouragement of Arts, Manufactures and Commerce for a hospital for the reception of penitent prostitutes. The result was the Magdalen Hospital, founded in 1758 (the term 'house' and 'hospital' remain interchangeable). Doubtless this was part of the increasing charitable apparatus through which the lives of Londoners were directed and sometimes ameliorated.[28] The wish to 'cure', rehabilitate and cleanse these women so they could return to society and become useful citizens was a forceful one. Like the Foundling Hospital, the Magdalen was just one of a range of institutions established to address the broad problem of immorality. The immorality and sexual misbehaviour of women threatened the future of the nation as their ability to produce legitimate children and their role as mothers were compromised. Sexually promiscuous women and the resulting illegitimate and/or abandoned children, together with those suffering from venereal disease, were all 'matter out of place', which worked to disrupt and endanger the social fabric. We have seen the ways in which this broad category interacted with and influenced the urban topography. How then did the spaces of the hospital address the needs and the danger presented by this social group?

Purity and danger

The Magdalen Hospital for Penitent Prostitutes grew out of the activities of many of the same protagonists as the Foundling Hospital and the Marine Society[29] – most notably here Jonas Hanway and John Fielding.[30] And, as its name suggests, it was designed to provide respite and care for prostitutes; and to encourage their moral reform so they might re-enter society. Although several different proposals were published, ranging from the creation of an isolated rural retreat to an industrial establishment (favoured by Fielding) and a quasi-house of correction as proposed by the magistrate Saunders Welch, the eventual foundation took the form of an urban hospital. Following a flurry of pamphleteering by Hanway and others, funds were raised by subscription and the new institution opened in Whitechapel just to the east of the City of London at 21 Prescot Street in August 1758. The building had been occupied by the London Hospital but little is known of its internal spatial arrangement. The choice of Prescot Street was not without significance as at this time it was a disreputable area with brothels, taverns and theatres. Indeed, many of these establishments had been forced out of the City of London in an attempt by the

authorities to clean up the area (Figure 4.6). Here purity and danger existed cheek by jowl.

The hospital immediately attracted willing penitents and a long list of generous subscribers. This was so much so that by 1768 a subscription list was opened for the building of a new hospital. A site was found on the south bank of the Thames at St George's Fields in Southwark to where several hospitals moved, including Bethlem, once the development of the road infrastructure was implemented in the 1760s (Figure 4.7). The subscription list was headed by Queen Charlotte, who donated £300. The following year the hospital received a royal charter from King George III, and in 1770 a new larger building in St George's Fields was commissioned (Figure 4.8).[31] Indeed, in 1865 the guidebook and commentary *Cruchley's London* remarked that 'Since its foundation to 1860, 8983 young women have been admitted. No young person who has behaved herself well during her stay in the house is discharged unprovided for.'[32] Once more we have a sense of the volumes of people (this time women) who were processed through the spaces of the hospital: an average of almost 900 women per annum or a weekly intake of around seventeen penitents from the local area. The women could protect their own identity as they were also able to

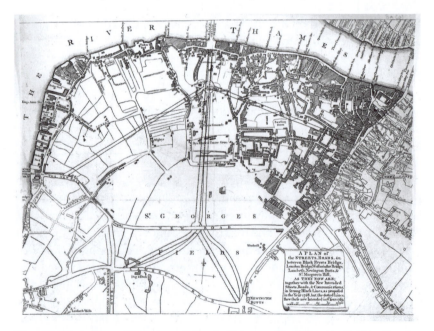

Figure 4.7 *A Plan of Streets and Roads Between Black Fryers Bridge, London Bridge, Westminster Bridge, Lambeth, Newington Butts and St Margaret's Hill, 1769.*

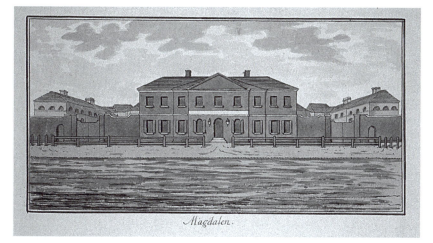

Figure 4.8 *View of the Magdalen Hospital, St George's Fields, Southwark* by Thomas Trotter, *c.*1790. Reproduced courtesy of the Guildhall Library, City of London.

assume other names when they entered the hospital, if they wished. And there were strict rules against reproaches for past sins and no enquiry into a woman's past was allowed. Indeed, they were expected to conduct themselves with 'the utmost propriety and humanity'. A woman was only admitted back into society if friends or relatives undertook to protect her and forgive her past, at which point her clothes and identity were returned to her.[33]

A great deal of attention has been paid to charity and prostitution as being strange bedfellows (if you will forgive the expression).[34] I am more interested in how the spaces of the Magdalen Hospital contained and directed matter out of place. Much can be gleaned from the discussion of the plan of the new premises as discussed by the colourful preacher who delivered weekly sermons at the hospital: William Dodd.[35] The most remarkable statement is Dodd's own preamble to the 'Explanation of the References in the Plan' that appears in the preface to the volume.

> Experience has proved it to be a matter of great importance to divide the Objects of this Charity into separate Classes, and to keep them from Communication with each other, and that they neither see, nor be seen from Persons – without.[36]

The new premises were intended to house 200 'objects' as recipients of charity were frequently referred to at this time.[37] The control over the meter of life is seen in the attention paid to the rhythms of the everyday

routines. The regulations over rest and diet state that from Lady Day to Michaelmas they rise at 6 a.m. and go to bed at 10 p.m. and from Michaelmas to Lady Day they rise at 7 a.m. and go to bed at 9 p.m. This is a period of complete darkness as no candles were allowed and nor fires in winter, the only exception being the sick wards. Even meal times were strictly regulated. Breakfast was at 9, for which half an hour was allowed, the main meal was at one o'clock and lasted an hour. Work stopped at 6 p.m. in the winter and 7 p.m. in the summer.[38]

The separate classes of women were kept apart, each having their own yard, conveniences and exercise grounds. The segregation continued in the chapel, where 'the Objects ... are placed in distinct Galleries, without communication between the Classes, or with any other part of the Chapel'. Each of these galleries had its own stair access. The classification and segregation of the 'objects' speaks already to the notion of hygiene and the concomitant will to deal with 'matter out of place'. Indeed, the dangerousness of this is identified by Dodd when he discusses the purpose of the hospital in a sermon delivered before the president of the institution:

> it is to take from our streets the shame of our community, the instruments of the foulest pollution, the most poisonous contagion.[39]

In his advice to the Magdalens, Dodd explained the intention was to enable 'you to recover lost Reputation, Health and Virtue ... you shall be enabled to return to life with a reputation recovered; no longer the scorn and contempt of your fellow creatures'.[40] In order to be purified, Dodd exhorts the Magdalens to 'Reflect ... upon the body polluted with iniquity'.[41]

The rules and regulations of the Magdalen House give an insight into the processes of purification and how the spaces of the hospital worked in this regard.

> 1 The House is divided into parts, in order to make total and distinct divisions of the objects, and the rooms are distinguished by being numbered.
> 2 The women are classed in each Ward ...
> 4 Each woman lies in a separate bed, and has a box for her cloaths and linen, under a lock and key, which is kept by herself.
> 5 Strict regard is had, by the Matron and her Assistants, that the Wards be kept completely ventilated, and the air pure ... [42]

Even those who were unwell were separated from the other Magdalens and segregated by the group they occupied in the hospital as 'in each class and division of the house, a room is set apart for the sick'. This description of the processes of purification reveals much of the importance attached to classification and progress. The Magdalens worked their way through the different ranks in the house. As they rose through them they received more privileges and comfort in terms of their accommodation. Clearly this refers to the growing concern for comfort at this time that has been discussed in relation to Bethlem.[43] The shift from the notion of comfort as being a moral and spiritual state to a more spatially defined concept is important here. The growing emphasis on physical comfort is linked to moral wellbeing. What interests me most here is that the ritual of cleansing is conceived of as the achieving of greater comfort, and this is expressed spatially. The spaces of the Magdalen Hospital become the process of purification for the penitents.

The regime emphasised silent regularity, isolation and hard work, and was almost monastic in its formulation. Attendance at chapel was essential, and as we have seen the spatial arrangement of the hospital facilitated movement to there from the different segregated parts of the building. (Figure 4.9) The Magdalens sat behind a screen with their faces shielded further by the large straw bonnets which formed part of their uniform. The Magdalen Hospital rapidly attracted the attention of the wider social world of London, and the chapel became a fashionable resort for the well heeled. On Sundays a congregation flocked there both to hear the sermons of the ever popular preacher, William Dodd (at least up until his execution for forgery following his trial in 1777), and to gawk at the screened figures of the penitents themselves. The governors enjoyed privileges in this regard as 'Every Member of the Committee is entitled to four tickets, to admit four persons to the Chapel on Sundays, viz. two for the morning, and two for the evening.'[44]

The scopic regime enabled and encouraged by the spaces of the Magdalen Hospital is in some ways akin to that of Bethlem. The cultural practice of visiting and viewing was part of a process that established and reinforced social hierarchies. The social ritual of looking helped keep matter in its place. But in the Magdalen Hospital both the viewer and viewed remain anonymous. Whereas objects of charity in Bethlem were not able to recognise the benevolence bestowed upon them so they were freed from any notion of obligation, the Magdalens had one chance to respond to treatment and reform.[45]

If we return to the notions of purity and danger as proposed by Mary Douglas, we might begin to understand more how the spaces

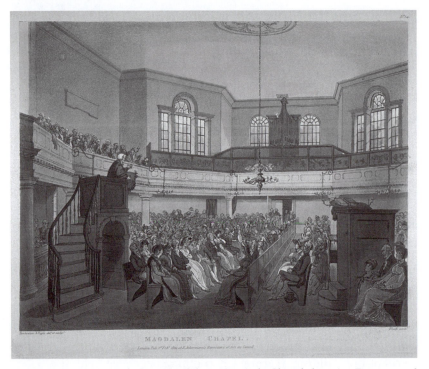

Figure 4.9 *Interior of the Magdalen Hospital Chapel* by A. Pugin and T. Rowlandson from Ackermann's *Microcosm of London*, 1809. Reproduced courtesy of the Guildhall Library, City of London.

of the Magdalen Hospital operate.[46] Douglas discusses the idea of a belief in ritual pollution with specific reference to religion. She is concerned with the problem of why certain things (or people) are thought to have special significance and are considered sacred whereas others are viewed as polluted. These beliefs result in taboos which may relate to touching, using or seeing objects or people. These taboos are predicated on the notion that contact with these items or people should be avoided as they are either too good or too dirty or polluting. These ritual taboos can apply constantly to an entire community or they can operate at specific times that relate to bodily functions or behaviours. Clearly Magdalens, the mad, and those with social and medical maladies fit this category, so becoming taboo. To the rest of society these groups are taboo as they do not fit into the accepted classification of the world. As such, according to Douglas they have a liminal existence on the borders of society. Perhaps more importantly for us, Douglas suggests that these groups exist in the boundaries between categories and as such they are seen as possessing both power and danger. Either way society militates against contact with such a

marginal person or thing. We have seen how hospitals were liminal spaces and this is a theme that continues throughout this study. We have also seen how the spaces of the hospital controlled the viewing process and so regulated the contact with these objects of taboo. In the Magdalen Hospital a screen provided a physical and visual barrier between the space of the penitents and 'ordinary' society. In Bethlem the mad were ranged in a long gallery like art objects, unable to return the gaze of the viewer, so remaining detached from the process.

The hospital in its various manifestations thus brought bureaucratic vigilance to the problem of matter out of place. We have seen how 'dirt' transgressed social boundaries and was confined in the liminal spaces of the hospital. The processes inherent in these spaces worked to move anomalous people to new statuses through the practice of ritual. In this way the validity, naturalness and purity of society was reaffirmed.

Chapter 5

The gift

Dare quam accipere

Robert Edge Pine portrays the Earl of Northumberland, patron of the Middlesex Hospital, laying the foundation stone of the new hospital building in Marybone Fields (Figure 5.1). The celebration of an occasion like this is not in itself unusual. However, the style of portrait might at first seem out of kilter with the event being recorded. Unlike the account that appeared in the *Gentleman's Magazine*, this is not a documentary piece.[1] Instead, Pine depicts Northumberland in Grand Manner fashion where this act of charity is recorded with the rhetorical flourish of the Academy.[2] Indeed, Pine was a leading portrait artist of the day and sometimes seen as having the potential to rival Sir Joshua Reynolds.[3] Northumberland's choice of portraitist is not then unusual for his status and rank. It is more his choice of how he was represented laying the foundation stone of the new Middlesex Hospital that is of interest here. Grand Manner portraits usually made reference to the sitter's social and cultural superiority by representing them in classical guise or showing their collections of antiquities and classical architecture. These art works both represent and reinforce the social bonds that were formed through cultural activities. It is the practice of patronage that is important here as artists, architects, musicians and assorted others had to please their gentlemen clients in order to earn a living.

What Northumberland's portrait articulates to me is the question of how medicine and the spaces it inhabited functioned within this established social regime of patronage and obligation. In this way the relationship of the built form of the hospital can be mapped on to the social relationships enshrined in the practice of medicine. There is no doubt that the dominance of the elite over political, social and cultural life was part of the unquestioned fabric of life in the eighteenth century. This status was omnipresent, pervading cultural symbols such as the arts, architecture, taste and modes of behaviour such as speech

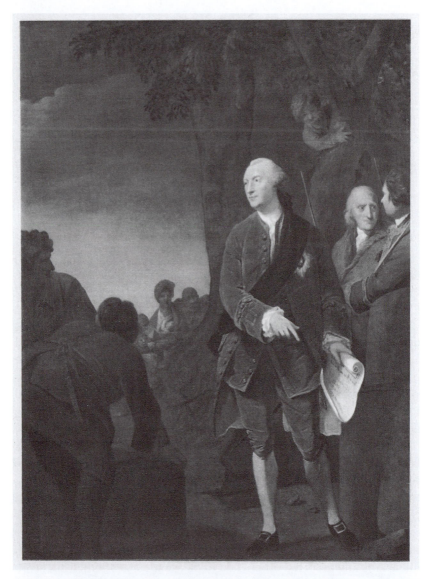

Figure 5.1 *The Earl of Northumberland in Marylebone Fields.* Showing the Earl laying the foundation stone of Middlesex Hospital by Robert Edge Pine, 1775. Reproduced courtesy of UCLH NHS Foundation Trust.

and manners. There was a distinct separation between aristocracy and gentry (here referred to collectively as gentlemen) and the common people. Ideally a 'gentleman' derived his wealth from his landed estates – he owned land, and for the super elite this included land in London. This social hierarchy was important in terms of the elite's engagement

Figure 5.2 *Marylebone Fields, Site of the New Middlesex Hospital* by Hieronymus Grimm, *c*.1750.

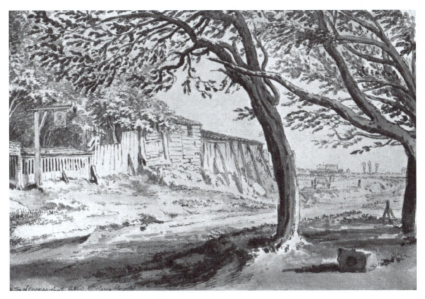

Figure 5.3 *Marylebone Fields, Site of the New Middlesex Hospital* by Hieronymus Grimm, *c*.1750.

with the medical profession. Physicians came near the bottom of the gentleman category and so were under a social obligation to the upper echelons. As such medicine was just another area of cultural practice where the elite enjoyed influence through their patronage. This was to

such an extent that they actually dictated the practice of medicine, as only those physicians who pleased, amused or gave the desired diagnosis retained the patronage of the upper classes.[4] Medicine in its broadest constituency was then under the patronage of the elite just like painting, sculpture, music, literature or indeed architecture. During our period the notion of patronage expands to include not only the interaction of individuals but also the institutionalisation of these kinds of exchanges. What, then, of the spaces of the hospital? In other words how did the architectural expression of the practice of medicine with its complex set of exchanges and obligations confirm or break with the established social and cultural patterns of patronage?

The architecture of the military hospital had made an important contribution to urban topographies across Europe in the late seventeenth century. As we have seen, Les Invalides in Paris complemented the baroque elegance of the city and represented the authority, military prowess and charitable benevolence of Louis XIV.[5] In London the royal patronage of the hospitals at Chelsea and Greenwich resulted in an upgrading of the metropolitan aesthetic.[6] Indeed, it was commonly noted that foreign visitors frequently mistook Chelsea and Greenwich for royal palaces as they were 'more fitted, by their grandeur and extent, for the residences of kings'.[7] Whereas, the ordinariness of the royal residences meant they were misinterpreted by tourists as being hospitals or housing for the poor. In contrast to the royal residences in the capital, the urban palaces of the elite that were built at the turn of the seventeenth century complemented the general improvement of London's building stock. Patterns of building changed in the early eighteenth century. Royal interest in grand projects of any kind faded and the opulence of the aristocratic town residence was largely eclipsed by the rise of the country house. The Georgian terraces of the West End became the norm, reflecting the profit-driven development of the great estates by speculative builders and their aristocratic landlords.[8] As one of the few large-scale buildings to be constructed in London during this period, the hospital became an important instrument in the urban development of the metropolis. The site of the new Middlesex Hospital was on the then borders of the West End on a greenfield site. The institution was as much a part of the spread of the metropolis westwards as any of the surrounding garden squares (Figures 5.2 and 5.3). But the new hospitals that appeared in London were not simply the product of royal or aristocratic beneficence. At the Royal Hospital Greenwich the list of subscribers had been headed by the king, who gave £2,000.[9] Members of the aristocracy chose to lead by example and gave around £500, whilst others pledged sums of between £40 and £200. But as Evelyn remarked, the promise of a gift

did not always materialise, or was at least slow to appear. For 4 July 1695 his diary notes: 'my Lord Godolphin [chief secretary to the Treasury] was the first of the subscribers who paid any money to this noble fabric'.[10] Between 1720 and 1745 no less than five of the major hospitals were founded in London. These institutions did not necessarily enjoy active royal patronage nor did they receive any state support. Instead, they relied on an intricate mix of private patronage from the gentleman class as well as the landed elite, voluntary work, subscription and the initiative of individuals.

The gift

We have already seen how the needs of large numbers of demobbed soldiers and sailors impacted on the demography, architecture and planning of London in the late seventeenth century. The royal hospitals of Chelsea and Greenwich augmented the image of the metropolis in terms of its aesthetic and its renown as a site of charity. Indeed, when Charles II sought funds to build Chelsea he remarked that he had often and 'with great grief observed that many of our loyal subjects, who formerly took up arms for us, our royal father of blessed memory, to resist that torrent of prosperous rebellion, which at last overturned this monarchy, & Church'. Building the hospital was his patriarchal duty to these 'loyal subjects' who were now reduced to 'extreme poverty'.[11]

Alongside the bellicose activities of the state, the changing social conditions across the country, not least in London itself, also impacted on the metropolitan infrastructure. This led to a range of architectural responses to how the needs of the less fortunate could be met. Charity, or benevolence, was encouraged by the more liberal wing of the Church of England. This, together with the eighteenth-century cult of sensibility, encouraged both compassion and a sense of moral or spiritual duty. The result was a shift in attitudes, both religious and secular, towards philanthropy. Indeed philanthropy in all its complexities was seen as an essential part of the definition of Englishness.[12] This was remarked on by the novelist Henry Fielding writing in the *Covent-Garden Journal* in the summer of 1752:

> Charity is, in fact, the very characteristic of this nation at this time. – I believe we may challenge the whole world to parallel the examples which we have of late given of this sensible, this noble, this Christian virtue.[13]

How then does the idea of philanthropy as a national characteristic fit into the kaleidoscopic vision of the hospital and its role in the making of the city outlined so far in this study? Eighteenth-century patronage

and philanthropy can be unravelled using a range of models that consider the moral, economic and social aspects of charitable acts. In terms of the moral aspects of giving, Marcel Mauss' *Essai sur le don* (1923–24)[14] is helpful here. Although it concentrates on gift-giving and exchange in 'primitive' societies, some of the broader issues raised shed light on the notion of charity in London at the beginning of the eighteenth century. First, Mauss considers the obligation to give gifts in terms of the concept that by giving, one shows oneself as generous, and thus as deserving of respect. And we can see why this might appeal to aristocratic patrons like the Earl of Northumberland and members of the royal family who wished to be associated with this kind of charity. It is also important to remember that there were many middle-class benefactors who bought their way into the system by becoming trustees through sustained donations to a particular hospital. The Middlesex Hospital gives us some idea of how these ventures started out, and indeed how they subsequently grew.[15] Only a year after its initial launch in 1745, the Middlesex ran into financial difficulties. The board of governors comprised twenty members who moved for tighter fiscal control of the enterprise together with chasing those who had promised subscriptions to the hospital, amongst whom were members of the nobility. The revised financial rigour also encouraged more subscribers at the rate of 3 guineas per annum. Indeed, status could be gained either by regular payment of the annual subscription or a lump sum donation of 20 guineas, either of which promoted the giver to the status of a governor of the hospital.

Commensurate with the act of giving is the obligation to receive gifts, an action through which respect is shown to the giver, making the receiver also appear to be generous. We see this at work for instance in the royal hospitals. These institutions helped form a new national identity as the country's debt to disabled and retired soldiers and sailors is recognised and returned by the state. The buildings were the physical/built expression of this kind of obligation. The grand gesture of giving is here articulated through grand edifices whose aesthetic evoked the notion of urban palaces. Finally, Mauss identifies the obligation to return the gift, which ensures that the status of giver and receiver is equal. Here the moral purpose of the hospital and its agency in defining the parameters of social life come to the fore. And this is manifest in the Magdelen Hospital where fallen women were 'cleansed' or 'cured' of their sins and then admitted back into society. Through these different aspects of the notion of the gift Mauss argues that giving and receiving are steeped in morality that establishes a moral bond between those who are exchanging gifts. Furthermore, Mauss argues that both objects and actions exchanged as gifts are laden

with power. He asks 'What power resides in the object given that causes its recipient to pay it back?'[16] The gift, then, functions as more than a commodity: it is the notion of the rendering of a service or duty (in Mauss' words *préstation totale*). This is a metonym for every aspect, whether it be economic, political, religious or personal, of the society it represents. And we can see how this operates in respect of charitable giving in London. Equally important for this study is the emphasis that Mauss places on the competitive and strategic functions of gift-giving. Here the social relations of giving (and I would also argue charity) can be understood through the attitude that greater respect is earned by giving more than others (we might say one's competitors). The lists of donors, patrons and trustees of hospitals, which were published frequently throughout the long eighteenth century, are testament to this. The act of giving moves the donor through the social structures inherent in the metropolis, and its power lies in the resulting ability to rearrange the fabric of society. The social bonds formed through the charity offered by these hospitals can be explained by Mauss. The giver does not merely give an object (here we can take this to mean both charity and the hospital building itself) but also part of himself, for the object is indissolubly tied to the giver: 'the objects are never completely separated from the men who exchange them'.[17] Because of this bond between giver and gift, the act of giving creates a social bond with an obligation to reciprocate on the part of the recipient. Here, Mauss could be speaking about London in the eighteenth century:

> First of all, we return, as return we must, to habits of 'aristocratic extravagance'.
>
> As is happening in English-speaking countries and so many other contemporary societies, whether made up of savages or the highly civilized, the rich must come back to considering themselves – freely and also by obligation – as the financial guardians of their fellow citizens. ... We should return to laws of this kind. Then there must be more care for the individual, his life, his health, his education (which is, moreover, a profitable investment), his family, and their future. There must be more good faith, more sensitivity, more generosity in contracts dealing with the hiring of services, the letting of houses, the sale of vital foodstuffs. And it will indeed be necessary to find a way to limit the rewards of speculation and interest.[18]

The broader social consequences of 'the gift' reinforce the heterotopic concept of the hospital as the acts of charity inherent in its setting up

and function resonate across the metropolis. To my mind this is a fundamental aspect of our understanding of how the hospital operated in London. It is at once indexical of the new social and political structures whilst at the same time the commodification of giving (and within this the notion of charity) reflects a consumer-driven capitalistic society. These institutions married together the impetus for and competitive nature of giving, and in the case of smaller institutions at least there was also a requirement for profit. According to Mauss, the 'free' gift that is not returned is a contradiction because it cannot create social ties. The notion of the gift helps us to understand the specifics of the social and economic forces at play in the institutionalisation of patronage and charitable giving. But more broadly we can see how this concept extends to illustrate the relationship of the physical presence of the hospital in the metropolis. The architecture of the building becomes an emblem of the institution, its charitable function and the intricacies of the gift exchange. And the building itself becomes a gift to the metropolitan infrastructure and social relations in the city.

The varying interpretations and meaning of the gift can be played out in the story of two hospitals that were established in the first half of the eighteenth century. Although quite different in purpose, Guy's Hospital and the Foundling Hospital call into question how these institutions impacted on the city's reputation as a site of charity. Moreover, the motives of and reaction to each of the principal benefactors, Thomas Guy and Thomas Coram, respectively, vivify how this 'national characteristic' of charity identified by Fielding was called into question. The 'gift' of the hospital operates not only on the level of the social relations in the metropolis, and it is important to note that these institutions did not always have a positive effect on the social status quo. I also want to consider the contribution the buildings themselves made to the cityscape and urban infrastructure.

Guy's gift

The biographical narrative of Thomas Guy and his charitable works are intricately linked. His background and career provide us with an example of how the new commercial class made their money and developed an interest in good works. He was born c.1644 in the London borough of Southwark. His beginnings were humble: his father was a bargeman and coal dealer who died when Guy was only eight years old. By 1668 Guy had completed his apprenticeship to a city bookseller and soon became wealthy through his business of printing Bibles and through judicious but moderate investments in stocks and shares. His fortune increased exponentially only towards the very end of his life. In 1720, when he was 75 years old, Guy sold his stocks in the now

notorious South Sea Company just before the bubble burst. Unlike many, whose timing was less fortuitous, he made an enormous profit of around £181,000 from the sale.[19] This sudden increase in personal wealth does not appear, however, to have been the prompt for his wish to fund a new hospital. Guy had been involved in a number of charitable projects throughout his life. Initially these were focussed on the town of Tamworth where he was the Member of Parliament (1695–1707), and included an almshouse established in 1688. By 1704 his attention had turned to London and he became a governor and major sponsor of St Thomas' Hospital. Not least he donated £1,000 to fund the building of three new wards in 1707, and his benevolence was publicly acknowledged with a plaque displayed on the principal facade of the hospital.

As a result of his good fortune in selling his South Sea stock at the right time, Guy decided to found his own eponymous institution in 1721. Guy's Hospital was originally established to treat the incurables discharged from St Thomas' Hospital.[20] His fellow governors supported his idea to meet this need and granted a plot of land on the south side of St Thomas Street for 1,000 years at a rent of £30 a year. The original design echoed the monastic beginnings of the hospital and generally followed the enclosed layout of other institutions that had recently been constructed.[21]

The buildings were ranged around a courtyard facing St Thomas Street. The arrangement is described in Guy's will as 'Squares of Building' that were flanked by arcades or open galleries at ground level. The first two quadrangles were completed before Guy died in 1724 (Figure 5.4). Two wings were planned to project from the north front to form the entrance forecourt – a design element already common to great houses as well as hospitals. These wings comprised on the east side a hall officers' residences and offices and on the west side the chapel, matron's house and surgeon's house. Like other hospitals, the design of Guy's lent itself to being built in stages so occupancy could commence almost immediately and costs could be spread out over time. Indeed, the first stage of construction cost almost £19,000, which is in itself is a substantial sum but it appears modest when compared to the £220,000 Guy left the hospital in his will. Generosity of this scale was unusual and the circumstances of the gift are worth noting. Guy had neither children nor any immediate family; however, a number of distant relatives were provided for in his will. As we have seen, he had made his fortune very late in life and had an established track record of laudable but restrained charitable giving before his South Sea windfall. How, then, are we to interpret and understand the gift of Guy's Hospital?

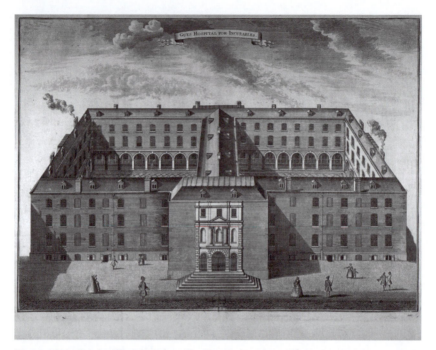

Figure 5.4 *Guy's Hospital* by T. Bowles, after Thomas Dance, *c.*1725. Reproduced courtesy of the Guildhall Library, City of London.

Let's consider this first of all as an example of the Maussian idea of obligation. Certainly the administrators of the hospital worked hard to publicise the generosity of Guy's gift. Such a large donation attracted attention and curiosity and this was helped by the unusual decision to publish Guy's will, which appeared as a fifty-five-page booklet and ran to three editions in the first year after his death.[22] Indeed Guy became a model citizen and his benevolence established important ties and obligations between the individual (albeit deceased) and the state. Guy ensured the longevity of his bequest by stipulating in his will that the structure and administration of the new hospital should be established on a legal basis by an Act of Parliament. Such was the eagerness to acknowledge the gift and absorb the new institution into the growing apparatus of the state, that having been rapidly approved by both houses of Commons and Lords it received the royal assent from King George I only three months after Guy's death.[23] Reciprocation came first in the wording of the Act itself, which praised Guy, stating 'The said charity deserveth to be promoted and encouraged [as it will] greatly tend to the Honour and Good of the publick.' In order to remind the public and any future philanthropist of the magnitude of Guy's gift, the Act also made

provision for a memorial 'for perpetuating the Memory of his said Generous and Charitable intentions'. A fund not exceeding £2,000 set up from Guy's own bequest was put aside for this purpose. In Maussian terms the 'free' gift has been returned in order to create social ties. A sculptural monument to Guy carved in white marble by John Bacon was erected in 1779 at the east end of the chapel. Guy is depicted inviting a stricken figure to the hospital, an image of which appears in low relief in the background. A shield bearing the arms of the hospital with the motto *Dare quam accipere* ('It is better to give than to receive') on a scroll hangs above this narrative scene. The base of the monument has two circular panels with figures in relief and bears the inscription:

> Underneath are deposited the Remains of
> THOMAS GUY,
> Citizen of London, Member of Parliament,
> and the sole Founder of this Hospital in his life time.
> It is peculiar to this beneficent Man to have persevered during a long course
> of prosperous industry, in pouring forth to the wants of Others, all that He had
> earned by labour, or withheld from self-indulgence.
> Warm with Philanthropy,
> and exalted by Charity his Mind expanded
> to those noble affections which grow
> but too rarely from the most elevated pursuits.
> After administring with extensive
> Bounty to the claims of Consanguinity,
> He established this Asylum for that stage
> of Languor and Disease to which the Charities of
> Others had not reached. He
> provided a Retreat for hopeless Insanity, and
> rivalled the endowments of Kings.
> He died the 27th of December, 1724,
> in the 80th Year of his Age.

This is indeed the 'aristocratic extravagance' that makes the rich responsible for the wellbeing of the poor. Moreover, the physical entity of the gift – the hospital building – became inscribed in the urban fabric.

Coram's charity

The Foundling Hospital was the result of the philanthropic endeavours of Thomas Coram. Like Thomas Guy, Coram's beginnings were modest and he also made his own fortune. He was born in Lyme Regis, Dorset and spent much of his early life at sea and in the American colonies where he operated a ship-building business at Taunton, Massachusetts from 1694 to 1705.[24] On his return to Britain he established himself as a successful merchant in London. His links with the Americas endured and in 1732 he became a trustee of James Oglethorpe's Georgia colony. In 1735 he sponsored a colony in Nova Scotia for unemployed artisans.

His commitment to charitable works was greatly encouraged by the plight of young children and infants in London, as large numbers of children were either entirely abandoned or thrown on the mercies of the parish. In London in the early eighteenth century, infant mortality was extremely high and nearly 75 per cent of children died before their fifth birthday. Contagious disease was a major cause; outbreaks of smallpox, typhus, dysentery, measles and influenza were commonplace. However, the gin craze was at least equally as culpable, as in the middle decades of the eighteenth century adults consumed an average of seven gallons per year. This is encapsulated in William Hogarth's engraving *Gin Lane* (Figure 5.5). Here we see the drunkenness, promiscuity and poverty encouraged by the gin craze. The principal focus of the scene is a woman who is clearly a drunkard. We can assume, given the syphilitic sores on her legs, that she has been driven to prostitution by her habit. This is shocking enough, but Hogarth depicts her as she lets her baby slip, apparently unheeded, doubtless to fall to its death. As part of its rich documentary quality, *Gin Lane* narrates the plight of other infants who are either being abandoned or fed gin. Although Hogarth published his social commentary after Coram received his royal charter for his hospital, it nonetheless gives a harrowing view of the situation Coram and others were trying to address.

London was late in providing welfare for orphans and abandoned children in comparison with many other European cities. Some of the earliest and best known examples were to be found in Italy. For instance, in Rome the Conservatorio della Ruota had been founded by Pope Innocent III in the thirteenth century. A century later La Pietà, an orphanage for girls, was founded in Venice. La Pietà was the most successful of the four orphanages in the city, all of which were run as self-funding businesses organised by a board of governors. The financial success of La Pietà was based largely on the musical training given to all the children and the resulting concerts they performed which brought in income. Indeed, the connection between charitable

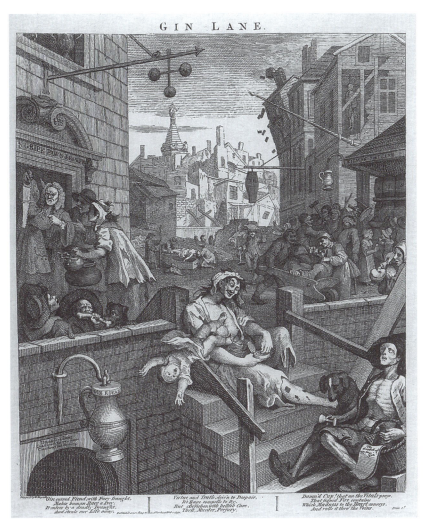

Figure 5.5 *Gin Lane* by William Hogarth, 1751.

institutions and the arts remains live throughout our period. Suffice to note here that the musician and composer George Frideric Handel supported the Foundling Hospital's charitable aims by giving benefit performances of his work in the chapel. Furthermore, in 1740 William Hogarth donated a portrait he had painted of Captain Coram. His gift encouraged many other artists to follow suit and Hogarth used the vast spaces of the hospital to display this work. The reciprocation was the formation of a public place for artists to exhibit their works. In this way the Foundling Hospital became the first gallery of British art.[25] Indeed the gift exchange continued as many of the artists involved in the project were made governors and started to meet at the hospital on an

annual basis. This activity helped prompt the idea of forming an academy for the exhibition of art. The display of art and the performance of music in hospitals were not uncommon events. In this way these institutions operated as early examples of temples to the arts in the metropolis.

Perhaps a more typical form of income was the donations made by aristocratic benefactors to support their illegitimate offspring. The bond between civic duty and charity continued into the fifteenth century as seen, for instance, in the Ospedale degli Innocenti ('Hospital of the Innocents') in Florence (1419). The hospital, which cared for both orphans and foundlings, was funded by the secular Arte della Seta or Silk Guild of Florence, one of the wealthiest in the city, which took its philanthropic duties seriously. It commissioned one of the city's leading architects, Filippo Brunelleschi, who designed an elegant, classically inspired structure with a colonnaded arcade. In both La Pietà and the Innocenti, the anonymity of the parents who chose to abandon their children was assured. And this was expressed in the design of the buildings. La Pietà had alcoves in the back wall of the building where infants could be left; whereas the design of the Innocenti included a basin located at the front portico where infants could be placed for adoption. In 1660 this system became more ingenious as a door with a rotating horizontal wheel was installed, which meant the infant was deposited inside the building without the parent being seen.

Attitudes towards abandoned children were quite different in Britain. Christ's Hospital, founded in 1552, was the only establishment dealing with foundlings as well as legitimate orphans, but by 1676 the illegitimate were no longer accepted. The many abandoned, homeless children living in the streets of London appalled Coram. But he also envisaged that the support given would turn these children into useful members of society. This kind of gift exchange and the obligations on both giver and recipient had already been articulated a few years earlier in 'Fog's Journal', a weekly column that appeared in the *Gentleman's Magazine*:

> Tho' we have many hospitals, yet we have one wanting, I mean an Hospital for Foundlings. Such a one I propose to have erected to receive all Children whose Parents may be inhuman enough to trust to the Care of the Publick and which I would have brought up at the publick Expence, and great care taken that none of them should ever hear of, or know their Parents. From such Hospitals erected in all Parts of Great-Britain, we might soon draw Men to recruit our

Army. As to the Girls, the Officers and soldiers might be obliged to take only them for Wives, by which those Gentlemen would be prevented from contracting any Alliance by Marriage.

Many would be the Advantages to the Nation form such a Salutary Regulation; but my Principal Aim is, that our Officers for the future may be made free from that Regard for their Country or their Relations, which at present so remarkably influences their Conduct, and which may often prove inconsistent with their private Interest. But there are other Advantages; viz.

1. As our Government Is chiefly supported by the Dependence of the People on the King and his Ministers for Pensions and Posts, consequently this Dependence must be the Basis of our Constitution or political Pyramid, and the wider its Base, the firmer it stands. Now as a great Number of Persons must be emply'd in managing these Hospitals, so they will create a great Number of new Posts, all which will be at the sole Disposal of the King's Ministers, and consequently widen the Base of our political Pyramid.[26]

Fog goes on to argue that an officer without kin will be more loyal to the crown compared to one with powerful relations. Also officers with no land cannot become members of the House of Commons but the author thinks ways can be found around this.

Coram's vision focussed slightly less on the obligations of the recipient of his charity to become a model citizen devoted to the rigid social structure discussed by Fog. Instead, his compassion emphasised succour and education so the children could make a useful contribution to society as tradesmen, domestic staff or indeed soldiers, once they became adults. But there continued to be great opposition to the purpose and aims of the hospital. It was believed that the sins of the parents were carried by their children. Thus abandoned infants bore the burden of immorality as not only were their parents unmarried but also poor. Needless to say, social attitudes about the consequences of alleviating the burden of unwanted pregnancies vacillated between the view that this kind of charity was encouraging infidelity, licentiousness and prostitution, and the desire to meet the human need of the defenceless infants. The former opinion is given voice by Thomas Malthus, the English demographer and economist, in his *The Principles of Population*. He argued that foundling hospitals discouraged marriage and therefore population, and that even the best management would be unable to prevent a high mortality, arguing that

> An occasional child murder from false shame is saved at a
> very high price if it can be done only by the sacrifice of some
> of the best and most useful feelings of the human heart in a
> great part of the nation.[27]

Such a violent attack on this form of charity was mercifully only one
point of view.

Coram's publicising of the problem of abandoned infants did
eventually prompt the 'aristocratic extravagance' necessary to begin to
offer a solution. His philanthropic vision struck a chord with the
gentleman and upper classes in London, who readily subscribed to his
non-profit-making enterprise. However, royal support for his scheme
was not initially forthcoming. From the inception of his project in the
early 1720s Coram presented King George I with numerous petitions
for his planned hospital but lacked the support of those who could
lobby the monarch on his behalf. His fortunes changed in 1727 when
George II ascended to the throne. His wife, Queen Caroline, was
sympathetic to the rescue of foundlings. Indeed, she wrote a
posthumously published pamphlet on the Hospital for Foundlings in
Paris. In order to solicit the support of the queen, Coram sought the
help of noble and fashionable women. And it is important to remember
that women of various social ranks continued to play an important role
in the founding and governing of hospitals in our period.

George II signed a Royal Charter on 17 October 1739. The
governors and guardians of this new enterprise met to receive this
charter on 20 November 1739 at Somerset House, and the Foundling
Hospital was established for the 'education and maintenance of
exposed and deserted young children'. The Foundling Hospital was
recognised by the Crown and received support for its work from the
state. In addition, it enjoyed widespread support from the public. The
board of governors comprised a substantial number of prominent
men and women, motivated in part at least by a sense of philanthropy
and a wish to do good. Moreover, although the Foundling was not a
clinical hospital, the children needed medical care. To this end several
prominent physicians including Dr Richard Mead offered their
services pro bono.[28]

The first children were admitted to the Foundling Hospital on
25 March 1741, into a temporary house located in Hatton Garden. These
premises were vacated in 1745 when the west wing of the newly built
hospital was completed on the Bloomsbury site in Lamb's Conduit Fields.
The governors began the search for a permanent site that would house
the purpose-built hospital. A solution was found in the area known as
Bloomsbury Fields, the Earl of Salisbury's estate, lying north of Great

Ormond Street and west of Gray's Inn Lane. It consisted of fifty-six acres of land amidst green fields. The price was £7,000, the earl donating £500 of this to the hospital. In September 1742, the foundation stone of the new hospital was laid. The hospital was designed by Theodore Jacobsen and followed the basic format established by Wren in the royal hospitals at Chelsea and Greenwich. Like Chelsea the material was plain brick.[29] And in common with these earlier examples the building comprised two wings and a chapel, built around an open courtyard. The west wing of the building was finished in October 1745, followed by one on the east side in 1752 to separate the girls from the boys. The new hospital added much to the image of the metropolis through its scale and purpose. It was described as 'the most imposing single monument erected by eighteenth century benevolence' and continued to attract a large number of donations. The Foundling Hospital is then an architectural realisation of the social structures of giving.

The site of the Foundling Hospital made a substantial footprint on the urban landscape (Figure 5.6). The building itself, which nestled in this rural/urban enclave, was not insignificant. It was bounded on its south front, which faced Guilford Street, by a 400-ft long screen-wall. A statue honouring Coram by William Marshall Calder flanked by gates and railings on either side stood in the centre of this range. Two continuous colonnades, each measuring 350 ft, ran north from the east and west ends of this screen wall. They supported the roof of a covered walk, creating the now familiar arrangements of a wide court enclosed on three sides. Each of these covered side-walkways had a central pedimented pavilion (Figure 5.7). The spaces of these walkways were used as workrooms for the children, who made rope to generate income for the hospital. The hospital complex also included a large chapel, built 1747–53. This stood as a separate block on the north side of the site. Following the monastic tradition in design, the ground floor of the chapel was surrounded by an open cloister. In a later building phase galleries were added above the cloisters.

Ruptures

Guy's and Coram's charitable visions resulted in grand architectural projects that made a substantial intervention in the urban topography of London. Indeed, as we shall see, Coram's legacy to the fabrication of a modern metropolis continued well beyond his own lifetime as his institution led the way in the development of Bloomsbury. But here in the second quarter of the eighteenth century we see two men both from modest backgrounds influencing the architectural aesthetic of the metropolis in a way that stands distinct from either the aristocratic owners of the great estates or the monarchy. The imposing edifices of

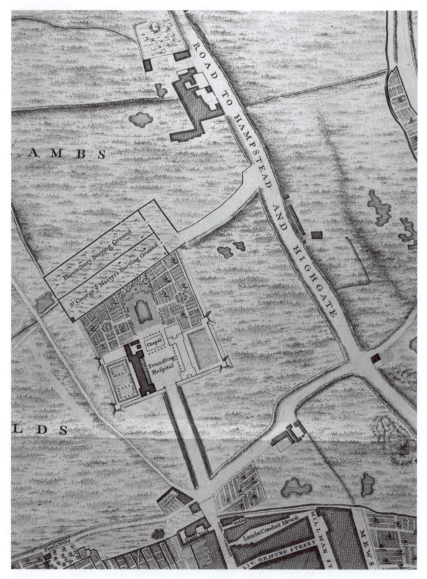

Figure 5.6 Map of the Foundling Hospital, from John Rocque's Map of London, Westminster and Southwark, 1746.

both hospitals were more impressive than any other building project at this time. The landed elite built few urban palaces, increasingly preferring a townhouse in the newly fashionable West End instead. The monarchy lived in modest accommodation, especially when compared to their European counterparts.

The grandeur of the Chelsea and Greenwich hospitals was echoed in Coram's and Guy's projects. But perhaps more importantly,

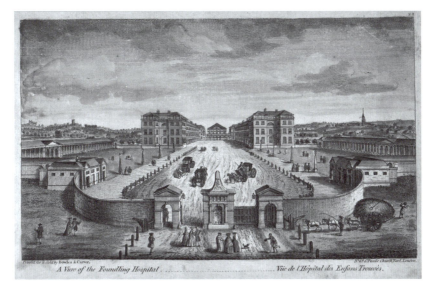

Figure 5.7 *The Foundling Hospital, a Bird's Eye View* by Thomas Bowles after L. P Boitard, 1753.

these buildings also worked to rupture the urban topography to impose a new aesthetic, new circulatory patterns and new social practices both within and without their spaces. Guy and Coram acquired large tracts of land in London. This was a limited commodity and it had been an important factor in determining the status of the elite. The substantial spaces occupied by these new hospitals added a new dimension to the social meaning of land. In addition, the social fabric was ruptured further as each hospital's survival beyond the life of Guy and Coram was assured through the law of mortmain. This law protected the land and buildings of the institution from any question of inheritance tax or change of ownership. But at the same time the use of mortmain for such large charitable concerns, both in terms of finances and real estate, disrupted the established systems of inheritance of land and wealth.[30]

The ruptures precipitated by the charitable giving of both Guy and Coram resonated further than the built fabric of London and traditional patterns of land ownership and inheritance. Their acts of philanthropy and patronage also sent shock waves through the social fabric of metropolitan society. In both cases the institutional structures offered the opportunity for social mobility. The elite participated in the hospital in the role of patron, donor or perhaps governor. But the gentleman classes could also be a part of these bureaucratic systems. A substantial or regular donation bought the status of governor. This gave this new burgeoning social group visibility, status and influence in the running of these institutions. Perhaps more importantly, governors

also had a say in how the spaces of the hospital operated and impacted on the urban fabric.

There were specific criticisms articulated against both Coram and Guy. As we have seen, in Coram's case it was the social relationships that were seen to be endorsed, if not encouraged by his gift that were unacceptable. All the children at the Foundling Hospital were the firstborn of unmarried women, and illegitimacy carried deep stigma, especially for the mother but also for the child.

Criticisms of Guy's benefaction focused on the generosity of his gift. Perhaps surprisingly, the appropriateness of any form of commemoration was publicly called into question. Rather than being an act of charity the gift was seen by Guy's detractors as an example of 'great Misers giving large Donatives to the Poor in their last Wills [which is not] Charity, but as they vainly think, a sort of compounding with God Almighty for giving nothing to the Poor in their Life time'.[31] My purpose here is not to debate the rights and wrongs of this interpretation of Guy. Rather, it is that this interpretation of the 'death-bed philanthropy' of Guy should have been so widely accepted as the predicate for his actions. It is true that Guy lived a comparatively frugal life in relation to the wealth he enjoyed (even before making his vast fortune). And it is also true that his moneylending business activities, geared principally to the landed elite who used their estates to secure their loans, could be interpreted as usury.[32] Yet there is no doubt that Guy's gift met a need and was in tune with the national characteristic of charity so ably articulated by Fielding. The population of London was growing and with it so did the number of chronically sick and incurable people requiring care. And, as we have seen, this charitable act was recognised and lauded by the state. But this kind of urban charity was new, and if Guy's gift is seen in a broader context we can begin to understand why such negative views of it were expressed. We have already noted that the number of hospitals increased exponentially in the opening decades of the eighteenth century and that these ranged from large institutions such as Guys to privately owned specialist hospitals that occupied modest premises. The new practice of establishing and funding hospitals came under fire as being merely an example of the belief that success in commerce did not detract from being a good Christian. The wealth of the newly established Britain was based on trade and there remained a problem reconciling economic behaviour with religious practice. Extremists, such as Bernard Mandeville, denounced charitable acts by claiming 'Pride and Vanity have built more Hospitals than all other Virtues together' in his *Fable of the Bees* (1723).[33] Indeed, his sceptical view of charity might as well have been aimed specifically at Guy: 'If a man

would render himself immortal ... and have all the Acknowledgement, the Honours, and Compliments paid to his Memory, that Vain-Glory herself could wish', there was no more effective way of achieving this than by a donation to a charitable institution.[34] But it is perhaps more likely that both ruptures to the social fabric and the shifts to patterns of land ownership and inheritance through mortmain explain why these charitable institutions became so contentious.

Chapter 6

The complete urbanisation of society

The gradual transformation of the concept of the city into the broader and more complex category of urban space has been a theme running throughout this study. The hospital in our period has been a means of exploring how the city morphed and changed as a social and cultural construct. The spaces that the hospital produced, defined and articulated are essential players in the narrative of the complete urbanisation of London. The fluidity and dynamism of the metropolis is perhaps most evident when we think about its ever-expanding size. This was manifest in a number of ways: the perimeter of the capital was extended; infrastructure and roadways were redefined; and monumental/national spaces and entranceways into the metropolis were created. Moreover, the increasing population led to a shift in demographics and growth in housing stock. And there is no doubt that the hospital made a substantial contribution to these developments. Hospitals moved from being a discrete, distinctive set piece of urban planning to become inscribed in the metropolitan fabric. In this way they were part of the dynamic of both domestic and monumental space. Two hospitals help us to explore this theme across our period. The Foundling Hospital in Bloomsbury exemplifies the engagement with domestic space in a number of ways. First, it operated as a rival of the metropolitan mansions of the elite. And later the hospital became a serious player in the production of townhouses on its estate. St George's Hospital at Hyde Park Corner both complements and continues this story. The institution first occupied a grand London house that had formerly been home to a member of the minor aristocracy. The institution went on to make a substantial contribution to the development of the monumental space on the western edge of London. In this way these hospitals played a part in the transformation of

London from an early modern city into a complex and dynamic urban space.

The work of Henri Lefebvre can help us to unpack and understand the history and evolution of the hospitals in Bloomsbury and at Hyde Park Corner. My interest here is in the space around the hospital and how the building interacts with and influences its surroundings and the metropolitan infrastructure. In this way the Foundling Hospital and St George's become a suitable end point for our consideration of the spaces of the hospital. Not least as in Lefebvre's terms these hospitals become instruments in the total transformation of 'the city' into 'the urban' and through this the 'complete urbanisation of society'.

In *The Production of Space*, Lefebvre presents the idea that there are different kinds of space starting with the straightforward concept of natural space (what we might call 'absolute space') and moving towards more complex notions of spatialities.[1] These are of interest here as Lefebvre argues that spatiality is a social construction as spatial practices and perceptions are the products of society. The link Lefebvre makes to space as a capitalist product is relevant here, as we see in the instances of these hospitals how the social production of space is commanded by a hegemonic class as a tool to reproduce its dominance:

> (Social) space is a (social) product ... the space thus produced also serves as a tool of thought and of action ... in addition to being a means of production it is also a means of control, and hence of domination, of power.[2]

Perhaps most importantly for us, Lefebvre argues that every society – and therefore every mode of production – produces a certain space, its own space.[3] Here in the spaces of the hospital we see across the spectrum of hegemonies. These range from 'upstart' grand buildings that rivalled the urban mansions of the elite to the royal splendour of Hyde Park Corner. More importantly the hegemonies represented here go beyond that of the ruling landed elite to encompass the capitalism of the rising merchant classes. The ruptures that the charitable predicates of the institution of the hospital caused in society have been noted in the previous chapter. And these ruptures in the social fabric are indeed continued in the way the hospital engaged with the architectural and spatial fabric of the city. In this way the Lefebvrian notion of spatialities comes to the fore.

London as absolute space

The perimeters of London grew and the city changed shape so frequently during the long eighteenth century that it was seen as having its own life force. This is typified by Charles Dickens who, commenting on London life in *Master Humphrey's Clock* shortly after the end of our period in 1841, avoids a physical description of the city. Instead the city is an organic, living being with a 'mighty heart'.[4] The actual shape of London did change quite considerably throughout the long eighteenth century. This was especially so in the opening decades of the nineteenth century. The city was described in *The Ambulator* in 1811 as being about seven miles long and between two and four miles deep. London, according to this and most other guides, comprised only the cities of London and Westminster and the borough of Southwark on the south bank of the Thames. By the second decade of the nineteenth century the size and shape of London had grown considerably. And this spread was remarked upon in Percy's *History* as continuing and 'swallowing up every villa in its [London's] environs and making them part of the great capital'.[5] The expanding metropolis now spilled out into the surrounding suburbs, blurring the definition between country and city.

The founding, rebuilding and/or re-siting of some of the major hospitals were also part of this dynamic process as they helped reshape the city, redefining its perimeter and boundaries. We have already seen the ways in which the royal hospitals at Greenwich and Chelsea altered the relationship between the metropolis and the river Thames. As we have seen, the new Bethlem Hospital extended London's reach with its site on the south bank of the river. Equally, after much debate, the Magdalen Hospital was established to the east of the city and then also moved to larger premises on the south bank.

The rapid spread of London westwards meant that new hospitals were required to meet the needs of residents. London's expansion to the west far exceeded the growth of the city in all other directions. It was fuelled by the landed elite who eagerly developed their metropolitan estates. Small private hospitals specialising in aspects of medical practice such as skin disease, opthalmics or childbirth nestled in the new urban labyrinth of the West End, meeting the needs both of the increased population for healthcare and of the middle and upper classes to be involved in charitable acts. The Middlesex Hospital, which was part of this urban expansion, responded to the distinct demographics of the West End as it enjoyed a programme of improvement of its new premises throughout our period.[6]

The narratives of the Foundling Hospital and St George's both intertwine and resonate across our period. Their contrasting geographies and social purpose cohere around questions of country versus city, monumental design and modernity. Using Lefebvre, I want to trace the spatiality of these hospitals and how they become tools to reproduce dominance.

'It is my delight to be / Both in the town and country'

One of the earliest examples of the response to the growth of the West End was the establishment of the institution now known as St George's. Like other hospitals, its beginnings were modest but its history was already being written only a couple of decades after its founding in 1719. Looking back to the hospital's beginnings, an account ordered by the board of governors in 1733 remarked that there had been no hospital to serve 'the poor sick and lame' in the whole of the City of Westminster.[7] In response to this need a group of benefactors led by the banker Henry Hoare, and including William Wogan, Robert Witham and Patrick Cockburn, opened a subscription in 1719 for an infirmary to offer relief to those whom subscribers judged as being 'proper objects of charity'. The institution began as Westminster Public Infirmary in Petty France, in 1720. It was located in an ordinary townhouse that was soon outgrown and quickly relocated to larger premises in Chapel Street in 1724. Once again a combination of good financial fortune and civic need combined to produce another monumental institution in London. In the early 1730s as a result of 'the stocks of the society increasing beyond expectation and the house being still too small as well as old and ruinous', the decision was made to move.[8] Money empowered ambition and a 'large and substantial building, in an airy situation within the City or liberty of Westminster' was sought.[9] In contrast to other hospitals that were founded or moved to improved premises at this time, the governors had no interest in constructing a new building. Instead, they sought an existing structure that would provide an instant solution to the problem of lack of space. This solution to the accommodation problem replicated the domestic scale of the existing premises. The increased need for space was met by simply multiplying the number of units of ordinary townhouses that had comprised the original hospital. As a consequence, the governors' initial preference was for a series of townhouses owned by Mr Green in and about Castle Lane in the lower part of Westminster.[10] But a forceful minority, including the physicians and surgeons attached to the institution and many of the founding subscribers, preferred the architecturally grander Lanesborough House at the higher part of

Westminster (Figure 6.1). Once again the solution was to occupy premises that had originally been intended for domestic use. But clearly Lanesborough House offered the possibility of a much grander edifice that would augment the status of the institution. Moreover, its interior spaces amply accommodated the various medical and bureaucratic needs of the institution. The interchangeability of domestic and institutional space is a hallmark of hospitals at the beginning of our period. Private residences, whether ordinary townhouse or urban mansion, were also places of business and spaces where strangers were received. In this way the spaces of the hospital look back to their monastic, medieval beginnings. But perhaps more importantly for our purposes, the space that Lanesborough House occupied in relation to London adds much to our understanding of the complete urbanisation of society.

Lanesborough House at Hyde Park Corner had been built in 1719 by James Lane, 2nd Viscount Lanesborough, in what was then open fields on the edge of London (Figure 6.2). As such it occupied a liminal space between the country and the city. The building project appears to be a little eccentric as Lanesborough was 70 years old when he moved into the house, where he died only five years later. Indeed the first owner and patron of the building is credited with having the inscription 'It is my delight to be / Both in the town and country' carved over one of the pediments on the main facade of the house.[11] A noble sentiment, but perhaps this also refers to the fact that his townhouse was situated only a mile away in Golden Square.

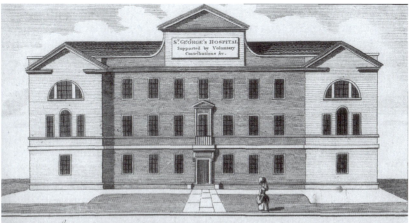

View of ST GEORGE'S HOSPITAL, at Hyde Park Corner.

Figure 6.1 *St George's Hospital* by W. H. Toms, 1756.

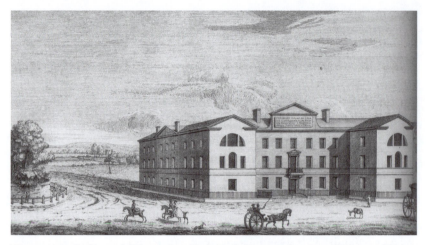

Figure 6.2 *St George's Hospital at Hyde Park Corner* after Isaac Ware, *c.*1736.

Daniel Lysons, a travel writer and author of a substantial commentary on London at the end of the eighteenth century, also gives us some idea of the character of Lanesborough. Lysons remarks that 'His Lordship is recorded by [Alexander] Pope as persevering in his favourite amusement of dancing in spite of the infirmities of old age. "–Sober Lanesborough dancing with the gout".'[12] It seems charitable acts were also part of Lanesborough's modus vivendi in later life, as Lysons also tells us 'The gallery over the cupola at St. Paul's, called now the Golden-gallery, was gilt at his expence a few days before his death.' It is not clear how or why this large semi-urban, semi-rural mansion became available to the governors of the new hospital. We do know Lanesborough's wife, Mary Compton, survived him by 14 years; the couple had no children; and the baronetcy became extinct on Lanesborough's death. But perhaps in this narrative we hear echoes of Thomas Guy and the kind of perceived death-bed charity that caused so much public outcry?[13]

The hospital building itself also caught the eye of Lysons, who commented

> Near Hyde-park-corner, on the south side of the road, stands St. George's Hospital for the reception of sick and lame; a noble foundation, supported by voluntary contributions. It was formerly the seat of James Lane, Viscount Lanesborough, who died there in the year 1724.[14]

The house was considered ideal by its supporters as it offered the benefits of country air. Indeed, the split in opinions over the new premises for the hospital proved irreconcilable and prompted the establishment of two separate institutions. The facility that remained in Castle Street (lower Westminster) became the Westminster Hospital, whilst that which took over Lanesborough House was initially known as the Hospital at Hyde Park Corner. It soon assumed the name of St George's Hospital – a name that is not without significance, as we shall see.

Hyde Park Corner was at this time an entranceway into London and was the meeting point of the westernmost edge of the metropolis and the suburb of Knightsbridge. Indeed, Knightsbridge had the reputation for healthy living on account of its fresh air and ready supply of asses' milk, which was then considered therapeutic.[15] The governors remarked that

> An hospital there, on account of its neighbourhood, could give no offence to any one; the building was large and strong, and many of the rooms were so contrived, as if they had been built for the uses to which they were now to be applied; it was near enough to the town to be supplied with all the

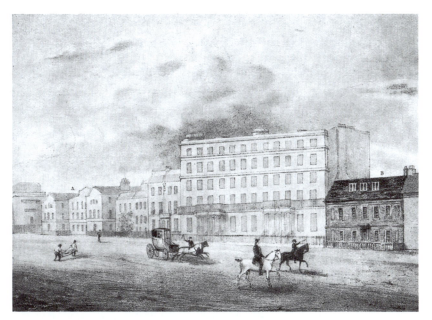

Figure 6.3 *View near Hyde Park Corner,* St George's Hospital appears on the left of the image facing Knightsbridge, R. Osborn Lithograph, 1828.

necessaries that would be wanting, so near that the Governors might attend without inconveniency, and yet far enough for the patients to be given the benefit of country air.[16]

The building itself also met the requirement of the governors in terms of size and aesthetic. It comprised a three-bay, three-storey red brick structure with a central block of almost 40 ft square with side extensions to east and west. The house ran parallel to Knightsbridge and it was separated from the street front by a low brick wall (Figure 6.3). The narrow central entrance door provided a memory trace of the domestic origins of the building. The internal arrangement of the floors lent itself to the various functions of the institution. Numerous offices and the surgery, the floor of which was covered in sail cloth, were located on the entrance level. A monumental wooden staircase led to the first floor. This was a galleried space that provided access only to the two wards: one for men and one for women, each accommodating fifteen patients. The open site meant that the hospital could be extended to meet the needs of the expanding population of this area of London and, by 1744, it had fifteen wards and over 250 patients. My concern here, however, is not so much with the adoption and adaption of a great house for such an institution, although this in itself is remarkable. Rather it is with the liminal space between country and city that the new hospital occupied, and the changing significance of this during our period.

Northern heights

The Foundling Hospital tells a similar story to St George's in terms of its spatial location. In the early eighteenth century Bloomsbury was considered one of the healthiest areas in London. Situated on the northern rim of the city, it afforded fine prospects of the hills of Highgate and Hampstead. There were three noble houses in the area: Southampton House (sometimes referred to as Bedford House as it was home to the Duke of Bedford), Montague House – later to house the first British Museum – and Thanet House (perhaps unsurprisingly, the residence of the Earl of Thanet). The focal point of the area was an upmarket garden square that was first called Southampton Square.[17] Southampton House formed the northern portion of this square and Montague House was situated slightly to the west of it. The other residents of this square were from the elite classes and included the likes of the Earl of Chesterfield, demonstrating that in the earlier part of the century this was an extremely fashionable area of town. The added kudos of an aristocratic townhouse forming part of the layout only enhanced the square's desirability. According to the early

nineteenth-century commentator Rowland Dobie, Southampton House had occupied 'one of the finest situations in Europe for a palace! ... [its] great situation and approach and gardens and view to the country at the back making a country retreat almost unnecessary'.[18] The impressive setting of Southampton House was soon eclipsed by the Foundling Hospital.

As a consequence of the number of imposing aristocratic houses, Bloomsbury had retained a large area of open land. This combined with its location, which was part rural and part urban, made it an ideal site for a hospital, especially for children. In 1740 the patrons and governors of the Foundling Hospital purchased 56 acres of land from the Earl of Salisbury. The patrons had originally wanted to purchase a smaller plot of some 34 acres. The land they did not wish to buy was the least attractive portion of the whole parcel and it would have been made even less desirable had it been detached from the rest of the estate. The original scheme comprised an arrangement not unlike that of the great London houses of the elite that stood in their own grounds, but it was on a larger scale. The building was to form the centrepiece of two enormous fields, and this ensemble became more impressive when the plot size increased by 22 acres. The architect selected was Theodore Jacobsen, of the family long connected with the Steelyard in the City of London. He was a Fellow of the Royal Society and his only other known architectural work was the Haslar Royal Hospital for sick soldiers at Gosport.[19] The general superintendence of the buildings was undertaken by James Horne, who acted as surveyor without fee.[20]

The open site on the northern edge of London was intended as a breathing space between country and city, which was considered essential for the children's well-being. The Earl of Salisbury was sympathetic to the cause and donated £500 of the £7,000 sale price to the hospital. Yet his charitable act was not universally well received, as there were those who would have paid far more for the land. However, Salisbury made it a condition of purchase that the land should not be developed but used solely as a site for the hospital. The establishing of the Foundling Hospital ruptured the cosy aristocratic ambience of this enclave of London. The building outshone its noble neighbours in terms of its extensive site, scale and impressive architectural form. Indeed, Jacobsen's imposing design rivalled the grandeur of the public buildings in London. As such the hegemony of the elite in the realm of the urban aesthetic was challenged.

By 1780, the Foundling Hospital was in a state of financial crisis and the rampant house building trade, which yielded handsome profits, was seen as a solution to the problems. We have already seen

how Lord Burlington had developed the ten acres to the rear of Burlington House, Piccadilly into a new up-market residential area. The growth of London and consequent demand for housing had prompted many aristocratic landowners to lease their London estates to speculative builders. In turn these developers built the terraces of houses and laid out the roads and garden squares that remain a hallmark of the capital. These kinds of enterprise made money for both landlord and developer and demand continued to outstrip supply for property in the West End. The governors wished to follow the example of the elite. But many considered this a shortsighted, if not erroneous assumption. Contemporary voices are heard in two pamphlets: *An Appeal to Governors of the Foundling Hospital and the Probable Consequences of Covering Hospital Lands with Buildings*, London, 1787; and *A Further Appeal to the Governors of the Foundling Hospital and Justification of Their Conduct in Not Having Covered the Hospital Lands with Buildings since the Institution of the Charity*, by John Holliday Esq., London, 1788.[21] It was argued that internal financial reforms would relieve the institution's problems[22] and the likely returns on the proposed speculative venture were called into question as rents were not much higher on lands given over to building rather than farming:

> Within a few hundred yards of the Hospital on the margin of the New Road, I have been well informed that the builder has contracted for three or four acres (to be extended to many more acres, if sub-contractors can be found) at a price which produces to the land-owner the *immense* sum of *twenty shillings per* acre annually.[23]

This was in fact little more than would be received from land used for agricultural purposes.[24] But objectors to the scheme felt that the land surrounding the Hospital would, if developed, produce a better market than this, perhaps partly because of the attraction of being sited near such an institution.[25]

Moreover, it was felt that the turning over of the fields to housing would severely impinge on the health of the children.

> that by building round the Hospital, it will *by degrees*, bring it into the town, and thus render it much less healthy for the purposes for which it was erected.[26]

More children – it was argued – might die from the effects of living in a polluted atmosphere than from any financial stringency during a period when administrative reforms were implemented.[27] It must be

remembered that one of the motives for building the hospital in the middle of fields was the benefit of the fresh air to the occupants.

The decision by the Foundling Hospital to develop its land had a direct impact on its surroundings and prompted the transformation of Bloomsbury into an urban area. Up until the final decades of the eighteenth century, Bloomsbury had held out against the tide of development by speculative builders. Indeed it remained a kind of rural oasis comprising aristocratic mansions and their grounds, and of course the magnificent new Foundling Hospital itself. As late as 1787 the Duke of Bedford was still adamant that no building work should take place to the north of Bloomsbury House as this would spoil his unbroken view to the north of the Highgate and Hampstead hills.[28] The duke's attitude had changed by 1795 as, to enable its estate development, the Foundling Estate needed to make roads opening into the duke's private road. At the same time the duke decided to begin to develop the area north of Bedford House known as the Long Fields. The fields were to be landscaped and turned into an ornamental pleasure ground and the roads bordering the fields to east and west be developed. These became Southampton and Bedford Terraces, respectively. But the idea of retaining some kind of open space covenant was added to the agreement with the developers of this land:

> the area or lawn extending northwards from the garden belonging to Bedford House to the estate of Lord Southampton, and also extending from the said intended [Southampton Terrace] westward to another intended terrace to be called Bedford terrace shall not be let or granted for building, nor shall the said Duke of Bedford ... permit any buildings to be erected thereon, except ornamental or other buildings for use of the ground, during the said term of ninety-nine years.[29]

In 1798 the duke entered into an agreement with the speculative developer James Burton, who was working on the Foundling Estate for the development of his estate. Burton produced a plan in 1800 'for the intended improvements on the estate of his Grace the Duke of Bedford'. But the gravitational pull of the fashionable new West End was such that the Duke of Bedford vacated Bedford House in the same year, giving it over to demolition.[30]

As a result of the decision to develop its land the Foundling Hospital eclipsed the hegemony of the elite in Bloomsbury. Decisions that impacted substantially on the urban infrastructure and

demographic of the area were led by a charitable institution rather than an aristocratic landowner. These were arrived at through intricate negotiations with developers. Indeed the rate system of housing was an effective instrument in determining the social makeup of an area, and this was germane to the process of speculative development. Moreover, we see how the Lefebvrian notion of space as a capitalist product comes to the fore here. Middle-class speculative builders intent on profit developed the land of the elite, and we find this again in the case of the Foundling Hospital. And it is evident that the institution's governors saw capitalistic ventures as the means of securing the future.

The significant role this speculative venture played in the development of the Foundling Estate is commented on by S. P. Cockerell, surveyor to the hospital, in his *Report to the Governors* of 1807:

> Mr Burton [the speculative developer] is the one individual (under the attention of the five gentlemen who compose the original building committee, and I hope I may add my own labours and exertions) to whom your excellent charity is indebted for the improvement which has taken place on the estate. All that has been done by the other builders is comparatively trifling and insignificant. Without such a man, possessed of very considerable talents, unwearied industry, and a capital of his own, the extraordinary success of the improvement of the Foundling Estate could not have taken place.
>
> Mr Burton has expended above £400,000 for the permanent benefit of the property of the Hospital. Great part of this he has done personally; the other part he has done by builders engaged under him, whom he has supplied with money and materials, secured by mortgage, or receiving his compensation in what are called carcass or profit rents, and has still heavy mortgages subsisting on unfinished buildings.
>
> [...]
>
> The measure of letting a large portion of land to such a man as Mr Burton was, I conceive, founded in prudence, and is justified by the event. ... he watched over and was interested in the success of the whole, was ready to come forward (and he has done it in a great variety of instances, and in some with considerable inconvenience and loss)

with money and personal assistance, to relieve and help forward those builders who were unable to proceed in their contracts; and in some instances he has been obliged to resume the undertaking, and to complete himself what had been weakly and imperfectly proceeded in.[31]

How far Burton's motives were driven by charity or profit remains enigmatic.

Infrastructures

The development of the Foundling Hospital's land offers a microcosm of the urbanisation of London, and of the way the country was absorbed into the city. Bloomsbury morphed from being a kind of semi-rural environment into an urbanised space with a complex array of social networks and built infrastructures. In addition, the turning over of fields to housing pushed out the perimeter of London, causing the city to change shape and size once again. The disappearance of these liminal green urban spaces did not go unnoticed by observers: 'Have we all not observed, that building about this metropolis is like wildfire; it catches from field to field, and goes on *ad infinitum*?'[32]

As with all developments, access was key. Indeed the hospital had enjoyed a deliberate splendid isolation as late as 1788, when a commentator remarked

> [There is] No road or way to west or north out of the land into the Metropolis or to the New Road. The late noble owner had no carriageway into it except from the Great North Road.[33]

The Foundling Hospital's money making scheme was greatly assisted by the laying out of the New Road, which forged an east–west axis across the northern edge of the metropolis.[34] This helped make the area more accessible, especially when coupled with the evolving road network to the west of the institution. Indeed, the term 'speculate to accumulate' might well have been invented for the capitalist ventures of Coram's charity. In 1795 the Foundling Hospital had to grant land worth £1,800 to the Duke of Bedford in return for the four openings into his estate in order to facilitate their own development. And the hospital remained a key player in the urbanisation of the area long enough for the tide of capitalism to turn. Twelve years later the Skinners' Company, which owned adjacent land to the east of the institution, negotiated two openings into the Foundling Estate at a cost of £1,500.[35]

Demographic trends

The Lefebvrian concept of space as a product of capitalism and as a social instrument combine in London's housing stock in our period. The system of rating houses according to their size and materials was codified into law and thus building practice in the opening years of the eighteenth century.[36] The Building Act of 1774 completely standardised the speculative building trade. It consolidated all of the preceding legislation that had attempted to ensure quality and safety in construction. At first glance this can be seen as part of the bureaucracy and arithmetic that was fast becoming a hallmark of modern urban life. But the impact this legislation also had on the aesthetic, topography and demography of London was enormous. The act established four 'rates' of houses based on the criteria of ground rent and floor area. These ranged from first rate – the most impressive, to fourth rate – the most modest. Aesthetic uniformity across all rates and across all new developments in London was assured by the mandatory use of brick or stone, width of street frontage and fenestration. The position of a house on an estate plan was determined by rate: with first-rate dwellings occupying space on the principal thoroughfares, squares, streets and lanes and so on working down the scale. Indeed, even the social space within was in the Act's purview, as the sizes of rooms and layouts were standardised according to rate. The choice of rate or rates formed part of the contractual arrangement between landowner and developer. As such rates operated as a means of controlling the demography of individual estates. The rates of houses reflected the intended class of their occupants and made it possible to proscribe the social makeup of urban areas. Leases granted to speculative developers specified the rates of houses to be built so the landed elite controlled the demographic trends in any new build area. But rates were also a means of policing boundaries. In the case of the Foundling Hospital the forces of land ownership, infrastructure and speculative development combined to produce a distinctive social space that challenged the hegemonies at play in the metropolis. Negotiations about access across estates not only involved cash payments or the gifting of land (as we have seen above) but also involved agreement about the rates of houses to be built on either side of an estate's boundaries. We see this for instance in the Foundling's access agreement with the Skinners' Company in 1807, which also included a clause that neither landowner would build houses of less than second rate for at least 200 ft north and south of their common boundary.[37]

Rates were also used as a means of establishing hierarchies within an estate. And the Foundling Hospital was no exception, as

Cockerell's plan intended 'That there shall be such principal features of attraction in the Plan as shall not be too great for a due proportion of the whole but yet sufficient to draw Adventurers to the Subordinate parts'.

The plan for the development of the land made the hospital the focal point. The square to the east was to be made up of only first-rate houses and enclosed gardens, the square to the west should have first- and second-rate houses on the principal streets. The areas to the north and south of the hospital should contain third-rate housing whereas the easternmost edge of the estate (Grays Inn Road) should be fourth rate with a view to converting them to shops once the area became more frequented. In this way the system of rate housing and the class values and identities it encapsulated worked to produce a socialised urban space. Here the spaces of the hospital operated not just a means of social production; they also expressed control and power. And we see a charitable institution rather than an aristocratic landowner as a predicate for these substantial changes in the urban topography.

New spaces for a new society

The system of rate houses offered 'invisible' hegemonies, but there are other more tangible forms of spatial practice through which power can be represented. The imposing presence of the Foundling Hospital resulted from the integration of classically inspired form and modern function. How was this aesthetic used in other instances and what kind of values were expressed? Here we can turn our attention back to St George's and a very different moment in the urban development of London. The internal layout of the hospital and the urban location the institution inhabited narrate important shifts in the social production of space. Despite its convenience and adaptability, by the early 1800s Lanesborough House was slipping into disrepair. New premises were now essential, not least as the number of local residents who relied on St George's had increased exponentially. The elite inhabited their grand townhouses and enjoyed medical treatment at home. But their swelled numbers were matched by the lower ranks employed as servants, shopkeepers and so on. Their medical needs were met by the charity of St George's. The social makeup of the West End was commented upon by Lord Byron in his satirical epic poem *Don Juan* when his eponymous hero arrives in London:

> In the great world – which, being interpreted,
> Meaneth the West or worst end of a city,
> And about twice two thousand people bred

By no means to be very wise or witty,
But to sit up while others lie in bed,
And look down on the Universe with pity –
Juan, as an inveterate patrician,
Was well receiv'd by persons of condition.[38]

The rapid expansion of the West End of London had impacted not only on extra demands placed on St George's Hospital but also on the nature of its geographical location. The new design responded to these changes and to developments in approaches to hospital design.

In the final quarter of the eighteenth century, there had been some discussion as to whether the design of a hospital made any contribution to the cure and wellbeing of patients. As a consequence several publications appeared that proposed changes to the plan, layout and management of hospitals. Amongst the most influential were John Aitken, whose *Thoughts on Hospitals* was published in 1771. This trend was not unique to Britain as the Frenchman Jacques Tenon published his *Memoires sur les hopitaux de Paris*. Tenon also visited a number of hospitals in Britain.[39] He was especially impressed by Plymouth Hospital which he visited with Charles Augustin Coulomb in 1787. Their visit was part of a French royal commission that had been set up to look at foreign hospitals. Despite the metropolitan glamour of some of the large London institutions, Plymouth was especially praised as the commission reported that 'in not one of the hospitals of France and England, we would say in the whole of Europe, except Plymouth hospital are the individual buildings destined to receive patients as well ventilated and as completely isolated'.[40]

By the early nineteenth century hospital design was becoming part of a national discourse about institutional architecture. It was becoming an accepted norm that different environments affected the treatment and recovery rates of patients. Ventilation was key as it aided recovery by minimising the accumulation of foul air. It became accepted that wards should have cross ventilation and that patients with contagious diseases should be segregated. St George's could not have been in a better location to respond to these new ideas. The old Lanesborough House at Hyde Park Corner was demolished to make way for a new 350-bed hospital. Building began in 1827 to a design by the architect William Wilkins, and the new hospital was completed by 1844 (Figure 6.4). The new design was an emblem of the kind of liberalism that was beginning to manifest itself in the design of institutional structures such as prisons and hospitals. Modern ideas about surveillance, as evident in Jeremy Bentham's panopticon, were beginning to influence this kind of architecture. In addition new

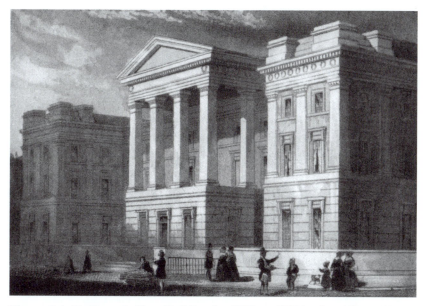

Figure 6.4 *St George's New Building by William Wilkins* by Albert Henry Payne, *c.*1836.

technologies including plumbing, drainage and sewerage were beginning to make hospitals into machines for the care and cure of patients.[41] The bureaucratic arithmetic that had been implicit in the institutions that developed in the eighteenth century now explicitly informed the plan and aesthetic of new-build hospitals.

Wilkins chose the H plan for the design of the new St George's. This was half way between the familiar block plan and the new pavilion-style layout that emphasised ventilation. Indeed this was acknowledged as important, as each of the principal wards was well fenestrated. The hybridity of the design expressed the tradition of charity and modernity of medical innovation inherent in the form and function of the new premises. The governors had requested

> a substantial Building of a size adequate to the increasing wants of this part of Town – providing in the most effectual way for the accommodation and comforts of the sick poor, and affording every desirable facility for the prosecution of scientific research.[42]

London and the nation

The interaction of the spaces of the hospital with the urban fabric continued with the development of Hyde Park Corner in the opening decades of the nineteenth century. Here the new St George's Hospital made a significant contribution to the creation of a monumental space that celebrated the nation. Hyde Park Corner had comprised a set of tollgates that defined the western perimeter of the metropolis. And we have seen how Lanesborough House occupied a liminal space that mediated the relationship between London and the country (Figure 6.2). The tollgates further articulated this ambiguity as they had formed a kind of barrier as well as an entrance into London (Figure 6.5). Indeed, the perception from the outside was that the perimeter of the city was pierced only by the arterial roads which connected the capital to the rest of the country. These 'macadamized sloughs'[43] terminated in London and underlined the city's importance to the country as a whole. They created a physical and metaphorical bond between urban and rural.

Just as the arterial roads pierced the perimeter of London from the outside, so the expanding city pressed on its own boundaries from within. The opening up of Hyde Park Corner and the removal of the tollgates enabled the further spread of London, as Percy's *History* noted: 'London continued spreading during the long war and peace has given new impetus to this except in the west where Hyde Park Corner is a stopping block.'[44]

The rebuilding of St George's, which coincides with the development of the monumental urban space, stands distinct from the

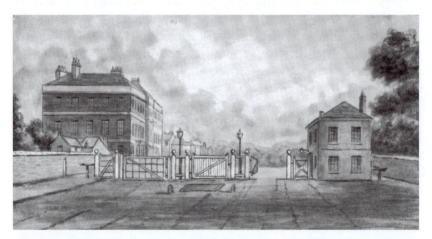

Figure 6.5 *The Turnpike at Hyde Park Corner.* Contemporary watercolour, anon., 1786.

Figure 6.6 The thoroughfare of Piccadilly detail seen in Wallis' Plan of London and Westminster, 1802.

other examples discussed in this study. In the other cases the hospital worked to create symbolic space and produced a new social environment. Here there were other factors at play so the hospital was only part of the process of the social production of space. It is more of an interaction between the spaces of the metropolis and of the hospital. St George's was caught up in a larger expression of hegemonies within this reconfigured space.

Hyde Park Corner stood to the north of the new royal residence of Buckingham Palace and at the western terminus of Piccadilly. It was the junction between the Great West Road, one of the arterial roads into London, which connected the city of Bath with Piccadilly and the West End. Piccadilly was one of the few straight roads in London that had been laid out in the seventeenth century and the Wallis Plan of London shows how Piccadilly cut a line east–west though the West End (Figure 6.6). Charles C. B. Dickens (son of the author Charles Dickens) described it thus: 'Piccadilly, the great thoroughfare leading from the Haymarket and Regent-street westward

to Hyde Park-corner, is the nearest approach to the Parisian boulevard of which London can boast.'[45] And his remarks are not without significance.

In the early nineteenth century both the western and eastern termini of Piccadilly were transformed into monumental spaces. This was part of the upgrading of the urban fabric of London known as the Metropolitan Improvements.[46] These comprised new roads, terraces of housing, shops and public buildings. The star piece of planning was the laying out of Regent Street in 1812, which carved an axis through the centre of the new West End. It formed a link between the then royal residence, Carlton House Palace, at its southern end and the Regent's Park at its north. Piccadilly Circus was laid out in 1819 to join the eastern end of Piccadilly with Regent Street. This was part of a larger plan to link the new spaces, including Waterloo Place and the planned King's Square (later Trafalgar Square), which had been formed as part of the upgrading of the urban fabric through the Metropolitan Improvements. All of this was intended to upgrade the urban aesthetic of London and to rival the Paris of Napoleon I. This sequence of monumental spaces spread west along Piccadilly to Hyde Park Corner. As such the site of St George's Hospital grew in importance for the urban infrastructure during the latter half of our period. Instead of the established pattern of the hospital redefining the spaces of the city, here the city redefined the spaces of the hospital. Different kinds of hegemonic spaces combined to form Hyde Park Corner, as it became a fusion of capitalism, social class and national identity (Figure 6.7).

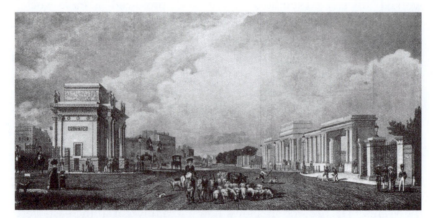

Figure 6.7 *Hyde Park Corner* by A. Bairnes after Schnebellie, 1828.

Symbolic space

The impetus for the transformation of Hyde Park Corner into a symbolic space came from two political events.[47] The victories over the French at Trafalgar (1805) and Waterloo (1815) gave impetus to the general need for a monumental space in London. In addition, Apsley House, which stood at Hyde Park Corner having the address Number 1 London, was bought by the nation for the Duke of Wellington in gratitude for his role at Waterloo. The second shift in the meaning of the space was prompted by King George IV's move westwards from Carlton House to Buckingham Palace in the mid-1820s. This meant a new royal residence on the outer limit of the city and introduced another axial route through London. The Mall ran from Trafalgar Square along St James' Park to the main entrance of Buckingham Palace, which was to be defined by Nash's Marble Arch. The palace was situated in the middle of two parks: St James' to the front and Green Park at the back. Hyde Park, just to the north of Green Park, also formed part of the large expanse of parkland in this area of London. These three green urban spaces joined at Hyde Park Corner. Hyde Park Corner was, then, a loaded space in terms of authority and empire and its development in the opening decades of the nineteenth century is partly about how this kind of representational space is made to connect with the new metropolitan environment. There is no other area of London that was the focus of so much public monumental building activity. A new royal residence, two triumphal archways/entrances, and the urban palace of a national hero were all perched on the edge of the metropolis. Although St George's was a completely separate project it was intimately bound up in this potent piece of urban planning. It both benefitted from and contributed to this symbolic space. Its function as a charitable institution could only enhance the environs of the new royal palace. Moreover, its grand architectural design made a substantial contribution to the splendour of Hyde Park Corner. In return its own status and aesthetic impact was augmented by its neighbouring buildings, their residents and the hospital's geographical location. And finally we must not forget the name: St George's. It is not clear when or why this name was chosen, but it works to complete the symbolic meaning of this national urban space.

Transformations

Despite the grand designs of Adam, Soane and others, in 1823, when the lease on the tollgates at Hyde Park Corner was about to expire, it was Decimus Burton who was brought in to redesign the area. The intention was to provide the monarch with a ceremonial route into this

royal park from his new palace. This comprised two arches: Hyde Park Screen (1822) and the Arch at Constitution Hill (1825–28). These were placed at a 90-degree angle to the junction of Piccadilly and Knightsbridge, the road coming in from the west in contradiction to the long-planned construction of an entrance to London across Piccadilly. This meant that the traditional gateway into London from the west at the end of Piccadilly was now irreversibly turned 90 degrees to align with Buckingham Palace. Both arches were to be decorated with sculptural celebrations of Britain's military victories, intellectual prowess and the Hanoverian dynasty.[48]

Those entering London from the west would now pass between the two gateways instead of proceeding through at least one of them. This is shown in a photograph of a painting by James Holland showing Hyde Park Corner in 1827 (Figure 6.8).[49] The missed opportunity of a gateway into London is picked up by the *Mechanics' Magazine* in 1827, which stated that the reorientation of the area had robbed London of its best opportunity for a monumental entrance to the city.[50] Most importantly for us, the new St George's Hospital also became part of this composition. It too was turned 90 degrees to face the new square rather than front the south side of Knightsbridge. As such it created a visual and stopping block for Piccadilly as it ran west. It also become part of the symbolic space of Hyde Park Corner.

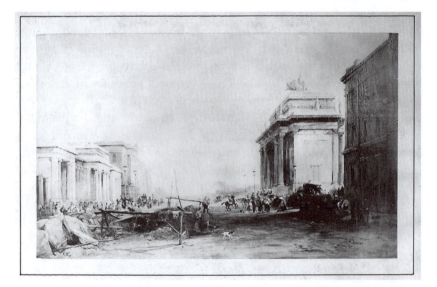

Figure 6.8 *Hyde Park Corner.* Photograph of an oil painting by James Holland, 1827.

For England and St George

If we think about the socially produced space of Hyde Park Corner as a means of reinforcing the idea of nation and nationhood our consideration of the spaces of the hospital has come full circle. This in turn underscores the value of urban space and society as it evolves from the idea of the city. At the beginning of our period London is seen as merely a city, an agglomeration of discrete areas and buildings that lacks much spatial coherence. The construction of the royal hospitals in Chelsea and then Greenwich are the beginnings of the production of more complex spatialities that endorse the hegemonic value of a coherent national identity. The hospital remains part of this process and its spaces, both interior and exterior, allow us to journey through the social, political and moral cultures of London in the long eighteenth century.

Notes

Preface

1　The history of these institutions has been traced by social historians, historians of medicine and those interested in the architectural design of the buildings that housed them. See for instance: Roy Porter, *Disease, Medicine and Society in England, 1550–1860*, London: Macmillan, 1987; Joan Lane, *A Social History of Medicine: Health, Healing and Disease in England, 1750–1950*, London: Routledge, 2001; and Christopher Lawrence, *Medicine in the Making of Modern Britain, 1700–1920*, London: Routledge, 1994. There have been a number of surveys of nationwide trends in hospital architecture and design, including H. Richardson (ed.), *English Hospitals 1660–1948: A Survey of Their Architecture and Design*, London: RCHME, 1998; and Christine Stevenson, *Medicine and Magnificence*, New Haven, CT and London: Yale University Press, 2000.

1　The spaces of the hospital

1　One of the most prolific writers around this topic is Roy Porter. Of his many publications see for instance: *Disease, Medicine and Society in England, 1550–1860*, London: Macmillan, 1987. See also: Joan Lane, *A Social History of Medicine: Health, Healing and Disease in England, 1750–1950*, London: Routledge, 2001; and Christopher Lawrence, *Medicine in the Making of Modern Britain, 1700–1920*, London: Routledge, 1994.

2　There have been a number of surveys of nationwide trends in hospital architecture and design. See for instance: H. Richardson (ed.), *English Hospitals 1660–1948: A Survey of Their Architecture and Design*, London: RCHME, 1998; and Christine Stevenson, *Medicine and Magnificence*, New Haven, CT and London: Yale University Press, 2000.

3　Michel Foucault, *The Archaeology of Knowledge and the Discourse on Language*, trans. A. M. Sheridan Smith, New York: Pantheon, 1972, p. 17.

4　S. and R. Percy, *The Percy Histories of Interesting Memories of the Rise, Progress and Presentation of All the Capitals of Europe*, 3 vols, London, 1823.

5　*The Gentleman's Magazine*, vol. XVIII, 18 May 1748, p. 198.

6　Ibid.

7　Rotha Mary Clay, *Medieval Hospitals in England*, London: Methuen, 1909, p. xvii ff.

8　Westminster Hospital Minute Books, entry for April 1716.

9 As quoted by John Langdon-Davis, *Westminster Hospital*, London: John Murray, 1952, ch. 1, p. 13.

10 Ibid.

11 See for instance the well-known discussion of this question by Jürgen Habermas, 'The Public Sphere', *New German Critique*, no. 3, Autumn 1974, pp. 49–55.

12 This question is discussed at length, albeit mostly with reference to regional examples, by Kathleen Wilson, 'Urban Culture and Political Activism in Hanoverian England: The Example of the Voluntary Hospital', in Eckhart Hellmuth (ed.), *The Transformation of Political Culture: England and Germany in the Late Eighteenth Century*, Oxford: Oxford University Press for the German Historical Institute London, 1990, pp. 165–184.

13 See for instance the accounts of the development of the medical school at Charing Cross Hospital in William Hunter, *Historical Account of Charing Cross Hospital and Medical School*, London: John Murray, 1914.

2 Heterotopias

1 See M. Foucault, 'Des Espaces Autres,' translated by J. Miskowiec as 'Of Other Spaces', *Diacritics*, Spring 1986, pp. 22–27.

2 Ibid., p. 24.

3 Ibid., p. 25.

4 For a discussion of Sir Christopher Wren's plans for Whitehall see for instance H. Colvin, J. Mordaunt Crook, K. Downes and John Newman, *The History of the King's Works*, vol. V, London: HMSO, 1977; and K. Downes, 'Wren and Whitehall in 1664', *Burlington Magazine*, vol. 113, no. 815, February 1971, pp. 89–93.

5 For a discussion of the development of London in the late seventeenth and early eighteenth centuries see E. McKellar, *The Birth of Modern London*, Manchester: Manchester University Press, 1995; and J. Summerson, *Georgian London*, Harmondsworth: Peregrine, 1949, and subsequent editions.

6 Wren's plans for St Paul's Cathedral are discussed inter alia in D. Keene, A. Burns and A. Saint, *St. Paul's: The Cathedral Church of London 604–2004*, New Haven, CT and London: Yale Center for British Art, 2004; J. Campbell, *Building St Paul's*, London: Thames and Hudson, 2008. For a discussion of Wren's City churches see P. Jeffery, *City Churches of Sir Christopher Wren*, Hambledon: Continuum, 1996.

7 Tudor and Stuart poor law is widely discussed. See for instance N. Fellows, *Disorder and Rebellion in Tudor England*, London: Hodder and Stoughton, 2001; Steve Hindle, *The State and Social Change in Early Modern England*, Basingstoke: Macmillan, 2000; John F. Pound, *Poverty and Vagrancy in Tudor England*, London: Longman, 1971; and Paul Slack, *From Reformation to Improvement: Public Welfare in Early Modern England*, Oxford: Clarendon Press, 1998.

8 13 and 14 Car. II, c12.

9 Examples of these council warrants can be found in George Hutt (ed.), *Papers Illustrative of the Origin and Early History of the Royal Hospital at Chelsea*, London: HMSO, 1872.

10 Foucault, 'Of Other Spaces', pp. 25, 27.

11 William Bray (ed.), *Diary and Private Correspondence of John Evelyn*, London: Henry Colburn, 1850, vol. II, p. 166.

12 Ibid., p. 163.

13 For a general discussion of the architecture see 'The Royal Hospital: Architectural Description', *Survey of London*: volume 11: Chelsea, part IV: The Royal Hospital, London: BT Batsford, 1927, pp. 12–29.

14 As quoted in J. Bold, P. Guillery and D. Kendall, *Greenwich: An Architectural History of the Royal Hospital for Seamen and the Queen's House*, New Haven, CT and London: Yale University Press, 2000.

15 Bray, *Diary and Private Correspondence of John Evelyn*, p. 342.

16 Warrant dated 25 October 1694; National Archives, ADM, 75/15.

17 The Queen's House was commissioned by Queen Anne of Denmark, wife of James I. Work stopped in 1618 when Anne became ill: she died the following year. It was thatched over at first-floor level and building only restarted when James' son Charles I gave Greenwich to his queen, Henrietta Maria, daughter of Henri IV of France, in 1629.

18 Colen Campbell, *Vitruvius Britannicus* appeared in three editions: 1715, 1717 and 1725.

19 Bray, *Diary and Private Correspondence of John Evelyn*, p. 344.

20 A. T. Bolton and H. D. Hendry (eds), *The Wren Society*, vol. VI, 1929 and vol. VIII, 1931; K. Downes, *Hawksmoor*, London, 1979, pp. 83–98; K. Downes, *Wren*, London, 1982, pp. 107–110; and Bold *et al.*, *Greenwich: An Architectural History*.

21 It is referred to as the 'side-step' plan as it was to be situated to the east of the 'avenue' that Queen Mary wished to keep open between the Queen's House and the river. Two annotated plans in the collection at All Soul's, Oxford AS, IV.19 and V.28; also see Wren Society, VI, pl. 10, lower, and VIII, pl. 21. See also A. Geraghty, *The Architectural Drawings of Sir Christopher Wren at All Souls College, Oxford: A Complete Catalogue (Reinterpreting Classicism: Culture, Reaction and Appropriation)*, London: Lund Humphries, 2007.

22 In 1705 the first disabled or retired seamen came to live in the hospital, the numbers rising to about 3,000 by 1814, after which they declined sharply, mainly because of the end of the Napoleonic wars, so much so that it closed in 1869.

23 National Archives, ADM, 67/1.

24 National Archives, ADM, 67/1, pp. 4–5.

25 For a discussion of Wren's visions for London see H. Colvin, J. Mordaunt Crook, K. Downes and John Newman, *The History of the King's Works*, vol. V, London: HMSO, 1977; Wren Society, 20 vols, 1924–43 (reprints of many of the original manuscript sources and most of Wren's drawings); and Stephen Wren, *Parentalia*

or Memoirs of the Family of the Wrens, 1750, reprinted by Gregg Press, 1965. For Wren's plans for the City churches see P. Jeffery, *City Churches of Sir Christopher Wren*, Hambledon: Continuum, 1996.

26 For a fuller discussion of the relationship between the Royal Naval Hospital and Les Invalides see John Bold, 'Comparable Institutions: The Royal Hospital for Seamen and the Hôtel des Invalides', Essays in Architectural History Presented to John Newman. *Architectural History*, vol. xliv (2001), pp. 136–144.

27 See for instance Carlo Fontana's *Il Tempio Vaticano e sua Origine*, Rome, 1694; and Le Jeune de Boullencourt's *Description Generale de l'Hostel Royale des Invalides*, Paris, 1683.

28 H. M. Colvin (ed.), *The History of the King's Works: 1660–1782*, London: HMSO, 1976.

29 For a discussion of the development of the great estates in London see J. Summerson, *Georgian London*, Harmondsworth: Peregrine, 1949; and D. Arnold, *Rural Urbanism: London Landscapes in the Early Nineteenth Century*, Manchester: Manchester University Press, 2005.

30 S. E. Rasmussen, *London: The Unique City*, Cambridge, MA: MIT Press, 1982, pp. 198–200.

31 Pierre Nora, *Lieux de mémoire*, 4 vols, Chicago: University of Chicago Press, 1999–2010.

3 There is no place like home

1 For debates concerning the ideas of luxury and magnificence in relation to Bethlem see Christine Stevenson, 'Robert Hooke's Bethlem', *Journal of the Society of Architectural Historians*, vol. 55, no. 3, 1996, pp. 254–275; and C. Stevenson, *Medicine and Magnificence: British Hospital and Asylum Architecture, 1660–1815*, New Haven, CT and London: Yale University Press, 2000. The intentions of the governors of Bethlem in regard to the design of the new premises in Moorfields is discussed by Jonathan Andrews in *The History of Bethlem Hospital*, London: Routledge, 1997.

2 For views of country houses see J. Kypp and J. Knyff, *Nouveau Théâtre de la Grande Bretagne*, 1715; and for visual lexicon of classically inspired buildings across Britain see Colen Campbell, *Vitruvius Britannicus*, 3 vols, 1715, 1717 and 1725. Prints of country houses are discussed by Tim Clayton in 'Publishing Houses: Prints of Country Seats', in D. Arnold, *The Georgian Country House*, Stroud: Sutton, 1998 (3rd edition published by the History Press, 2012), pp. 43–60.

3 Jacques Derrida, 'Point de folie – maintenant l'architecture', trans. Kate Linker, *AA Files*, no. 12, Summer 1986, pp. 65–75.

4 The speed with which the new building was erected was largely achieved through shoddy building practices, and less than 100 years later there were serious structural problems. The site was in fact the old city ditch – in effect a rubbish pit. This, together with the fact that no proper foundations were dug,

led to severe subsidence. In addition the bricks were poor quality, the structural timbers were too short and the walls were not properly tied. On top of all of this the roof was too heavy. By the beginning of the nineteenth century the floors were uneven and the French-inspired north facade enjoyed a wave akin to the Baroque fantasies Bernini had produced for Paris, but this was by accident rather than design. Moreover, the intense development of this area of London robbed the hospital of the light and air that had once seemed so beneficial.

5 The historiography of the link between the Tuileries and Hooke's design for Bethlem Hospital is fully discussed in C. Stevenson, 'Robert Hooke's Bethlem', *Journal of the Society of Architectural Historians*, vol. 55, no. 3, 1996, pp. 254–275.

6 For a discussion of the transformation of Bethlem and other royal hospitals located in the City of London into metropolitan institutions, see Sir Lionel Denny, 'The Royal Hospitals of the City of London', *Annals Royal College of Surgeons England*, vol. 52, no. 2, 1973, pp. 86–101.

7 For a discussion of Wren's City churches see P. Jeffery, *City Churches of Sir Christopher Wren*, Hambledon: Continuum, 1996.

8 Wren's plans for St Paul's Cathedral are discussed inter alia in D. Keene, A. Burns and A. Saint, *St. Paul's: The Cathedral Church of London 604–2004*, New Haven, CT and London: Yale Center for British Art, 2004; J. Campbell, *Building St Paul's*, London: Thames and Hudson, 2008.

9 The new premises designed by James Lewis were situated in St George's Fields across the river Thames in the borough of Lambeth. The structure was later adapted to house the Imperial War Museum. Demolition of Hooke's 'palace' began in 1807 before the move to Lambeth.

10 For a fuller discussion of this point see C. Stevenson, 'Robert Hooke's Bethlem', *Journal of the Society of Architectural Historians*, vol. 55, no. 3, 1996, p. 261.

11 This point is discussed in a broader context by Sandra Cavallo, 'The Motivations of Benefactors: An Overview of the Approaches to Charity', in Jonathan Barry and Colin Jones (eds), *Medicine and Charity before the Welfare State*, London: Routledge, 1991, pp. 46–62.

12 For a fuller discussion of these debates see C. Stevenson, 'Robert Hooke's Bethlem', *Journal of the Society of Architectural Historians*, vol. 55, no. 3, 1996.

13 On this point see Colin Rowe, 'James Stirling: A Highly Personalized and Very Disjointed Memoire', in Peter Arnell and Ted Bickford (eds), *James Stirling: Building and Projects*, New York: Rizzoli, 1984, pp. 22–23.

14 E. P. Thompson, *The Poverty of Theory, or An Orrery of Errors* (1978), new edition London: Merlin Press, 1995, pp. 230–231.

15 On this point see Jonathan Barry and Colin Jones (eds), *Medicine and Charity Before the Welfare State*, London: Routledge, 1991, in particular the essay by Jonathan Andrews, 'Hardly a Hospital, but a Charity for Pauper Lunatics?', pp. 63–81.

16 I discuss this in more detail in Chapter 5: *Dare Quam Accipere*.

17 For a discussion of this see my essays, 'The Country House and Its Publics' and 'The Illusion of Grandeur', in D. Arnold, *The Georgian Country House*, Stroud: Sutton, 1998 (3rd edition published by the History Press, 2012), pp. 20–42 and 100–116.

18 The dubious and abusive practices that went on in Bethlem are discussed by Patricia H. Allderidge, 'Historical Notes on the Bethlem Royal Hospital and the Maudsley Hospital', *Bulletin New York Academy of Medecine*, vol. 47, no. 12, 1971, pp. 1537–1546. Allderidge also makes the point that the fact Bethlem became such a focus for criticism masked the (often worse) practices at private institutions.

19 The paintings were produced by Hogarth between 1732 and 1733. These were engraved and published as prints in 1735. Many subsequent editions of the prints have followed. The paintings are now in the collection of the Sir John Soane's Museum, London.

20 See Chapter 4, 'Matter out of Place'.

21 For a fuller discussion of *The Rake's Progress* see inter alia Ronald Paulson, *Hogarth's Graphic Works*, 3rd edn, London: The Print Room, 1989; or Ronald Paulson, *Hogarth*, 3 vols, New Brunswick, NJ: Rutgers University Press; Cambridge: Lutterworth Press, 1991–93.

22 Scene 2 of *The Rake's Progress* is sometimes interpreted as the interior of Burlington House on Piccadilly, home of Richard Boyle, third Earl of Burlington. Burlington and his coterie were frequently lampooned by Hogarth for their 'foreign' taste in architecture and the arts.

23 On this point see Mark Girouard, *Life in the English Country House*, New Haven, CT and London: Yale University Press, 1978. The social use of space is also alluded to in C. Stevenson, *Medicine and Magnificence: British Hospital and Asylum Architecture, 1660–1815*, New Haven, CT and London: Yale University Press, 2000, p. 38.

24 Christine Stevenson contests that originally men were housed on the ground floor and women on the first but this arrangement did not last long. See C. Stevenson, 'Robert Hooke's Bethlem', *Journal of the Society of Architectural Historians*, vol. 55, no. 3, 1996, p. 261.

25 Henri Lefebvre, *Rhythmanalysis: Space, Time and Everyday Life*, London: Continuum International, 2004, Introduction, p. xii.

26 On this point see John E. Crowley, *The Invention of Comfort: Sensibilities and Design in Early Modern Britain and Early America*, Baltimore, MD: Johns Hopkins University Press, 2003.

27 *An Account of the Occasion and Manner of Erecting the Hospital at Lanesborough House, near Hyde-Park-Corner*. Published by order of the General Board of Governors, London, 1734.

28 See J. Blomfield, *St George's 1733–1933*, London: Medici Society, 1933.

29 See Chapter 5 for further discussion of this point.

30 See 'The London Lock Hospital and its Founder', *British Medical Journal*, 6 July 1946, p. 16.

31 Ibid.

32 George Dance the Younger was assisted by John Soane in the production of these designs. A number of drawings relating to the competition and the actual project are held in the Sir John Soane's Museum. The relationship between Dance and Soane and the design of St Luke's are discussed in Pierre de la Ruffinière du Prey, *John Soane, the Making of an Architect*, Chicago and London: University of Chicago Press, 1982, see chapter 3 in particular; and Jill Lever, *Catalogue of the Drawings of George Dance the Younger (1741–1825) and of George Dance the Elder (1695–1768) from the Collection of the Sir John Soane's Museum*, London: Soane Museum, 2003, see catalogue entries for St Luke's Hospital for Lunatics.

33 Sigmund Freud, *The Uncanny* (1919), corrected reprint in *Sigmund Freud, Art and Literature*, Pelican Freud Library, vol. 14, ed. Albert Dickson, Harmondsworth: Penguin, 1985, pp. 335–376, this quotation at p. 339.

4 Matter out of place

1 See for instance Roy Porter, *Disease, Medicine and Society in England, 1550–1860*, London: Macmillan, 1987; and Joan Lane, *A Social History of Medicine: Health, Healing and Disease in England, 1750–1950*, London: Routledge, 2001; and for a critique of the social history of medicine, see 'Medical History without Medicine: Editorial', *Journal of the History of Medicine*, January 1980, pp. 5–7.

2 Mary Douglas [1966], *Purity and Danger: An Analysis of Concepts of Pollution and Taboo*, London: Routledge, 2002, p. 35.

3 Michel Foucault (trans. Alan Sheridan, 1977) *Discipline and Punish: The Birth of the Prison*, New York: Vintage, 1995, ch. 3, pp. 195–228.

4 Ibid., p. 198.

5 Ibid., p. 197.

6 Ibid., p. 199.

7 On this point see Donna T. Andrew, *Philanthropy and Police: London Charity in the Eighteenth Century*, Princeton, NJ: Princeton University Press, 1989, p. 8; and Stanley Nash, 'Prostitution and Charity: The Magdalen Hospital, a Case Study', *Journal of Social History*, vol. 17, no. 4, Summer 1984, pp. 617–628.

8 For a discussion of the broad issues of public health in our period see A. Carmichael, 'History of Public Health and Sanitation in the West before 1700', and J. Duffy, 'A History of Public Health and Sanitation in the West since 1700', in K. Kiple (ed.), *The Cambridge World History of Human Disease*, Cambridge and New York: Cambridge University Press, 1993, pp. 192–206.

9 For a fuller discussion of the leper hospitals in medieval and early modern London see Marjorie B. Honeybourne, 'The Leper Hospitals of the London Area', *Transactions of the London and Middlesex Archaeological Society*, XXI, part 1, 1963, pp. 3–61.

10 The term 'lock' is probably derived from the old French word for rags: *loques*. This refers to the dressings applied to the sores of lepers. In its Anglophone

version the word lock also implies that these kinds of hospital 'locked' away those who had contagious diseases or who were impure.

11 Norman Moore, *History of St Bartholomew's Hospital*, London, 1918, pp. 371–372 and 376.

12 John D. Thompson and Grace Goldin, *The Hospital: A Social and Architectural History*, New Haven, CT and London: Yale University Press, 1975, p. 84.

13 On this point see M. A. Waugh, 'Attitudes of Hospitals in London to Venereal Disease in the Eighteenth and Nineteenth Centuries', *British Journal of Venereal Diseases*, April 1971, pp. 146–150.

14 See 'The London Lock Hospital and Its Founder', *British Medical Journal*, 6 July 1946, p. 16.

15 For a fuller discussion of lock hospitals see J. Bettley, 'Post Voluptatem Misericordia: The Rise and Fall of the London Lock Hospitals', *London Journal*, vol. 10, no. 2, Winter 1984, pp. 167–175. See also Donna Andrew, 'Two Medical Charities in Eighteenth-century London', in Jonathan Barry and Colin Jones (eds), *Medicine and Charity Before the Welfare State*, London: Routledge, 1991, pp. 89–94.

16 See 'The London Lock Hospital and Its Founder', *British Medical Journal*, 6 July 1946, p. 16.

17 Donna Andrew, 'Two Medical Charities in Eighteenth-century London', in Jonathan Barry and Colin Jones (eds), *Medicine and Charity Before the Welfare State*, London: Routledge, 1991, p. 91.

18 Ibid.

19 E. M. Butler (ed.), *A Regency Visitor: The English Tour of Prince Puckler-Muskau Described in His Letters 1826–1828*, London: Collins, 1957. Letter dated 8 April 1827, p. 189.

20 For a fuller discussion of *A Harlot's Progress* see inter alia Ronald Paulson, *Hogarth's Graphic Works*, 3rd revised edition, London: The Print Room, 1989; or Ronald Paulson, *Hogarth*, 3 vols, New Brunswick, NJ: Rutgers University Press/ Cambridge: Lutterworth Press, 1991–93.

21 The failure of Gonson's initiative was predictable. What is of interest here is the developing rhetoric used in describing prostitution and the social processes that evolved around the will to address the problem and the impact on the built fabric of the city.

22 For a fuller discussion of *A Harlot's Progress* see inter alia Ronald Paulson, *Hogarth's Graphic Works*, 3rd edn, London: The Print Room; or Ronald Paulson, *Hogarth*, 3 vols, New Brunswick, NJ: Rutgers University Press/Cambridge: Lutterworth Press, 1991–93.

23 For a fuller discussion of Bridewell as a prison and charitable institution see L. W. Cowie, 'Bridewell', *History Today*, vol. 23, no. 5, 1973; and E. G. O'Donoghue, *Bridewell Hospital, Palace, Prison, Schools*, in particular vol. 2: *From the Death of Elizabeth to Modern Times*, London: John Lane, 1923–29.

24 J. Boswell, *Boswell's London Journal 1762–1763*, ed. F. Pottie, London: Heinemann, 1951, p. 230.

25 For a fuller discussion see Donna T. Andrew, *Philanthropy and Police: London Charity in the Eighteenth Century*, Princeton, NJ: Princeton University Press, 1989; and Alysa Levene, *Childcare, Health and Mortality at the London Foundling Hospital, 1741–1800: 'Left to the Mercy of the World'*, Manchester: Manchester University Press, 2007.

26 *The Rambler*, no. 107, Tuesday 26 March 1751.

27 R. Dingley quoted in William Dodd, *An Account of the Rise, Progress, and Present State of the Magdalen Hospital, for the Reception of Penitent Prostitutes*, London: W. Faden, 1770, p. 2. This was sold at the Magdalen Hospital. The volume runs to some 370 pages but the pagination is not always consistent. Where possible the location of the passage referred to is given.

28 On this point see Sarah Lloyd, 'Pleasure's Golden Bait: Prostitution, Poverty and the Magdalen Hospital in 18th Century London', *History Workshop Journal*, no. 41, 1996, pp. 50–70.

29 This was founded in 1756 with a view to increasing naval recruitment, especially of orphaned teenagers. By 1763, the Society had recruited over 10,000 men and boys. In 1772 the Society was incorporated in an Act of Parliament.

30 For a history of the Magdalen Hospital see S. B. D. Pearce, *An Ideal in the Working: The Story of the Magdalen Hospital, 1758–1958*, London: Magdalen Hospital, 1958. Also Miles Ogborn, *Spaces of Modernity: London's Geographies 1680–1780*, New York and London: Guilford Press, 1998.

31 Dodd, *An Account of the Rise, Progress, and Present State of the Magdalen Hospital*, pp. iv, 411 and endmatter.

32 G. F. Cruchley, *Cruchley's London in 1865: A Handbook for Strangers Showing How to Get There, Where to Go and What to Look At*, London, 1865.

33 Dodd, *An Account of the Rise, Progress, and Present State of the Magdalen Hospital*, pp. 405, 407.

34 On this point see Lloyd, 'Pleasure's Golden Bait'; and Nash, 'Prostitution and Charity'.

35 Dodd, *An Account of the Rise, Progress, and Present State of the Magdalen Hospital*.

36 Ibid., Preface, unpaginated.

37 Although to the post-structuralist ear this word is loaded with significance, I have resisted the temptation to analyse too deeply the term 'object' when used in this context.

38 Dodd, *An Account of the Rise, Progress, and Present State of the Magdalen Hospital*, p. 407.

39 Ibid., p. 78.

40 Ibid., p. 206.

41 Ibid., p. 226.

42 Ibid., pp. 326–327.

43 See chapter 3, 'No Place Like Home', particularly page 57, and for a more general discussion of the notion of comfort see John E. Crowley, *The Invention of Comfort: Sensibilities and Design in Early Modern Britain and Early America*, Baltimore, MD: Johns Hopkins University Press, 2003.

44 Dodd, *An Account of the Rise, Progress, and Present State of the Magdalen Hospital*, p. 393.

45 The idea of gift exchange and obligation is discussed more fully in Chapter 5. The Magdalens were not allowed to return to the hospital if they fell back into their old ways.

46 Douglas, *Purity and Danger*.

5 The gift: *dare quam accipere*

1 This event was described quite differently in the *Gentleman's Magazine*, 15 May 1755.

2 The Royal Academy of Arts was founded in 1768 by King George III. Sir Joshua Reynolds was its first president. See Sidney C. Hutchinson, *The History of the Royal Academy, 1768–1968*, New York: Taplinger Publishing, 1968.

3 Pine lacks a biographical study but for information on his practice see Christopher Wright, Catherine May Gordon and Mary Peskett Smith, *British and Irish paintings in Public Collections: An Index of British and Irish Oil Paintings by Artists Born Before 1870 in Public and Institutional Collections in the United Kingdom and Ireland*, New Haven, CT and London: Yale University Press, 2006, p. 643; and entry by Lionel Cust in the *Dictionary of National Biography*, vol. 45, 1895–1900, p. 313.

4 See Nicholas D. Jewson, 'Medical Knowledge and the Patronage System in 18th Century England', *Sociology*, vol. 8, 1974, pp. 369–383.

5 Les Invalides was 'publicised' to promote this image of Louis XIV. See for instance Le Jeune de Boulencourt, *Description Générale de l'Hôtel Royal des Invalides Etabli par Louis Le Grand ... Avec les Plans, Profils et Elevations de Ses Faces, Coupes et Appartements*, Paris, 1683.

6 For a discussion of the relationship of the architecture of Chelsea to palace design see M. Binney, 'The Royal Hospital, Chelsea', *Country Life*, vol. clxxvii (1982), pp. 1474–1477, 1582–1585, 1476 ff.

7 Thomas Faulkner, *An Historical and Descriptive Account of the Royal Hospital at Chelsea*, London, 1805, p. 46.

8 On this point see John Summerson, *Georgian London*, Harmondsworth: Peregrine, 1949; and D. Arnold, *Rural Urbanism: London Landscapes in the Early Nineteenth Century*, Manchester: Manchester University Press, 2006.

9 William Bray (ed.), *Diary and Private Correspondence of John Evelyn*, London: Henry Colburn, 1850, vol. II, pp. 344–345.

10 Ibid.

11 These sentiments were expressed in a letter written by Charles II in October 1684 to William Sancroft, archbishop of Canterbury and the king's former

chaplain. It is quoted in G. Hutt (ed.), *Papers Illustrative of the Origin and Early History of the Royal Hospital at Chelsea, London*, London: Eyre & Spottiswoode, 1872, p. 14.

12 For a discussion of the idea of philanthropy in relation to the provincial hospital see Roy Porter, 'The Gift Relation: Philanthropy and Provincial Hospitals in Eighteenth-century England', in L. Granshaw and Roy Porter (eds), *The Hospital in History*, London: Routledge, 1989, pp. 149–178.

13 *The Works of Henry Fielding*, ed. James P. Browne, London 1871, vol. X, pp. 78–79, entry from *The Covent Garden Journal*, no. 44, 2 June 1752.

14 The first English translation appeared in 1954 but I am using Marcel Mauss, *The Gift: The Form and Reason for Exchange in Archaic Societies*, trans. W. D. Halls, foreword by Mary Douglas, London: Routledge, 1990.

15 For a history of the development of Middlesex Hospital see Hilary St George Saunders, *The Middlesex Hospital, 1745–1948*, London: Max Parrish, 1949.

16 Mauss, *The Gift*, p. 3.

17 Ibid., p. 31.

18 Ibid., pp. 68–9.

19 On this point see David Owen, *English Philanthropy, 1660–1960*, Cambridge, MA: Harvard University Press, 1965, p. 45.

20 A full account of the setting up of the hospital and its subsequent development can be found in Samuel Wilks and G. T. Bettany, *A Biographical History of Guy's Hospital*, London: Ward Lock, Bowden & Co., 1892.

21 For a full discussion of the design of Guy's Hospital see *Survey of London: Volume 22: Bankside (the parishes of St Saviour and Christchurch Southwark)*, Sir Howard Roberts and Walter H. Godfrey (eds), 1950, ch. 10, 'Guy's Hospital', pp. 36–42.

22 *The Last Will and Testament of Thomas Guy, Esq., Late of Lambard Street, Bookseller: Containing an Account of His Publick and Private Benefactions*, London: Printed for J. Peele, at Locke's Head in Paternoster Row, 1725.

23 'An Act Incorporating the Executors of the Last Will and Testament of Thomas Guy, late of the City of London, Esq. Deceased, and others, in Order to better Management and Disposition of the Charities given by his said Last Will', Act II George I cap. Xii. This received royal assent on 24 March 1725.

24 Coram's early life is discussed in Hamilton Andrews Hill, *Thomas Coram in Boston and Taunton*, Worcester, MA: C. Hamilton, 1892.

25 For a discussion of the Foundling Hospital as an early form of artistic academy see Rhian Harris and Robin Simon (eds), *Enlightened Self-interest: The Foundling Hospital and Hogarth*, London: Draig Press, 1997; and Benedict Nicholson, *Treasures of the Foundling Hospital*, Oxford: Clarendon Press, 1972.

26 This appeared in the weekly essay 'Fog's Journal', no. 312, 26 October, entitled 'The Political Projector', in *The Gentleman's Magazine*, vol. 4, October 1734, p. 558.

27 Thomas Malthus, *The Principles of Population*, (1798) 5th edn, London: John Murray, vol. I, 1817, p. 434.

28 For a full discussion see Ruth McClure, *The London Foundling Hospital in the Eighteenth Century*, New Haven, CT and London: Yale University Press, 1981; and R. H. Nicols and F. A. Wray, *The History of the Foundling Hospital*, Oxford: Oxford University Press, 1935.

29 See C. R. Ashbee (ed.), *Survey of London, King's Cross Neighbourhood*, vol. xxiv, part iv, London, 1952.

30 The Mortmain Act, 1736:9 (George II c. 36) confirmed the increasing willingness on the part of English courts to recognise as 'charitable' a significantly broader range of organisations both religious and secular. On this point see Gareth Jones, *History of the Law of Charity, 1532–1827*, Cambridge: Cambridge University Press, 1969, pp. 257–259.

31 John Dunton, *An Essay on Death-Bed-Charity, Exemplify'd in the Life of Mr Thomas Guy, Late Bookseller in Lombard Street, Madam Jane Nicholas, Late of St Albans. And Mr Francis Bancroft, Late of London Draper; Proving that Great Misers Giving Large Donatives to the Poor in Their Last Wills Is No Charity*, London, 1728, p. 2.

32 This is discussed in H. C. Cameron, *Mr Guy's Hospital, 1726–1948*, London: Longmans, Green & Co., 1954.

33 Bernard Mandeville, *The Fable of the Bees: Or. Private Vices. Publick Benefits* [1723–9], 2 vols, ed. F. B. Kaye, Oxford: Clarendon Press, 1924, see especially 'Essay on Charity and Charity Schools', vol. I, pp. 254 ff.

34 Ibid., p. 265.

6 The complete urbanisation of society

1 Henri Lefebvre, *The Production of Space*, Oxford: Blackwell, 1991.

2 Ibid., p. 26.

3 Ibid., p. 59.

4 Charles Dickens, *Master Humphrey's Clock*, ed. Peter Mudford, London: Everyman, 1997, p. 67.

5 S. and R. Percy, *The Percy History and Interesting Memorial on the Rise, Progress and Present State of All the Capitals of Europe*, 3 vols, London: T. Boys, 1823, vol. III, p. 353.

6 See the discussion in Chapter 5.

7 *An Account of the Occasion and Manner of Erecting the Hospital at Lanesborough House, near Hyde-Park-Corner*, published by order of the General Board of Governors, London, 1734.

8 Ibid., p. 1.

9 Ibid.

10 Ibid.

11 J. Blomfield, *St George's 1733–1933*, London: Medici Society, 1933, p. 5.

12 Daniel Lysons, *The Environs of London: Volume 2: County of Middlesex*, 1795, pp. 162–184. In his footnote 284 Lysons gives the reference to this remark as Pope's *Moral Essays*, I. 1. 230.

13 Lysons, *The Environs of London*, pp. 162–184. In his footnote 285 Lysons gives the reference to this remark as *British Journal*, 8 August 1724.

14 Ibid.

15 J. Blomfield, *St George's 1733–1933*, London: Medici Society, 1933, p. 5.

16 *An Account of the Occasion and Manner of Erecting the Hospital at Lanesborough House*, p. 2.

17 This was later renamed Bloomsbury Square. See D. Arnold, *Rural Urbanism: London Landscapes in the Early Nineteenth Century*, Manchester: Manchester University Press, 2006.

18 R. Dobie, *The History of the United Parishes of St Giles in the Fields and St George's Bloomsbury*, London, 1829, p. 138.

19 This hospital was seen as exemplary in terms of its design by both British and foreign commentators. See for instance: Jacques Tenon (trans. Jacques Carré), *Journal d'Observations sur les Principaux Hôpitaux et sur Quelques Prisons d'Angleterre*, (1787), Clermont-Ferrand: Presses Universitaires Blaise Pascal, 1992.

20 See R. H. Nichols and F. A. Wray, *History of the Foundling Hospital*, London: Oxford University Press, 1935.

21 Henceforth *An Appeal* and *A Further Appeal*, respectively.

22 *An Appeal*, p. 24.

23 Ibid., p. 23.

24 *A Further Appeal*, p. 12.

25 *An Appeal*, p. 24.

26 Ibid., p. 32.

27 Ibid., pp. 22–23.

28 Donald J. Olsen, *Town Planning in London*, New Haven, CT and London: Yale University Press, 1982, p. 48.

29 Building contract between the Bedford Estate and James Burton and Henry Scrimshaw for Southampton Terrace, 6 July 1795, as quoted in Olsen, *Town Planning in London*, p. 50.

30 The Duke of Bedford paid Burton £5,000 to demolish Bedford House and allowed him to sell the materials. Instead, he preferred to live on another peer's estate in a leasehold house in the West End.

31 This was a pamphlet written by S. P. Cockerell addressed 'To the Governors and Guardians of the Hospital for the Maintenance and Education of Exposed and Deserted Young Children: Assembled in General Court', London, 1807. Henceforth Report 1807.

32 *A Further Appeal*, p. 7.

33 Ibid., p. 6.

34 This is discussed in J. Summerson, *Georgian London*, Harmondsworth: Peregrine, 1949, pp. 21–22 and 173 esp.

35 Foundling Hospital Building Committee Minutes 3, pp 84–85.

36 The rate system of housing classification is discussed in J. Summerson, *Georgian London*, Harmondsworth: Peregrine, 1949, pp. 125–126.

37 Foundling Hospital Building Committee Minutes 3, pp. 84–85.

38 Lord George Byron, *Don Juan*, Canto XI (XLV), London, 1823.

39 Tenon, *Journal d'Observations*.

40 On this point see Harriett Richardson (ed.), *English Hospitals 1660–1948: A Survey of Their Architecture and Design*, London: Royal Commission on the Historical Monuments of England, 1998, p. 81.

41 On this point see Rhodri Windsor Liscombe, *William Wilkins 1778–1839*, Cambridge: Cambridge University Press, 1980, p. 151 ff.

42 Final Report of the Building Committee, 18 April 1834.

43 E. M. Butler (ed.) *A Regency Visitor: The English Tour of Prince Puckler-Muskau Described in his Letters 1826–1828*, London: Collins, 1957. Letter dated 8 April 1827, p. 190.

44 S. and R. Percy, *The Percy History*, p. 353.

45 Charles C. B. Dickens, entry for 'Piccadilly' in *Dickens's Dictionary of London* (1888), Devon: Old House Books (facsimile edn), 1993.

46 I discuss the Metropolitan Improvements at length in *Rural Urbanism: London Landscapes in the Early Nineteenth Century*, Manchester: Manchester University Press, 2006.

47 There had been earlier attempts to redesign the space from the mid-eighteenth century onwards. These are discussed in Dorothy Stroud, 'Hyde Park Corner', *Architectural Review*, vol. 106, 1949, pp. 379–397; and Arnold, *Rural Urbanism*, ch. 5, pp. 123–150.

48 For a fuller discussion of the development of Hyde Park Corner see Arnold, *Rural Urbanism*.

49 At least two prints of this image exist. One is held at the Victoria and Albert Museum and is not accessioned in box no. A149a. A version of the photograph is also held in a private collection.

50 *Mechanics' Magazine*, vol. VIII, no. 208, 18 August 1827, p. 65 ff.

Bibliography

Contemporary sources
Books, pamphlets and maps

An Act for incorporating the executors of the last will and testament of Thomas Guy in order to the better management and disposition of the charities given by his said last will, London: John Baskett (etc.) 1724.

Anon., *An account of the rise, progress, and state of the London Infirmary, supported by charitable and voluntary subscription, for the relief of sick and diseased manufacturers, seamen in the merchant service, and their wives and children, from the first institution on the 3d of November, 1740, to the 12th of May 1742, inclusive*, London: 1742.

Anon., *A conspectus of prescriptions in medicine, surgery, and midwifery: containing upwards of a thousand modern formulae, including the new French medicines, and arranged tables of doses. Selected from the highest professional authorities, intended as a remembrancer for general practitioners. 2nd edition enlarged and improved*, London: printed for John Anderson and W. Simpkin and R. Marshall, J. Nimmo, Adam Black, Edinburgh: Hodges and M'Arthur, Dublin, 1826.

Anon., *A description of Bedlam; with an account of its present inhabitants, both male and female: shewing the causes of their confinement, their different humours, and intervals of mirth and melancholy: taken from their own mouths, and publish'd for universal instruction and entertainment: to which is subjoin'd, An essay upon the nature, causes and cure of madness by the author of The tale of the bee and spider*, London: Printed for T. Payne, 1722.

Anon., *A Treatise of diseases of the head, brain, & nerves: more especially of the palsy, apoplexy, lethargy, epelepsy, convulsions, frenzy, vertigo ... ; to which is subjoin'd a discourse on the nature, real cause and certain cure of melancholy in men and vapours in women by a physician*, 5th edn with additions, London: printed and sold by the author's appointment, 1727.

Anon., *A Treatise of warm drink: wherin it is prov'd by experience and good authorities, that beer, or any other liquor so qualify'd, is far more wholesome than that which is drank cold; with a confutation of such objections as are made against it intersprest with divers observations touching the drinking of cold water; and published for the preservation of health*, 2nd edn, London: printed for J. Wilford, 1725.

Anon., *A Treatise on foreign teas, abstracted from an ingenius work, lately published, entitled An essay on the nerves ... in which are observations on mineral waters, coffee, chocolate &c...* London: G. Cooke, *c*.1799.

Anon., *A view of human nature: or, Select histories; giving an acount of persons, who have been most eminently distinguish'd by their virtues or vices, their perfections or defects, either of body or mind ... the whole collected from the best authors in various languages*, London: S. Birt, 1750.

Anon., *An Account of the occasion and manner of erecting the hospital at Lanesborough House, near Hyde-Park-Corner*, published by order of the General Board of Governors, London, 1734.

Anon., *Facts in connection with the treatment of insanity at St. Luke's hospital; with letters on the subject to Lord Brougham, the committee of St. Luke's hospital, Drs Birkbeck, Elliotson, and others*, London: Effingham Wilson, 1841.

Anon., *Practical observations on insanity and the treatment of the insane; addressed particularly to those who have relatives or friends afflicted with mental derangement; also hints on the propriety of making the study of mental disorders a necessary adjunct to medical education*, London: W. J. Anderson, 1828.

Anon., *Sketches in Bedlam: or Characteristic traits of insanity, as displayed in the cases of one hundred and forty patients of both sexes, now, or recently, confined in New Bethlem. To the above are added, a succinct history of the establishment, its rules, regulations, treatment of patients. By a constant observer.* London: Sherwood, Jones, 1823.

Anon., *State of physic in London: with an account of the charitable regulation made lately at the College of physicians, towards preparing medicines there at the intrinsic value for the poor, and giving them advice gratis, Wednesdays and Saturdays in the afternoon, all year round ...* London: E. Whitlock, 1698.

Anon., *The complete midwife's practice enlarged, in the most weighty and high concernments of the birth of man ...From the experience of ... Sir Theodore Mayern, Dr. Chamberlain, Mr Nich. Culpeper ... with instructions of the Queen of France's midwife 5th ed. Enlarged by John Pechey*, London: H. Rhodes, J. Phillips, J. Taylor, K. Bentley, 1698.

Anon., *The English Midwife enlarged: containing directions to midwives*, London: Printed for Rowlandson Reynolds, 1682.

Anon., *The ladies dispensensory: or, Every woman her own physician. Treating of the nature, causes, and various symptoms, of all the diseases, infirities, and disorders, natural or contracted, that most peculiarly affect the fair sex ... Of the management of newborn infants, and the diseases they are usually subject to.* London: James Hodges, 1740.

Anon., *The London practice of midwifery; to which are added, instructions for the treatment of lying-in women, and the principal diseases of children*, 4th edn, London: Printed for Longman, Hurst, Rees, Orme, 1816, and subsequent editions 1820, 1826.

Anon., *The London practice of physic: Wherein the definitions and symptoms of diseases, with the present methods of cure, are clearly laid down: to which are added, proper tables ... and complete indexes 6th edition with amendments*, Dublin: Printed by Nicholas Kelly, for William Gilbert and John Rice, 1793.

Anon., *The practice of the British and French hospitals*, London: John Murray, 1773.

J. Boswell, *Boswell's London Journal 1762–1763*, ed. F. Pottie, London: Heinemann, 1951.

T. Bowen, *An historical account of the origin, progress, and present state of Bethlem Hospital: founded by Henry the Eighth, for the cure of lunatics, and enlarged by subsequent benefactors, for the reception and maintenance of incurables*, London, 1783.

J. Britton and A. Pugin, *Illustrations of the Public Buildings of London; with Historical and Descriptive Accounts of each Edifice*, 2 vols, London: J. Taylor, 1838.

S. P. Cockerell, 'To the Governors and Guardians of the Hospital for the Maintenance and Education of Exposed and Deserted Young Children: Assembled in General Court', London, 1807.

G. F. Cruchley, *Cruchley's London in 1865: A Handbook for Strangers Showing how to get There, Where to go and What to Look at*, London: G. F. Cruchley, 1865.

R. Dobie, *The History of the United Parishes of St Giles in the Fields and St George's Bloomsbury*, London: printed for the author, 1829.

W. Dodd, *An Account of the Rise, Progress, and Present State of the Magdalen Hospital, for the Reception of Penitent Prostitutes*, London: W. Faden, 1770.

J. Dunton, *An Essay on Death-Bed-Charity, Exemplify'd in the life of Mr Thomas Guy, Late Bookseller in Lombard-Street, Madam Jane Nicholas, of St. Albans. And Mr. Francis Bancroft, late of London draper*, London: printed by D. L. and sold by J. Roberts, 1728.

J. Evelyn, *Diary and Private Correspondence of John Evelyn*, ed. W. Bray, 2 vols, London: Henry Colburn, 1850.

T. Faulkner, *An Historical and Descriptive Account of the Royal Hospital at Chelsea*, London: Printed for T. Faulkner, Paradise-Row, Chelsea, 1805.

Gentleman's Magazine

Grand ... Avec les Plans, Profils et Elevations de Ses Faces, Coupes et Appartements, Paris: Gabriel Martin, 1683.

W. Harrison, *A New and Universal History: Description and Survey of the Cities of London and Westminister, the Borough of Southwark, and Their Adjacent Parts*, London: J. Cooke, 1776.

R. Horwood, Map of London, Westminster and the Borough of Southwark. London: Richard Horwood, 1799.

J. Kypp, and L. Knyff, *Nouveau Théâtre de la Grande Bretagne*, 1715.

The Last Will and Testament of Thomas Guy, Esq., Late of Lambard Street, Bookseller: Containing an Account of his Publick and Private Benefactions, London, 1725.

Le Jeune de Boulencourt, Description Générale de l'Hôtel Royal des Invalides Etabli par Louis Le Life and memoirs of Elizabeth of Chudleigh, afterwards Mrs. Hervey and Countess of Bristol, commonly called Duchess of Kingston. Written from authentic information and original documents. London: Printed for R. Randall, 1788.

W. Maitland, *The History of London from its Foundation to the Present Time By William Maitland*, 2 vols, London: T. Osborne and J. Shipton, & J. Hodges, London, 1756.

B. Mandeville, *The Fable of the Bees: or. Private Vices. Publick Benefits* [1723–29], 2 vols, ed. F. B Kaye, Oxford: Clarendon Press, 1924.

Mechanics' Magazine

S. Percy and R. Percy, *The Percy Histories of Interesting Memories of the Rise, Progress and Presentation of All the Capitals of Europe*, 3 vols, London, 1823.

W. H. Pyne, T. Rowlandson and A. Pugin, *The Microcosm of London*, 3 vols, London: R. Ackermann, 1808–10.

J. Rocque, Map of London, Westminster and Southwark, London: John Pine, 1746.

J. T. Smith, *Antiquities of London and Environs. Engraved & Publish'd by J.T. Smith Dedicated to Sir James Winter Lake, Bart. F.S.A. Containing many Curious Houses, Monuments & Statues never before Publish'd* ... London: J. Sewell, T. Simco, J. Manson, Messrs Molteno and Colnaghi, J. T. Smith and N. Smith, 1791.

Secondary sources
Books

D. S. Allen, *The Early Years of the Foundling Hospital 1739–1773*, London: D. S. Allen, 2010.

D. T. Andrew, *Philanthropy and Police: London Charity in the Eighteenth Century*, Princeton, NJ: Princeton University Press, 1989.

J. Andrews, *The History of Bethlem Hospital*, London: Routledge, 1997.

H. Andrews Hill, *Thomas Coram in Boston and Taunton*, Worcester, MA: Charles Hamilton, 1892.

D. Arnold, *Rural Urbanism: London Landscapes in the Early Nineteenth Century*, Manchester: Manchester University Press, 2005.

——*The Georgian Country House*, Stroud: Sutton, 1998.

C. R. Ashbee (founding editor), *Survey of London, vol. 24: The Parish of St Pancras*, part 4, King's Cross Neighbourhood, ed. Walter H. Godfrey and W. McB. Marcham, London, 1952.

J. Barry and C. Jones (eds), *Medicine and Charity before the Welfare State*, London: Routledge, 1991.

J. Blomfield, *St George's 1733–1933*, London: Medici Society, 1933.

J. Bold, P. Guillery and D. Kendall, *Greenwich: An Architectural History of the Royal Hospital for Seamen and the Queen's House*, New Haven, CT and London: Yale University Press, 2000.

A. T. Bolton and H. Duncan Hendry (eds), *The Wren Society*, vols VI (1929) and VIII (1931), Oxford: Oxford University Press.

J. Brownlow, *The History and Objects of the Foundling Hospital: With a Memoir of the Founder*, 3rd edn, London: C. Jaques, 1865.

E. M. Butler (ed.), *A Regency Visitor: The English Tour of Prince Puckler-Muskau, Described in His Letters 1826–1828*, London: Collins, 1957.

G. Byron, *Don Juan*, Canto XI (XLV), London, 1823.

H. C. Cameron, *Mr Guy's Hospital, 1726–1948*, London: Longmans, Green & Co, 1954.

C. Campbell, *Vitruvius Britannicus*, 3 vols, London: 1715, 1717 and 1725.

J. W. P. Campbell, *Building St Paul's*, London: Thames and Hudson, 2008.

S. Cavallo, 'The Motivations of Benefactors: An Overview of the Approaches to Charity', in Jonathan Barry and Colin Jones (eds), *Medicine and Charity before the Welfare State*, London: Routledge, 1991.

R. M. Clay, *Medieval Hospitals in England*, vol. XVII, London: Methuen & Co., 1966.

H. M. Colvin, Joseph Morduant Crook, Kerry Downes and John Newman, *The History of the King's Works*, vol. 5, London: HMSO, 1976.

A. J. Copeland, *Bridewell Royal Hospital, Past and Present: A Short Account of It as Palace, Hospital, Prison, and School, with a Collection of Interesting Memoranda Hitherto Unpublished*, London: Wells Gardner, Darton & Co., 1888.

J. E. Crowley, *The Invention of Comfort: Sensibilities and Design in Early Modern Britain and Early America*, Baltimore, MD: Johns Hopkins University Press, 2003.

D. Cruickshank, *The Royal Hospital Chelsea: The Place and the People*, London: Third Millennium, 2004.

C. Dickens, *Master Humphrey's Clock*, ed. Peter Mudford, London: Everyman, 1997.

C. B. C. Dickens, *Dickens's Dictionary of London* [1888], Devon: Old House Books (facsimile edn), 1993.

M. Douglas, *Purity and Danger: An Analysis of Concepts of Pollution and Taboo*, London: Routledge, 1966.

K. Downes, *The Architecture of Wren London*, London: Granada, 1982.

P. R. Du Prey, *John Soane: The Making of an Architect*, Chicago and London: University of Chicago Press, 1982.

N. Fellows, *Disorder and Rebellion in Tudor England*, London: Hodder and Stoughton, 2001.

C. Fontana, *Il Tempio Vaticano e sua Origine*, Rome, 1694.

M. Foucault, *Discipline and Punish: The Birth of the Prison*, trans. Alan Sheridan [1977], New York: Vintage, 1995.

—— *The Archaeology of Knowledge and the Discourse on Language*, trans. A. M. Sheridan Smith, New York: Pantheon, 1972.

S. Freud, 'The Uncanny' (1919) corrected reprint in *Sigmund Freud, Art and Literature*, the Pelican Freud Library, vol. 14, ed. Albert Dickson, Harmondsworth: Penguin, 1985.

A. Geraghty, *The Architectural Drawings of Sir Christopher Wren at All Souls College, Oxford: A Complete Catalogue*, London: Lund Humphries, 2007.

M. Girouard, *Life in the English Country House*, New Haven, CT and London: Yale University Press, 1978.

W. H. Godfrey, *Survey of London: vol. 11: Chelsea, part IV: The Royal Hospital*, London: B. T. Batsford, 1927.

M. Gorsky and S. Sheard (eds), *Financing Medicine: The British Experience since 1750*, London: Routledge, 2006.

R. Harris and Robin Simon (eds), *Enlightened Self-interest: The Foundling Hospital and Hogarth*, London: Draig Press, 1997.

E. Hellmuth (ed.), *The Transformation of Political Culture: England and Germany in the Late Eighteenth Century*, Oxford: Oxford University Press for the German Historical Institute London, 1990.

S. Hindle, *The State and Social Change in Early Modern England*, Basingstoke: Macmillan, 2000.

W. Hunter, *Historical Account of Charing Cross Hospital and Medical School*, London: John Murray, 1914.

G. Hutt (ed.), *Papers Illustrative of the Origin and Early History of the Royal Hospital at Chelsea*, London: HMSO, 1872.

P. Jeffery, *City Churches of Sir Christopher Wren*, London: Hambledon Continuum, 1996.

C. Jones, *The Charitable Imperative: Hospitals and Nursing in the Ancien Régime and Revolutionary France*, London and New York: Routledge, 1989.

G. Jones, *History of the Law of Charity, 1532–1827*, Cambridge: Cambridge University Press, 1969.

C. M. Kazmierczak, *Christ's Hospital of London, 1552–1598:, 'A Passing Deed of Pity'*, Selinsgrove, PA: Susquehanna University Press; London: Associated University Presses, 1995.

D. Keene, Arthur Burns and Andrew Saint, *St. Paul's: The Cathedral Church of London 604–2004*, New Haven, CT and London: Yale Center for British Art, 2004.

K. F. Kiple (ed.), *The Cambridge World History of Human Disease*, Cambridge and New York: Cambridge University Press, 1993.

J. Lane, *A Social History of Medicine: Health, Healing and Disease in England, 1750–1950*, London: Routledge, 2001.

J. Langdon-Davis, *Westminster Hospital*, London: John Murray, 1952.

C. Lawrence, *Medicine in the Making of Modern Britain, 1700–1920*, London: Routledge, 1994.

—— *Charitable Knowledge: Hospital Pupils and Practitioners in Eighteenth-century London*, Cambridge: Cambridge University Press, 2005.

H. Lefebvre, *The Production of Space*, Oxford: Blackwell, 1991.

—— *Rhythmanalysis: Space, Time and Everyday Life*, London: Continuum International, 2004.

A. Levene, *Childcare, Health and Mortality at the London Foundling Hospital 1741–1800: 'Left to the Mercy of the World'*, Manchester: Manchester University Press, 2007.

J. Lever, *Catalogue of the Drawings of George Dance the Younger (1741–1825) and of George Dance the Elder (1695–1768) from the Collection of the Sir John Soane's Museum*, London: Soane Museum, 2003.

R. W. Liscombe, *William Wilkins 1778–1839*, Cambridge: Cambridge University Press, 1980.

D. Lysons, *The Environs of London: Volume 2: County of Middlesex*, London, 1795.

R. K. McClure, 'The Captain and the Children: Captain Thomas Coram, 1668–1751, and the London Foundling Hospital, 1739–1799', Ph.D. thesis, Columbia University, 1975.

—— *The London Foundling Hospital in the Eighteenth Century*, New Haven, CT and London: Yale University Press, 1981.

E. McKellar, *The Birth of Modern London*, Manchester: Manchester University Press, 1995.

Thomas Malthus, *The Principles of Population* [1798], 5th edition, vol. I, London: John Murray, 1817.

M. Mauss, *The Gift: The Form and Reason for Exchange in Archaic Societies*, trans. W. D. Halls, foreword by Mary Douglas, London: Routledge, 1990.

J. Mohan and M. Gorsky, *Don't Look Back? Voluntary and Charitable Finance of Hospitals in Britain, Past and Present*, London: Office of Health Economics, 2001.

N. Moore, *History of St Bartholomew's Hospital*, London: C. A. Pearson, 1918.

R. H. Nichols and F. A. Wray, *The History of the Foundling Hospital*, Oxford: Oxford University Press, 1935.

B. Nicolson, *The Treasures of the Foundling Hospital with a Catalogue Raisonné Based on a Draft Catalogue by John Kerslake*, Oxford: Clarendon Press, 1972.

P. Nora, *Lieux de Mémoire*, 4 vols, Chicago: University of Chicago Press, 1999–2010.

E. G. O'Donoghue, *Bridewell Hospital, Palace, Prison, Schools*, in particular vol. 2: *From the Death of Elizabeth to Modern Times*, London: John Lane, 1923–29.

M. Ogborn, *Spaces of Modernity: London's Geographies 1680–1780*, New York and London: Guilford Press, 1998.

D. Olsen, *Town Planning in London*, New Haven, CT and London: Yale University Press, 1982.

D. Owen, *English Philanthropy, 1660–1960*, Cambridge, MA: Harvard University Press, 1965.

R. Paulson, *Hogarth's Graphic Works*, 3rd edn, London: The Print Room, 1989.

——*Hogarth*, 3 vols. New Brunswick, NJ: Rutgers University Press; Cambridge: Lutterworth Press, 1991–93.

S. B. P. Pearce, *An Ideal in the Working: The Story of the Magdalen Hospital, 1758–1958*, London: Magdalen Hospital, 1958.

N. Pevsner, *History of Building Types, 1902–1983*, London: Thames and Hudson, 1976.

R. Porter, *Disease, Medicine and Society in England, 1550–1860*, London: Macmillan, 1987.

J. F. Pound, *Poverty and Vagrancy in Tudor England*, London: Longman, 1971.

S. E. Rasmussen, *London: The Unique City*, Cambridge, MA: MIT Press, 1982.

H. Richardson (ed.), *English Hospitals 1660–1948: A Survey of Their Architecture and Design*, London: RCHME, 1998.

G. Rivett, *The Development of the London Hospital System: 1823–1982*, London: King's Fund, 1986.

H. Roberts and W. H. Godfrey (eds), *Bankside (the Parishes of St. Saviour and Christ Church, Southwark), London County Council Survey of London*, vol. 22, London: Joint Publishing Committee Representing the London County Council and the London Survey Committee, 1950.

C. Rowe, 'James Stirling: A Highly Personalized and Very Disjointed Memoir', in Peter Arnell and Ted Bickford (eds), *James Stirling: Building and Projects*, New York: Rizzoli, 1984.

J. A. Sheetz-Nguyen, *Victorian Women, Unwed Mothers and the London Foundling Hospital*, London: Continuum, 2012.

P. P. Slack, *From Reformation to Improvement: Public Welfare in Early Modern England*, Oxford: Clarendon Press, 1998.

H. St. George Saunders, *The Middlesex Hospital, 1745–1948*, London: Max Parrish, 1949.

C. Stevenson, *Medicine and Magnificence: British Hospital and Asylum Architecture, 1660–1815*, New Haven, CT and London: Yale University Press, 2000.

J. Summerson, *Georgian London*, Harmondsworth: Peregrine, 1949.

J. Taylor, *Hospital and Asylum Architecture in England, 1840–1914: Building for Health Care*, London: Mansell, 1991.

E. P. Thompson, *The Poverty of Theory, or An Orrery of Errors* [1978], new edn, London: Merlin Press, 1995.

J. D. Thompson and Grace Goldin, *Hospital: A Social and Architectural History*, New Haven, CT: Yale University Press, 1975.

S. Wilks and G. T. Bettany, *A Biographical History of Guy's Hospital*, London: Ward, Lock, Bowden & Co., 1892.

K. Wilson, 'Urban Culture and Political Activism in Hanoverian England: The Example of the Voluntary Hospital', in E. Hellmuth (ed.), *The Transformation of Political Culture: England and Germany in the Late Eighteenth Century*, Oxford: Oxford University Press for the German Historical Institute London, 1990, pp. 165–184.

S. Wren, *Parentalia, or Memoirs of the Family of the Wrens* [1750], reprinted Upper Saddle River, NJ: Gregg Press, 1965.

C. Wright, Catherine May Gordon and Mary Peskett Smith, *British and Irish Paintings in Public Collections: An Index of British and Irish Oil Paintings by Artists Born Before 1870 in Public and Institutional Collections in the United Kingdom and Ireland*, New Haven, CT and London: Yale University Press, 2006.

Articles

Anon., 'The London Lock Hospital and Its Founder', *British Medical Journal*, 6 July 1946.

P. H. Allderidge, 'Historical Notes on the Bethlem Royal Hospital and the Maudsley Hospital', *Bulletin of the New York Academy of Medicine*, vol. 47, no. 12, December 1971, pp. 1537–1546.

J. Bettley, 'Post Voluptatem Misericordia: The Rise and Fall of the London Lock Hospitals', *London Journal*, vol. 10, no. 2, Winter 1984, pp. 167–175.

J. Bold, 'Comparable Institutions: The Royal Hospital for Seamen and the Hôtel des Invalides', Essays in Architectural History Presented to John Newman, *Architectural History*, vol. xliv, 2001, pp. 136–144.

M. Binney, 'The Royal Hospital, Chelsea', *Country Life*, clxxvii, 1982, pp. 1474–1477, 1582–1585.

L. W. Cowie, 'Bridewell', *History Today*, vol. 23, no. 5, 1973, pp. 350–358.

L. Cust, entry for 'Robert Edge Pine' in Sydney Lee (ed.), *Dictionary of National Biography*, vol. 45, pp. 313–314, London: Smith, Elder and Co, 1896.

L. Denny, 'The Royal Hospitals of the City of London', *Annals of the Royal College of Surgeons of England*, vol. 52, no. 2, 1973, pp. 86–101.

J. Derrida, 'Point de folie#####maintenant l'architecture', trans. Kate Linker, *AA Files*, no. 12, Summer 1986, pp. 65–75.

K. Downes, 'Wren and Whitehall in 1664', *Burlington Magazine*, vol. 113, no. 815, February 1971, pp. 89–93.

M. Foucault, 'Des Espaces Autres' trans. by Jay Miskowiec as 'Of Other Spaces', *Diacritics*, Spring 1986, pp. 22–27.

J. Habermas, Sara Lennox and Frank Lennox, 'The Public Sphere: An Encyclopedia Article (1964)', *New German Critique*, no. 3, Autumn 1974, pp. 49–55.

M. B. Honeybourne, 'The Leper Hospitals of the London Area', *Transactions of the London and Middlesex Archaeological Society*, XXI, part 1, 1963, pp. 1–55.

N. D. Jewson, 'Medical Knowledge and the Patronage System in 18th Century England', *Sociology*, vol. 8, no. 3, 1974, pp. 369–385.

S. Lloyd, '"Pleasure's Golden Bait": Prostitution, Poverty and the Magdalen Hospital in 18th Century London', *History Workshop Journal*, vol. 41, 1996, pp. 50–70.

S. Nash, 'Prostitution and Charity: The Magdalen Hospital, a Case Study', *Journal of Social History*, vol. 17, no. 4, Summer 1984, pp. 617–628.

L. Prior, 'The Architecture of the Hospital: A Study of Spatial Organization and Medical Knowledge', *British Journal of Sociology*, vol. 39, no. 1, March 1988, pp. 86–113.

C. Stevenson, 'Robert Hooke's Bethlem', *Journal of the Society of Architectural Historians*, vol. 55, no. 3, September 1996, pp. 254–275.

D. Stroud, 'Hyde Park Corner', *Architectural Review*, vol. 106, 1949, pp. 379–397.

M. A. Waugh, 'Attitudes of Hospitals in London to Venereal Disease in the Eighteenth and Nineteenth Centuries', *British Journal of Venereal Diseases*, April 1971, pp. 146–150.

Index